# Origins of Religious Art & Iconography in Preclassic Mesoamerica

edited by

## H.B. NICHOLSON

UCLA Latin American
Center Publications

Ethnic Arts Council
of Los Angeles

1976

Library of Congress Catalog Card Number: 75-620028
ISBN: 0-87903-031-3

Printed in the United States of America

Cover illustration from Alfonso Caso,
"Calendario y escritura de las antiguas culturas de Monte Albán,"
in *Obras completas de Miguel Othón de Mendizábal*
(Mexico, 1947), Fig. 23.

# Origins of Religious Art and Iconography in Preclassic Mesoamerica

UCLA Latin American Studies Series

Volume 31

A Book on Lore

*Series editor*

Johannes Wilbert

*Editorial committee*

Robert N. Burr

Gerardo Luzuriaga

Susan K. Purcell

James W. Wilkie, *Chairman*

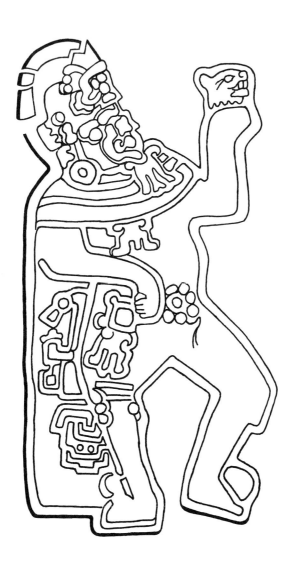

*To the memory of Sir Eric Thompson whose enormous contribution to Mesoamerican archaeology will be an enduring landmark.*

# PREFACE

The papers in this volume stem from a two-day conference, "Origins of Religious Art and Iconography in Preclassic Mesoamerica," held in the auditorium of Haines Hall on the campus of the University of California, Los Angeles, February 25-26, 1973. The sponsoring organizations were The Ethnic Arts Council of Los Angeles (Chairman, Jay Last), which bore nearly all costs, and the UCLA Latin American Center (Director, Johannes Wilbert), Department of Anthropology (Chairman, Philip Newman), Museum of Cultural History (Director, Pierre Delougaz), and Chicano Studies Center (Director, Rodolfo Alvarez). During the first day's session, chaired by H. B. Nicholson, nine papers were delivered orally, each followed by very brief discussion periods. These papers were delivered by the following persons, in order: Tatiana Proskouriakoff (Peabody Museum, Harvard University), María Antonieta Cervantes (Department of Archaeology, National Museum of Anthropology, Mexico), Peter David Joralemon (Department of Anthropology, Yale University), Jacinto Quirarte (College of Fine and Applied Arts, University of Texas at San Antonio), Michael Coe (Department of Anthropology, Yale University), Joyce Marcus (Dumbarton Oaks Center for Pre-Columbian Studies, Washington, D.C.), Hasso von Winning (Southwest Museum, Los Angeles), Peter Furst (Department of Anthropology, State University of New York, Albany), and H. B. Nicholson (Department of Anthropology, University of California, Los Angeles).

The second day's session, chaired by Michael Coe, was devoted to a three-hour period of discussion. Those who had delivered papers the day before constituted the discussional panel and accepted questions and considered comments from the audience. At this second session, two brief presentations on related topics were also delivered, one of which was subsequently enlarged to become a full-length article that appears as the fourth paper in this volume. The public was invited to attend both sessions and attendance at both exceeded expectations.

Many persons contributed to the success of the symposium—too many to thank individually—particularly various members of the Ethnic Arts Council of Los Angeles, staff members of the UCLA Museum of Cultural History, and graduate students of the UCLA Department of Anthropology. We would like to express, in this collective way, our sincere appreciation to them all for their indispensable aid.

MELVIN SILVERMAN, M.D.
*Chairman, Program Committee,*
*Ethnic Arts Council of Los Angeles*

JOHANNES WILBERT,
*Director, Latin American Center,*
*University of California, Los Angeles*

H. B. NICHOLSON,
*Department of Anthropology,*
*University of California, Los Angeles*

# CONTENTS

Preface                                                                                    vii

H. B. Nicholson    Introduction                                                              1

Maria Antonieta Cervantes    Olmec Materials in the National Museum of
Anthropology, Mexico                                                                         7

Peter David Joralemon    The Olmec Dragon: A Study in Pre-Columbian
Iconography                                                                                 27

Jacinto Quirarte    The Relationship of Izapan-Style Art to Olmec and
Maya Art: A Review                                                                          73

L. R. V. Joesink-Mandeville and Sylvia Meluzin    Olmec-Maya Relation-
ships: Olmec Influence in Yucatan                                                           87

Michael D. Coe    Early Steps in the Evolution of Maya Writing                             107

Joyce Marcus    The Iconography of Militarism at Monte Albán and
Neighboring Sites in the Valleys of Oaxaca                                                  123

Hasso von Winning    Late and Terminal Preclassic: The Emergence of
Teotihuacán                                                                                 141

H. B. Nicholson    Preclassic Mesoamerican Iconography from the Perspec-
tive of the Postclassic: Problems in Interpretational Analysis                              157

Index                                                                                       177

# Introduction

H. B. Nicholson

Research into pre-Hispanic Mesoamerican culture history has been characterized by various trends and cycles over the past few decades. Many of the leading pioneers were intensely interested in the ideological aspect—particularly religious ideology—of Mesoamerican civilization in which, it was recognized almost from the beginning, religion had played an especially pervasive role. This early trend culminated, during the years before and after the turn of the century, in the monumental research of Eduard Seler and his direct and indirect followers. Seler made many important contributions; not the least was his method—only indifferently successful before his time—of interpreting pre-Hispanic (particularly central Mexican) depictions of religious character by undertaking thorough comparisons with all relevant archaeological data, native tradition pictorials, and ethnohistorical textual sources.

By the close of the Selerian period, in the early 1920s, the religious ideology of, above all, the late pre-Hispanic central Mexican peoples was reasonably well understood, at least in broad outline. Most important extant archaeological pieces from this region bearing representations with religious connotations had been more or less accurately interpreted. Similar types of central Mexican remains dating to the pre-Postclassic or those from other Mesoamerican regions of whatever date, however, were not nearly as well elucidated—and posed a major challenge for future scholarship. Interest in iconographic interpretation in Mesoamerican studies somewhat slackened during the next few years, although certain dedicated students successfully carried on the tradition of the sage of Steglitz. The second quarter of the century was dominated much more by a great upsurge in excavational archaeology, with consequent refinement of ceramic and other artifactual typologies and the working out of detailed regional phase sequences.

Another strong movement emerged in the post-World War II years: intensive cultural ecological and settlement pattern studies. This trend was inspired particularly by the writings of V. Gordon Childe and others on ancient Near Eastern and European cultural beginnings, including the influential concepts of the "Neolithic" and "Urban Revolutions." This new research thrust, often—consciously or unconsciously—with obvious intellectual Marxist overtones, was especially characterized by a strong developing interest in the articulations between ancient Mesoamerican cultures and their environments. Increasingly, efforts were made to analyze and to try to explain the specific cultural processes that had been operative in the evolution of the pre-European New World's most complex civilization, focusing on subsistence and technological and economic systems. This movement rapidly accelerated during the next few years, exerting a powerful influence on nearly all of the younger archaeologists entering the Mesoamerican field. Although there were occasional exceptions, most of the active practitioners of this approach concerned themselves rather minimally with the ideological and esthetic aspects of the ancient cultural systems they were investigating. This trend is perhaps best exemplified by a provocative 1968 book, *Mesoamerica: The Evolution of a Civilization*, by William Sanders and Barbara Price, which ably summarizes much of the research objectives and theoretico-methodological preoccupations of the "cultural ecological school." Precisely what is conspicuously lacking in this broad survey and analysis of major evolutionary trends in Mesoamerican civilization is any genuinely adequate consideration of the religious-ritual-divinatory ideology that constituted such a massive dimension of the history of this area co-tradition.

The relative lack of attention to the religious ideological aspect on the part of the more "materialist-Marxist"-oriented archaeologists—and most of the "new archaeologists" would appear also to take this basic tack—undoubtedly stems from their conviction that the prime causative forces in culture lie imbedded in what Julian Steward defined as the "cultural core": cultural ecological

adaptations, technological-economic-demographic systemic patterns and articulations, and so on. Religion and its concomitant esthetic are from this point of view usually relegated to the less fundamental, more derivative "secondary" or "superstructural" cultural sphere. As Sanders and Price (1968:9) have put it, citing Leslie White, "nonmaterial aspects of culture have evolved as adaptations to technological revolutions." Elsewhere (1968:38) they sum up their approach by speaking of "the ecological system as the primary matrix of change." The record, however, of Old World cultural and political history would appear to suggest that religious ideology may not by any means have played such a passive and "secondary" role from the standpoint of cultural causation and creativity—even before the emergence of the great, organized religious systems such as Buddhism, Manichaeism, Christianity, and Islam. In fact, it can be argued that the precise role played by religious ideology and ritual in the process of culture change and growth is one of the most challenging problems in current anthropology.

There are growing signs that in some anthropological and archaeological circles the currently fashionable relative downgrading of the ideational sphere as a source of culture change may be somewhat slackening. Significantly, during the 1970 Wenner-Gren conference at Burg Wartenstein to discuss the overall Mesoamerican genesis (published in 1971), the suggestion that the "spiritual" or "human" factor should not be entirely neglected in approaching these problems was variously made, even by archaeologists normally quite "materialistically" oriented. For example, Gordon Willey, one of the leaders among New World archaeologists most dedicated to settlement pattern studies and related approaches, explicitly urged more consideration of the "dimension of ideology" when seeking to discern and explain the mainsprings of Mesoamerican civilization. And a leading British Americanist, Geoffrey Bushnell, at the same conference spoke of his sometime weariness and dissatisfaction with the "unrestrained materialism of the ecological approach."

Particularly in an area co-tradition such as Mesoamerica, where the immense importance of religion is admitted by all, even by the most committed "cultural ecologist," the advisability of appropriate attention to this aspect would appear to be self-evident. Eric Thompson, in his recent book, *Maya History and Religion* (1970), has suggested (1970:47) that the Mayanist archaeologist can neglect ethnohistory only "at his peril." I would, in turn, suggest that those interested in the causative forces involved in the emergence and further developmental efflorescence of Mesoamerican civilization possibly are neglecting the religious ideological sphere—as evidenced by esthetic-symbolic expression—also at their peril.

Interestingly, at the very height of the popularity of the "Marxist-materialist" approach to the study of pre-Hispanic Mesoamerica two quite contrastive trends also emerged. One was a broadly humanist thrust, primarily initiated in Mexico by Angel M. Garibay and Miguel León-Portilla, which concentrates on the oral literary and "philosophical" achievement of late pre-Hispanic Mesoamerican peoples, especially the central Mexican Nahua-speakers. As might be expected, the adherents of this approach generally tend to slight the "materialistic" aspect of the indigenous cultures almost as conspicuously as the cultural ecologists and those who share their same basic orientation tend to minimize the ideational and esthetic expressive spheres.

The second trend is what primarily concerns us here. It is characterized by a strong upsurge of interest in iconographic analysis and interpretation, now directed more toward other areas and periods than late pre-Hispanic central Mexico. Not unexpectedly, in view of the vigorous growth of the field of art history during the past few years, students from this discipline are increasingly playing major roles in this movement, which until recently was almost completely dominated by archaeologists and ethnohistorians. Like their counterparts in the Old World field, art historians working with Mesoamerican materials have not been content by any means with purely esthetic-stylistic analyses but have also determinedly pursued iconographic interpretations.

Again, where the current activity in Mesoamerican iconographic studies appears to differ most strikingly from that of former times is in its much greater attention to areas and periods previously considerably less investigated from the point of view of iconography. Often this seems to be owing to the availability of substantial amounts of fresh data resulting from both controlled archaeological investigations and widespread "huaquerismo," above all in the Olmec, Izapan, Monte Albán, Classic Veracruz, "Ñuiñe," and "Early Far West

Mexican" traditions. Although considerable material from these traditions has been extant (or above ground, at least) since the last century or even earlier, not until recently has the true culture historical position of some of these data become reasonably clear, particularly for Olmec and Izapan. Some other Mesoamerican regional traditions, such as Lowland Maya, Teotihuacán, and Xochicalco, which received considerable earlier attention by Seler and others, have since yielded many new data of great esthetic and iconographic importance.

All of this recent activity, of course, can take full advantage of the much greater overall knowledge and understanding of Mesoamerican archaeology-ethnohistory gained during the past few years. An especially influential development has been the recognition of the vital role in the emergence of Mesoamerican high culture exerted by the Olmec tradition centered in the Gulf Coast region—and the almost equally key role seemingly played by the Izapan tradition as a lead-in to the spectacular rise of the Classic Lowland Maya tradition. As scholarly interest in the cultural processes involved in the genesis and evolution of Mesoamerican civilization has flamed up rather spectacularly, the cultural ecologists, who undeniably led the way in this endeavor, find themselves being increasingly joined by students who focus more on those archaeological data that evidence ideological, esthetic, and intellectual patterns and themes.

From the standpoint of improved balance and perspective, this greater attention to iconographic interpretation can only be strongly welcomed by all serious Mesoamericanists. Yet the considerable difficulties commonly encountered in attempting these analyses and elucidations to aid in the reconstruction of ancient Mesoamerican religious ideological patterns must be clearly recognized. The symbols, depictive scenes with obvious or apparent religious-ritual connotations, and hieroglyphic texts on the objects, monuments, and structures produced by the emergent Mesoamerican civilizations reflect ideologies and communication systems that flourished many centuries before the Conquest—and the intervening changes and shifts must often have been quite substantial. Although cautious backward extrapolation from the Contact iconographic systems—insofar as they in turn, can be reconstructed and understood from both textual and archaeological data—can often

achieve valuable results, the pitfalls and difficulties here are many and varied. Currently a controversy is raging over precisely this issue, that is, the validity of utilizing Conquest period data to interpret ancient Mesoamerican remains, which is explicitly dealt with in the final article in this volume. Whatever one's particular position concerning this debate might be, the significant point is that a determined, aggressive attack on these problems is steadily increasing and already encouraging results appear to be mounting up.

The UCLA conference on Origins of Religious Art and Iconography in Preclassic Mesoamerica was conceived with this growing recognition of the value and importance of iconographic-esthetic interpretation in Mesoamerican studies very much in mind. It seemed to the organizers that general interest in the earlier stages of this aspect of Mesoamerican civilization was perhaps at an all time high. Accordingly, with this topic as the basic conference theme, various scholars whose interest and competence in this research area were well known were invited to participate by presenting papers and contributing to the ensuing discussions. A certain geographical and temporal balance was attempted and is, hopefully, reflected in the coverage of the papers. The first two papers are devoted to what many consider to have been the first clear-cut New World high culture, now almost universally called Olmec. Cervantes describes the exhibition organization—and the conceptual bases on which it rests—of what is undoubtedly the most important single collection of Olmec archaeological pieces in existence. Joralemon, one of the leading students of Olmec iconography, focuses his discussion on a fundamental supernatural conception that was clearly ancestral to a whole family of "terrestrial-celestial monsters" in later Mesoamerican cultures.

Most students now seem to accept the basic working hypothesis that the complex of iconographies centered in south Chiapas-Guatemala and subsumed under the generic term, Izapan, represent at least partial spin-offs from Olmec as well as probable parallel developments. It is being increasingly recognized that the Classic Lowland Maya iconographic-esthetic-writing system probably is genetically closely linked with this earlier Izapan tradition. Two articles are directly relevant to this theme. Quirarte, a prominent "Izapanist," discusses certain significant iconographic features of the overall system and its relationship to the

earlier Olmec and later Maya systems. Coe, one of the few archaeologists who has made important contributions to both the "ideational-iconographic" and "cultural ecological" sectors of Mesoamerican prehistory, summarizes current knowledge of the probable evolution of Classic Lowland Maya hieroglyphic writing and calendrics from Izapan (and ultimately Olmec?) beginnings.

With the Joesink-Mandeville and Meluzin paper the geographical locus shifts to the north, to Yucatan, the great limestone shelf that projects out into the Caribbean—which has traditionally been held to have been not very actively involved in the Olmec-Izapan efflorescence that, again, at least in part, apparently provided the necessary underpinning for Classic Lowland Maya civilization. Joesink-Mandeville and Meluzin, however, present some interesting evidence that North Yucatan was not as noninvolved with the developing Olmec-Izapan iconographies of the Middle-Late and Protoclassic as was formerly believed.

The next two papers are concerned with two key regions of western Mesoamerica and tend to move somewhat forward in time. Marcus provides a provocative pioneer attempt to squeeze more meaning out of certain place signs in Protoclassic and Classic Monte Albán tradition relief carvings and, inter alia, publishes various relevant new carvings from the Valleys of Oaxaca. Von Winning discusses the transition from Preclassic to Classic in central Mexico in terms of certain important iconographic themes. Finally, in the last paper in the volume the writer comes to grips with the difficult question of to what extent it is legitimate to employ Conquest period ethnographic data to aid in the interpretation of earlier archaeological remains, with special attention to the recent invoking of Panofsky's "principle of disjunction" by a leading art historian who is very critical of the use of this type of "upstreaming" or "direct historical approach."

The essential thrust of all of these papers is "particularistic" or "historical" in the narrower sense rather than generalizing or "scientific" or "processual," in contrast to the professed aims of many of those archaeologists who adhere to the cultural ecological approach—and all of the "new archaeologists." No attempt is made to examine the functional articulation, if any, between the subsistence-technological-economic sector of the culture and the ideological-expressive. These questions certainly deserve further examination, and it is to be hoped that anthropologically oriented archaeologists will devote more attention to them than they have hitherto received. Before the functional and processual aspects can be very satisfactorily analyzed, however, as accurate reconstructions as possible of the writing, religious, iconographic, and esthetic systems of the earliest Mesoamerican high cultures and their historical interrelationships must be undertaken. Before the "why" of the past can be satisfactorily answered we must have available to us for analysis an essentially accurate "what" of the past. These eight articles contribute substantially to our knowledge of the ideological and esthetic aspects of early Mesoamerica—and ideology and esthetics are precisely those dimensions that provided most of the distinctive cultural personality of this great area co-tradition and most clearly set it apart from any other in world history. They are presented here with the hope that they together constitute another significant stride down the long road toward greater understanding of the history, structuring, and patterning of the ideational aspect of the New World's most advanced indigenous civilization.

# Olmec Materials in the National Museum of Anthropology, Mexico

MARIA ANTONIETA CERVANTES

Department of Archaeology
National Museum of Anthropology
Mexico

The archaeological exhibits of the museum are organized according to geographical and cultural areas. An introduction explains anthropology in its different branches, and in a general hall the superarea called Mesoamerica is defined.

The Central Highlands are presented in four halls that refer to the four main chronological divisions of pre-Hispanic Mesoamerican cultural development: The Origins, Formative or Preclassic, Classic, and Historical or Postclassic. The last and fifth hall is devoted to Aztec culture.

After the Central Highlands hall come the galleries of the Oaxaca, Gulf Coast, Maya, Northern, and Western cultures. Each hall is subdivided into subareas and follows a chronological order for the exhibition of the objects.

The three subareas in which the gallery of the Gulf Coast Cultures is divided are the Huasteca or northern area, the central area where the Tajín culture flourished, and the southern or Olmec area.

The need to restructure this last section gave me the opportunity to revise the available materials in the collections and to establish more accurate criteria for their display.

The material that is classified as Olmec proceeds from different sources; nevertheless, we can organize it in two main groups: (1) pieces precisely documented, obtained in excavations conducted by specialists; (2) pieces lacking reliable information. Pieces in the second group were given by private sources or recovered from illicit dealing, those obtained by accidental discoveries, and objects that were kept for a long time in the storeroom. In the former group we have the results of the excavations made by Stirling, Drucker, Coe, Vaillant, Covarrubias, Piña Chán, Grove, Romano and García Moll, Flannery, Heizer, Navarrete, Lowe, and others. The remarkable pieces of the Covarrubias collection, "The Wrestler," the Tenango head, and many others of extraordinary quality, belong to the latter group.

The first step was to separate the pieces that had a detailed record of their origin and association from those lacking such data. All this, which sounds so simple, had never been attempted before. It was necessary to reread everything published relating to the subject, to distribute the objects correctly and in this way form significant units (for example, the reconstruction of offerings) and to recover from the museum's storeroom many other pieces that nobody had seen for many years.

With this objective in view and the available information studied and revised, I proceeded to organize and draw up documentation that would be easily understood by the nonspecialist. Thus, through their visits to the museum, the public could learn the features that define the Olmec culture.

One of the basic ideas of the documentation is that in a museum context it is only possible to convey information to the public with reference to the exhibited materials. Taking an object as a point of departure, we can make important cultural inferences relating to the culture that created the object, but it is absolutely necessary to focus on the object itself. Therefore, theoretical approaches are not totally viable in a museum situation.

To validate my sequential approach, I consulted with and received advice from Matthew Stirling, Michael Coe, David Grove, Gareth Lowe, and Carlos Navarrete, who on various occasions very generously gave part of their time to discuss the nature of the objects, their origin, antiquity, meaning, use, and so on.

After I had exhausted the Olmec bibliography, I developed new maps, plans, labels, drawings, and photos, to establish the chronological and area location of Olmec culture.

The Olmec hall was ultimately divided into five wings: (1) San Lorenzo; (2) La Venta; (3) other sites in the Gulf Coast region; (4) Extension; and (5) Survivals. In the first two sections I placed the materials for which I have an exact provenience and chronology. In the third wing I grouped the materials from different sites on the Coast and others whose origins are unknown. This was done to exhibit the totality of elements that define Olmec style, without any consideration of chronology. In the next section I showed how the Olmec

style spread to different regions, and in the fifth section I isolated the survival of certain Olmec stylistic features in other Gulf Coast materials.

The first section (Figs. 1-6) pertains to the site of San Lorenzo, Veracruz, which currently is considered the place of origin and development of the Olmec culture. It is explained by referring to the ten extraordinary monuments in the museum's collections, each of which has a label that refers to political, religious, or esthetic aspects of Olmec culture.

I have also included a series of maps, plans, drawings, and photographs of the elements or cultural features that have been found at this site: the earth mounds, the stone drains, the artificial ponds, and so on.

From the Coe excavations in San Lorenzo, Veracruz, only two complete vessels and a small jade plaque (surely from the Nacaste phase) were obtained. Unfortunately, the museum has not yet (Spring, 1973) received these materials in order to exhibit the typical pottery from that site. Some weeks ago, however, a few confiscated pieces were brought to the museum. I presume that they correspond to the Limón Carved, Differentially Fired, and Xochiltepec White types. A series of small figurines also from the San Lorenzo phase

was included in the confiscated material. Since I do not know their origin, I have shown them as Olmec ceramics but have not related them to materials of known provenience.

The graphic materials of La Venta, Tabasco, are presented in the second section (Figs. 7-19). Maps, plans, labels, and photos clearly indicate the particular period that was contemporary with San Lorenzo. At this point in time La Venta and San Lorenzo had similar elements: monumental altars, colossal heads, and sculpture in the round. La Venta, however, continues its development until some time later. A seated sculpture, intentionally mutilated, starts the La Venta sequence in the exhibition. It corresponds to the earliest Olmec occupation of the site. Aside from this, the other materials in the exhibition are of a later phase. Ceramics from Drucker's excavations—which are very different from those of the San Lorenzo phase—are shown even though the figurines still retain much of the ancient style.

The development of Olmec lapidary work in La Venta is really extraordinary, and I tried to show it by organizing a sequence of offerings that Stirling and Drucker had found in their excavations. The only complete offering known was No. 4. In spite of my efforts, I was able to gather only a

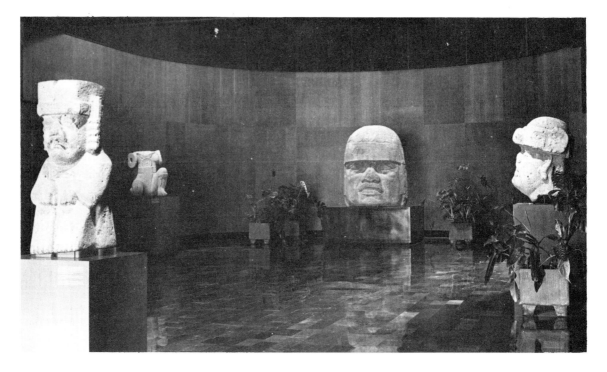

Fig. 1. San Lorenzo Section, with 4 monuments (two more are still in the storeroom).

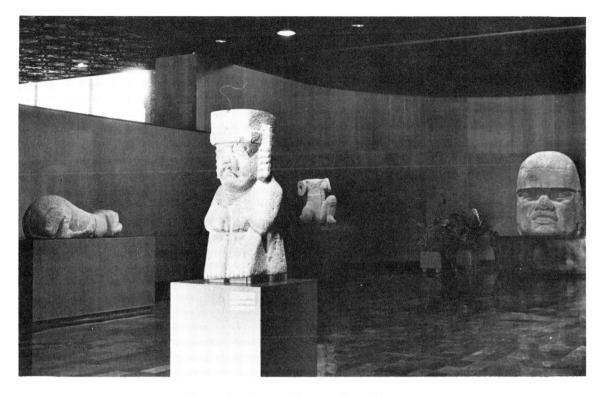

Fig. 2. San Lorenzo Section. General view.

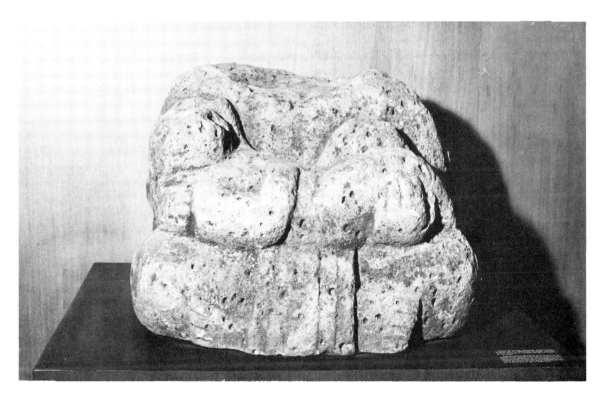

Fig. 3. Monument 12, San Lorenzo, Veracruz.

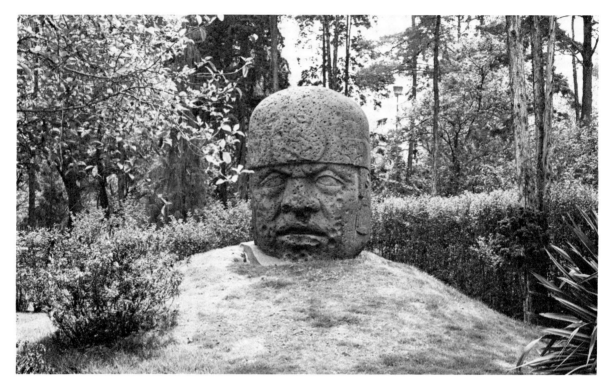

Fig. 4. Head No. 2, San Lorenzo, Veracruz.

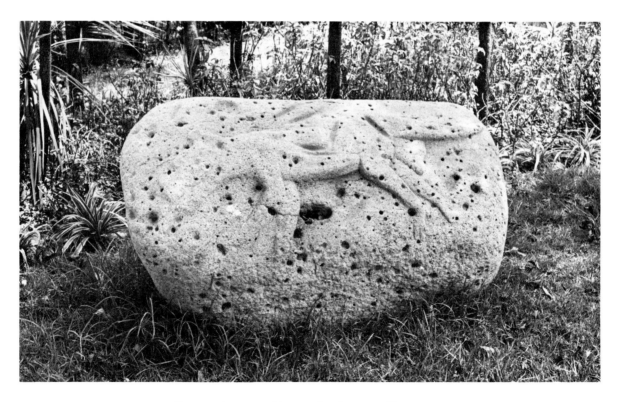

Fig. 5. Monument No. 21, San Lorenzo, Veracruz.

Fig. 6. Olmec ceramics from San Lorenzo Phase. Without provenience (confiscated material).

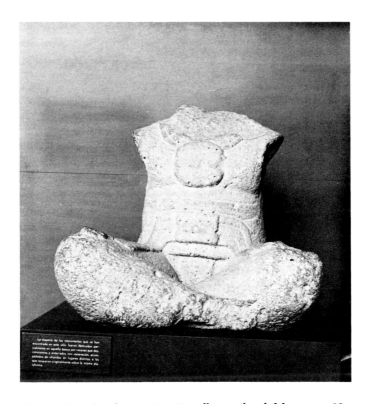

Fig. 7. Seated sculpture, intentionally mutilated. Monument 23 from La Venta, Tabasco.

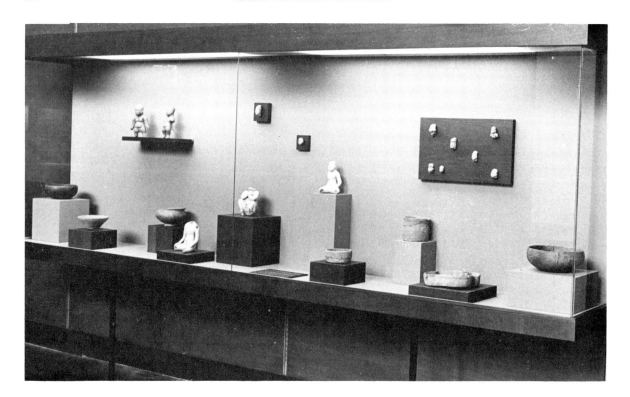

Fig. 8.  Ceramics from La Venta, Tabasco.

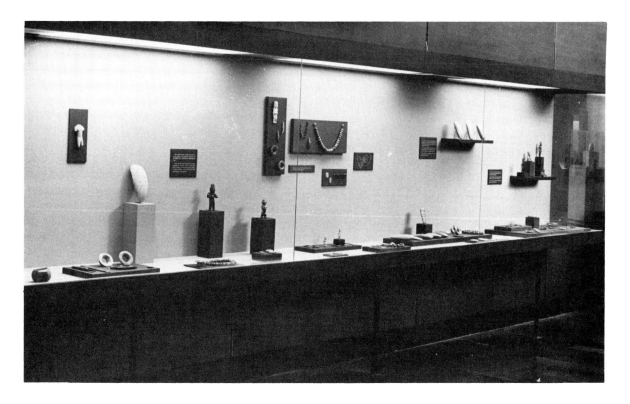

Fig. 9.  Showcase containing lapidary work from La Venta, Tabasco.

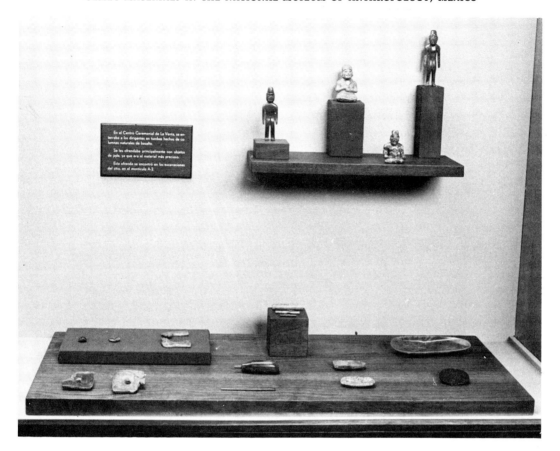

Fig. 10. Offering from Mound A-2, La Venta, Tabasco.

Fig. 11. Offering from Tomb E, Mound A-2, La Venta, Tabasco.

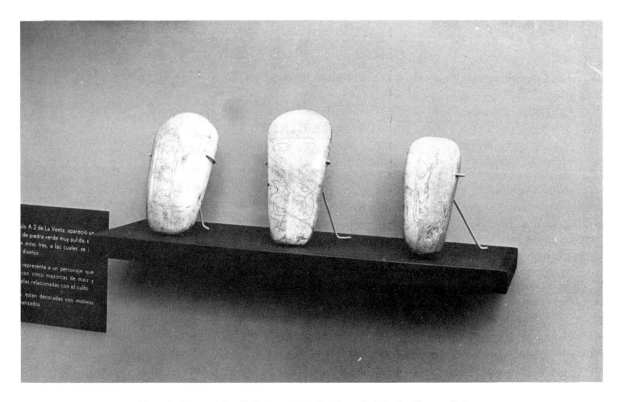

Fig. 12. Part of the Offering 1942-C, Mound A-2, La Venta, Tabasco.

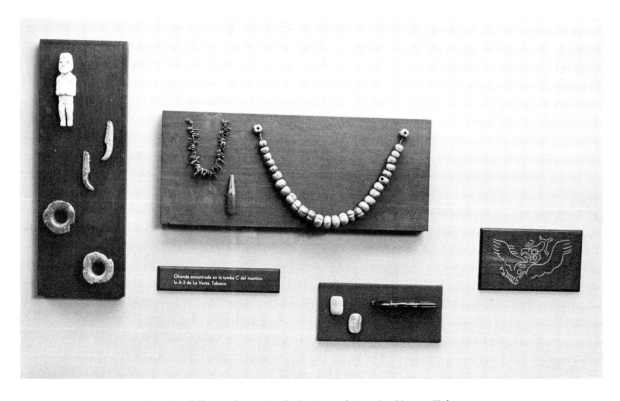

Fig. 13. Offering from Tomb C, Mound A-3, La Venta, Tabasco.

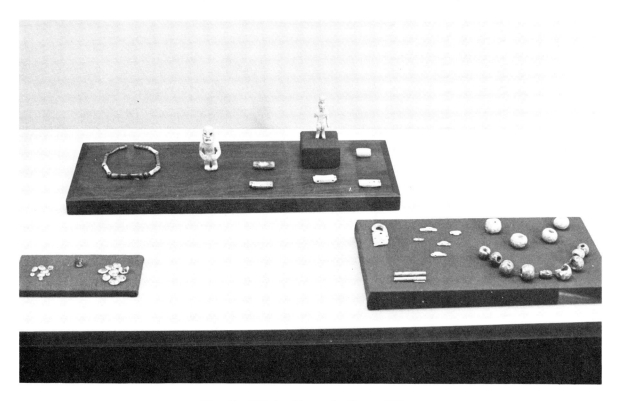

Fig. 14. Offering No. 3, La Venta, Tabasco.

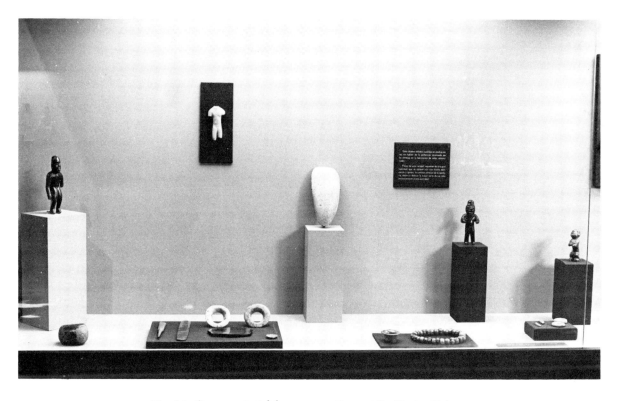

Fig. 15. Stone material from excavations at La Venta, Tabasco.

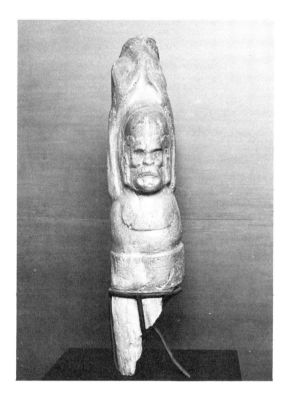

Fig. 16. Monument 12, La Venta, Tabasco. The Monkey.

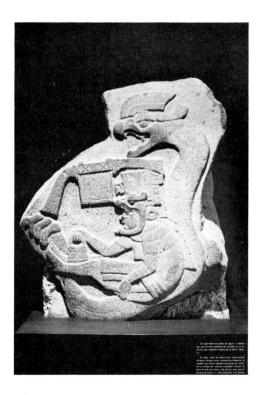

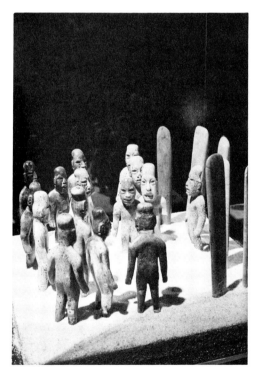

Fig. 17. Monument 19, La Venta, Tabasco.          Fig. 18. Offering No. 4, La Venta, Tabasco.
The Serpent and a Priest.

Fig. 19. General view of the La Venta wing.

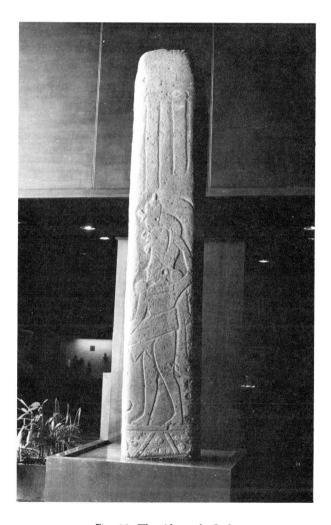

Fig. 20. The Alvarado Stela.

few additional (but incomplete) offerings; thus, the best part of the jade offerings can now be admired at the museum. This showcase is flanked by a sculpture representing a monkey and that magnificent relief of a serpent and a priest, which by their stylistic features are from the latest levels of La Venta. The famous No. 4 offering is displayed in front of this showcase.

The third section (Figs. 20-25) is formed by two showcases, which, as I have already stated, contain objects from different sites of the Gulf Coast, many of them lacking provenience; I include them to better define the Olmec style of the Gulf Coast. Here the following materials are exhibited: green stone celts, awls, necklaces, plaques with incised carvings, pyrite mirrors, "spoons," clay and stone baby-face figurines, the were-jaguar, and so on. "The Wrestler" and the Arroyo Sonso Jaguar sculptures are placed in the center of the section, to exemplify the monuments of the area. Next, a showcase displays very small stone jewelry: buttons, pectorals, the Cerro de las Mesas canoe, The Dwarf and other tiny figurines.

To present a clearer idea of this section, a table with representations of the Olmec style elements is shown. On it are indicated the materials that can be seen in the gallery. For those that are not in the museum's possession, I include either a photo or a drawing.

The fourth section (Figs. 26-27) begins with a graphic table and a distribution map. These show the existence of elements or features of Olmec style that appear in sites beyond the Gulf Coast area. The table and map demonstrate that these elements are few in comparison with those that existed in Veracruz and Tabasco. Furthermore, they are quite scattered and not concentrated. If the object is in the gallery, it is marked as such on the table; when it is not there, a photo or a drawing of the object is shown.

I next present a showcase containing Central Highland materials from Tlatilco, Tlapacoya, and Las Bocas of unquestionable Olmec style. Stylistically related objects from Oaxaca, Guerrero, Chiapas, and Colima are shown in another case. I quote the text of the label:

The objects proceeding from the Gulf Coast show a group of forms and symbols that must have expressed the political and religious concepts of the Olmecs. These same concepts are found in pieces proceeding from different places, far from the Veracruz and Tabasco zone.

In none of the sites out of the coastal zone do we find together all of the features that define the Olmec culture; they are usually found mixed with objects pertaining to the local culture and in all instances they are less in number than the local elements. This leads one to suppose that the Olmec presence outside its original area is explained by the diffusion of Olmec beliefs, through commercial exchange, rather than by political domination.

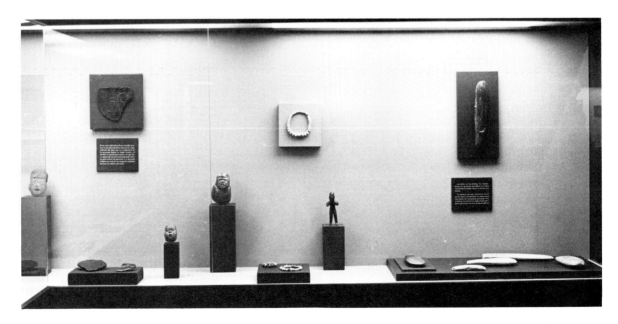

Fig. 21. Third section. First showcase, containing celts, figurines, plaques, pyrite mirrors, and necklaces.

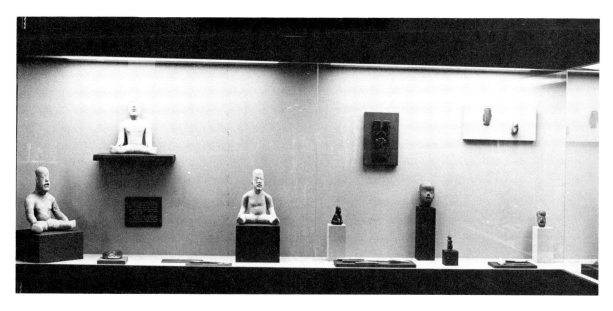

Fig. 22. Third section. Second showcase, containing spoons, anthropomorphic axes, baby-faces, etc.

Fig. 23. The Wrestler and the Arroyo Sonso Jaguar.

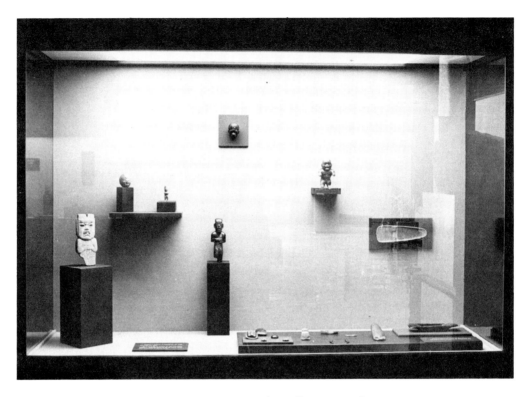

Fig. 24. Showcase with small stone jewelry.

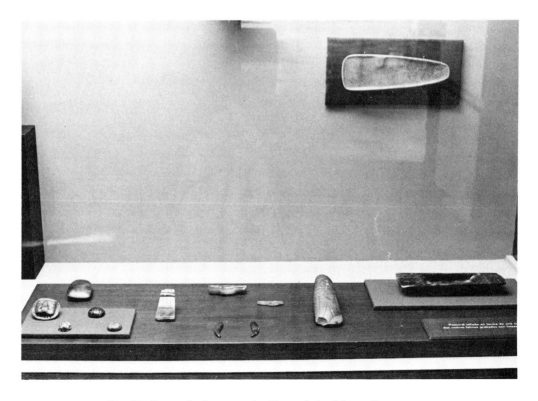

Fig. 25. Pectorals, buttons, the Cerro de las Mesas Canoe, etc.

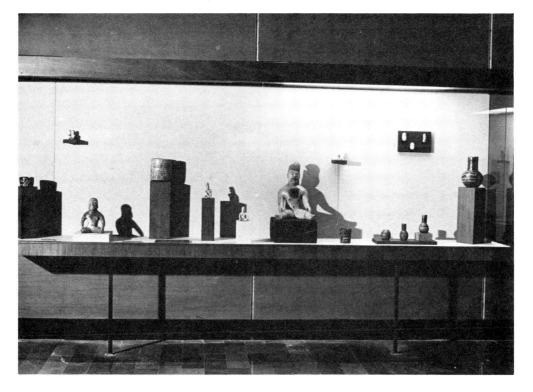

Fig. 26. The fourth section. Central Highland materials: Tlatilco, Tlapacoya, Las Bocas.

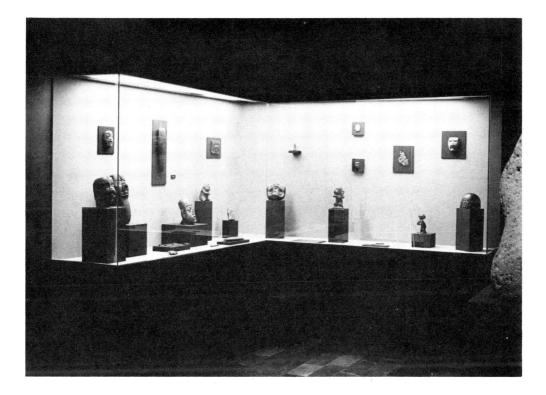

Fig. 27. Objects from Guerrero, Oaxaca, Chiapas, etc.

It is interesting to point out that as a result of this classification, when examining the materials of different zones I observed that in the Central Highlands, Oaxaca, and Chiapas the presence of Olmec features is manifested in ceramics and that this coincides with the types of the San Lorenzo Phase from Veracruz. In contrast, when I classified the materials from other areas where Olmec features appear, I noted that these features are found in the lapidary pieces, reliefs, stelae, isolated sculptures and even in paintings but not in ceramics—and all are related to La Venta style in its more recent phases.

The last part of the gallery (Figs. 28-30) is occupied by those materials from the Gulf Coast which are chronologically later, but in which we still can recognize elements of the ancient Olmec style. It appears that some of these elements have a great continuity in time. Here Monument C and Stela C from Tres Zapotes, the reproduction of the Tuxtla Statuette, and some feline-featured masks are shown. Two small cases containing some of the jade material from the Cerro de las Mesas big offering also belong to this section.

We can only talk of an Olmec Culture in the climax area, where it is well defined and can be clearly distinguished at San Lorenzo, Tres Zapotes, and Laguna de los Cerros in Veracruz and La Venta in Tabasco. It seems that the ceramics and the lapidary pieces obtained by Gareth Lowe at San Isidro and other sites in Chiapas indicate that this zone also participated in the Olmec culture. Most of the objects are similar to those of the Gulf Coast but do not reach the levels of development shown in monumental sculpture, water control systems, and the like.

In the Central Highlands and other areas we find instead objects that are clearly Olmec in style but which are found mixed with local cultural complexes, with traditions that are even older than these alien objects. I am not speaking of an Olmec influence because apparently as long as the contact lasted the local style did not change. What I speak of is the presence of Olmec features very well fixed in some few objects and scattered throughout different Mesoamerican zones. This is why when we find characteristics of the style we do not necessarily suppose that the site belongs to the Olmec culture. Style is one thing and culture another, even though a style is an aspect of an entire cultural complex.

Unfortunately, the gallery is not yet complete (Spring, 1973). There are still some large monuments to be moved, and the graphic material is still in preparation. We hope it is going to be finished quite soon (so the museographers say).

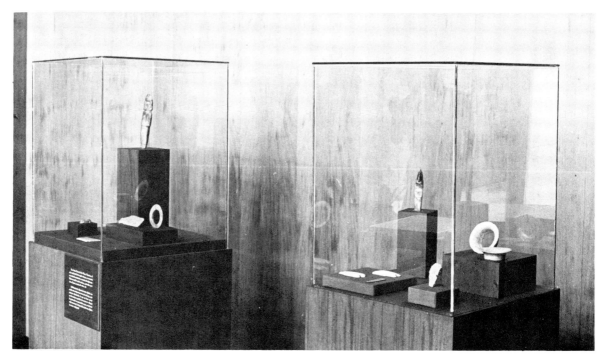

Fig. 28. Part of the Cerro de Las Mesas big offering.

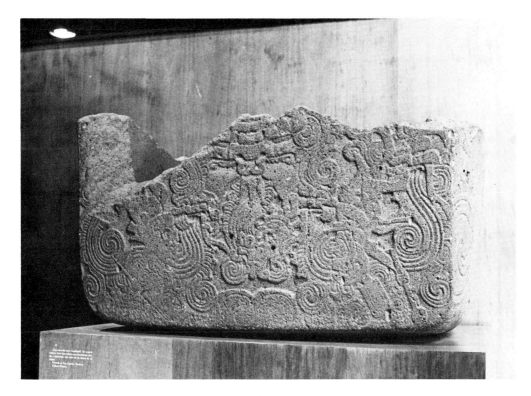

Fig. 29. Monument C, from Tres Zapotes, Veracruz.

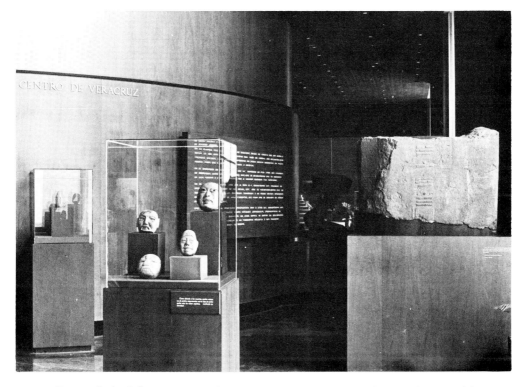

Fig. 30. Stela C (lower portion) from Tres Zapotes, Veracruz, the reproduction of the
Tuxtla Statuette, and some feline-featured masks.

# The Olmec Dragon:
# A Study in Pre-Columbian Iconography

PETER DAVID JORALEMON

Department of Anthropology
Yale University

*Dedicated to the memories of Miguel Covarrubias
and Matthew W. Stirling*

## Figures

Images in each figure are generally arranged according to iconographic similarity. Figures should be read loosely from left to right and from top to bottom. The diagrams are designed to illustrate iconographic associations and, with the exception of Figures 1, 23-25, are not meant to imply temporal or spatial relationships. The entries in the following list provide information on the physical composition, type, provenience, present location and source of drawing for each object. The location of a published photograph of each piece is noted whenever possible.

## Abbreviations

| | | | |
|---|---|---|---|
| AMNH | American Museum of Natural History | MNAM | Museo Nacional de Antropología de México |
| COL | Collection | MPA | Museum of Primitive Art |
| DO | Dumbarton Oaks | PC | Private Collection |
| EJ | Eugenia Joyce | PDJ | Peter David Joralemon |
| FD | Felipe Dávalos | RD | Redrawn |
| FVF | Frederick V. Field | SK | Susan Klein |
| MAI | Museum of the American Indian, Heye Foundation | SW | Susan Weeks |
| | | UP | Unknown Provenience |
| MDC | Michael D. Coe | USNM | United States National Museum |

J ust over one hundred years ago José Melgar wrote a short study of the Colossal Head of Hueyapan (Melgar 1869) and became the first person ever to publish a description of an Olmec object and the first scholar to offer an iconographic interpretation of Olmec art. Since Melgar's time, Saville (1929), Stirling (1939-1965), Drucker (1952), Covarrubias (1942-1957), Coe (1962-1972), I (Joralemon 1971), and many others have suggested interpretations of Olmec art. Although the full meaning of Olmec symbolism is still uncertain, the basic structure of Olmec art and the essential content of Olmec religion are gradually becoming clear.

Our present understanding of Olmec symbolism is based on three principal hypotheses. The first of these was put forward by Miguel Covarrubias in 1946 (see Fig. 1). Covarrubias (1946) constructed a chart showing the evolution of Olmec werejaguars into the rain gods of late Postclassic Mexico. On the basis of stylistic evidence Covarrubias speculated that a continuity in religious tradition might have existed between Olmec civilization, on the one hand, and the Postclassic civilizations on the other. In 1955 Matthew Stirling presented a second hypothesis on the nature of Olmec symbolism (see Fig. 2). Stirling suggested that Monument 1 from Río Chiquito and Monument 3 from Potrero Nuevo represent sexual intercourse between a jaguar and a human female (Stirling 1955:8, 19-20, Pls. 2, 25, 26a). He noted that the offspring of such a union would naturally be half-jaguar and half-human and observed that just such a combination of traits can be seen in any number of Olmec sculptures. Therefore, Stirling argued, the Olmec might have traced their ancestry back to a primeval union between jaguar and human. Neither Covarrubias' continuity hypothesis nor Stirling's were-jaguar hypothesis has yet been subjected to rigorous testing. Nevertheless, both interpretations have been accepted by most students of Olmec iconography.

A third iconographic hypothesis was advanced by Michael Coe in 1968 and defined and tested by this author in 1971. The hypothesis grew out of a short analysis of the iconographic detail carved on a green stone statue from Las Limas, Veracruz (Coe 1968a:111, 114-115). A schematic rendering of this detail is shown in Figure 3. Coe pointed out that the four profiles carved on the shoulders and knees of the Las Limas Figure and the infant image held in the Figure's lap all represent different beings. The only important feature the five images have in common is the cleft head. The right shoulder profile (Fig. 3b) has an almond-shaped eye with incised iris. A double band transects the eye and frames a row of three spots carved on the profile's temple. The image has a human nose and a protruding upper lip. A bifid fang is attached to the upper jaw. The left shoulder profile (Fig. 3c) is represented with an undecorated, trough-shaped eye and flame eyebrow. The nose is human but the extended upper lip and the lipless lower jaw are not. A single bifurcated fang descends from the upper jaw. The infant held in the lap of the Las Limas Figure (Fig. 3d) is a were-jaguar. Typical almond-shaped eyes, pug nose, and toothless, snarling mouth are depicted. The creature wears a decorated headband, serrated ear coverings, and a pectoral and loincloth embellished with crossed bands symbols. The right knee profile (Fig. 3e) has an oblong eye that is constricted at the back; crossed bands decorate the squarish iris. The creature's long trapezoidal nose sits on top of a squared-off upper jaw. The large mouth is drawn up at the back corner and contains a bifid tongue and a downturned bracket motif. The left profile (Fig. 3f) is represented with a crescent-shaped eye and a human nose. An enormous front tooth projects from the L-shaped upper jaw. A sixth image, which escaped Coe's notice, is carved on the chin of the Las Limas Figure (Fig. 3a). It is a frontal representation with oblong eyes and two different types of flame eyebrows. The creature's peculiar mouth turns down at one end and up at the other. A maize symbol sprouts from the cleft head.

If each of the images carved on the Las Limas Figure represents a different being, how should one interpret this monument? Following Covarrubias's continuity hypothesis, Coe suggested that

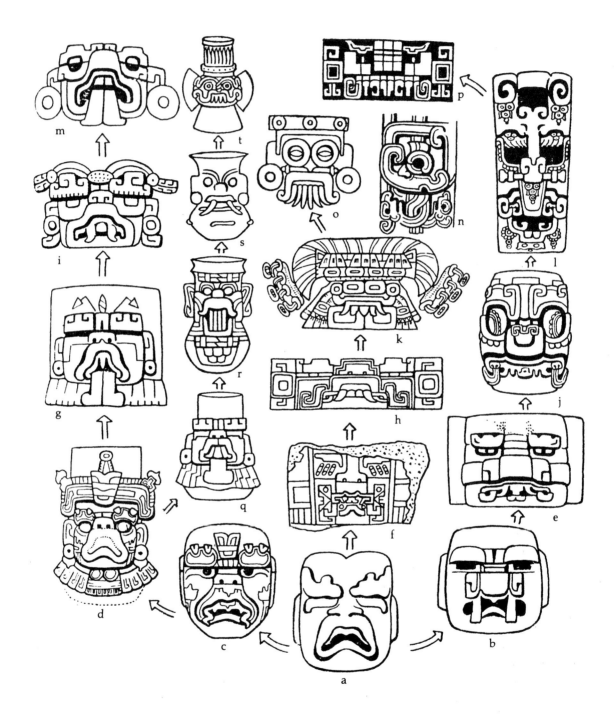

Fig. 1. *The Covarrubias Hypothesis.* Drawing: Covarrubias 1946: Lám. 4.

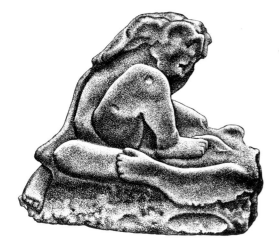 

a

b

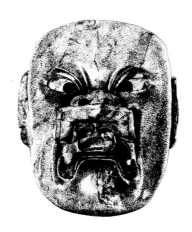

c

Fig. 2. *The Stirling Hypothesis*
  *a.* Basalt Monument 1, Río Chiquito, Veracruz. Drawing: FD. Photo: Stirling 1955:Pls. 25, 26*a*. Two views.
  *b.* Basalt Monument 3, Potrero Nuevo, Veracruz. Drawing: FD. Photo: Stirling 1955:Pls. 25, 26*a*. Two views.
  *c.* Jade mask, UP. COL. DO. Drawing: EJ. Photo: Handbook of the Robert Woods Bliss Collection 1963: Pl. 31.

32

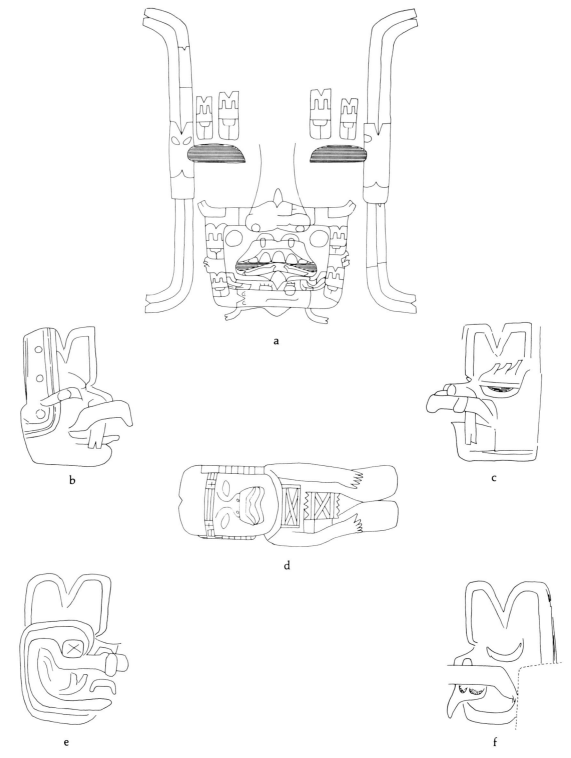

a

b

c

d

e

f

Fig. 3. *The Las Limas Hypothesis*

    *a.* Facial incising on a green stone figure, Las Limas, Veracruz. COL. Museo de Antropología, Jalapa. Drawing: PDJ. Photo: Medellín Zenil 1965: Fotos 5-8.

    *b.* Incised profile on the right shoulder of the Las Limas Figure.

    *c.* Incised profile on the left shoulder of the Las Limas Figure.

    *d.* Infant figure carried in the arms of the Las Limas Figure.

    *e.* Incised profile on the right knee of the Las Limas Figure.

    *f.* Incised profile on the left knee of the Las Limas Figure.

the Las Limas Figure depicts the Olmec prototypes of gods worshipped in Postclassic Mexico. On the basis of Aztec iconographic conventions, he identified Figure 3b as Xipe Totec, Figure 3c as the Fire Serpent, Figure 3d as the Rain God, Figure 3e as Quetzalcoatl and Figure 3f as the Death God and implied that the frontal representation in Figure 3a should be identified as the Maize God. Using these correlations of Olmec images with Postclassic deities, Coe then speculated on the philosophical underpinnings of Olmec religion.

Perhaps we have the ancient Mexican belief in the unity of opposite principles: Xipe and the Feathered Serpent standing for greenness and Life, opposed to the Fire Serpent—harbinger of heat and drought—and Death. That the world is not an exactly even balance of both is suggested by the primary position of the Rain God, bringer of good harvests. (Coe 1968 a:114)

In sum, the Las Limas hypothesis makes three propositions about Olmec religion and iconography: the Olmec worshiped a multiplicity of gods; Olmec deities are prototypes of certain Postclassic supernaturals; Olmec religion is based on a philosophy of dualism.

I have subjected the Las Limas hypothesis to rigorous testing since 1968. To date, all three propositions have held up under scrutiny: none of them has been falsified. My testing procedure has been to ask three questions of the Las Limas hypothesis:

1. Does the hypothesis account for existing data?

2. Does the hypothesis explain new information?

3. Does the hypothesis generate additional hypotheses?

During the initial phase of my iconographic investigations, I collected photographs and drawings of numerous Olmec objects in museums and private collections. Many of the objects in my files depicted the same creatures portrayed on the Las Limas Figure. I divided the corpus of representations into iconographic groups each of which was characterized by an essentially unique combination of formal attributes. These basic Olmec images were labeled gods and given numerical designations. The results of my preliminary research into Olmec iconography were reported in a Dumbarton Oaks monograph (Joralemon 1971). My conclusions supported the proposition of the Las Limas hypothesis that Olmec religion is

polytheistic and showed that the Las Limas Figure could be used as a key to Olmec iconography.

Over the past six years I have continued to record every Olmec object that has come to my attention: hundreds of additional representations have been added to my research files. This new body of iconographic information was not involved in the formulation or the preliminary testing of the original hypothesis; it therefore represents a body of new data against which to test the Las Limas hypothesis. Newly recorded iconographic information gives added support to the Las Limas hypothesis. It also reveals several errors in my 1971 publication. There is new evidence for Gods I, II, III, IV, VI, VIII, and strong indication that God VII should be included in the God I group and that the two representations of God IX should be considered images of God II. Support for God X continues to be weak. My initial uncertainty about God V has been confirmed: it is a false category that should no longer be maintained. Both a careful examination of new evidence and a reconsideration of previously reported material have led me to conclude that Olmec religion was principally based on the worship of the six gods whose images are carved on the Las Limas Figure and that these six divinities should be grouped into three iconographic pairs: Gods I and III, Gods II and IV, and Gods VI and VIII (see Fig. 4). Before proceeding to a detailed analysis of the symbolism of the first of these deity pairs (Gods I and III), let us review the general characteristics of Olmec iconographic images.

The primary concern of Olmec religious art is the representation of creatures that are biologically impossible. Such mythological beings exist in the mind of man, not in the world of nature. Natural creatures were used as sources of characteristics that could be disassociated from their biological contexts and recombined into non-natural, composite forms. A survey of iconographic compositions indicates that Olmec religious symbolism is derived from a wide variety of animal species.[1] In the process of disassociation and recombination natural features apparently retain their original identities. The cayman's dentition, the jaguar's nose, the bird's wing and the serpent's body are recognizable in even the most bizarre portrayals of the Olmec Dragon. Figure 5 depicts several examples of mythological hybridization: human-jaguar (Fig. 5a), jaguar-bird (Fig. 5b), bird-serpent (Fig. 5c), jaguar-cayman-fish

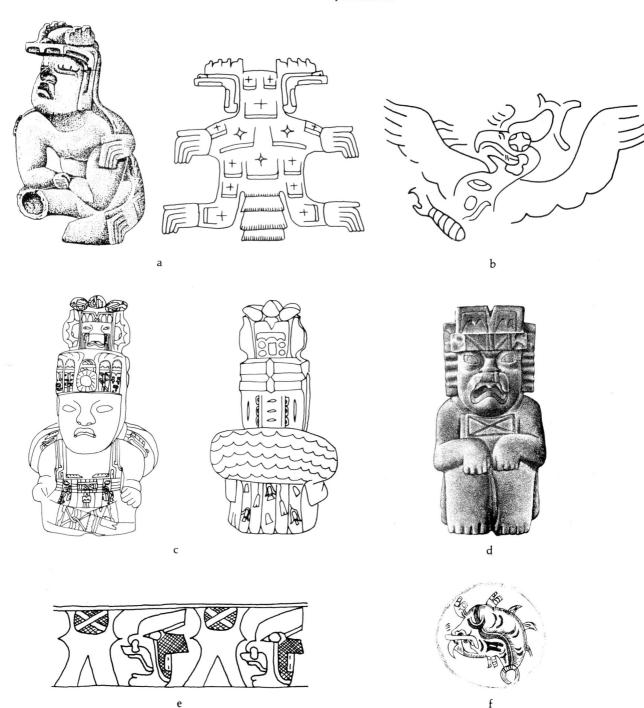

a

b

c

d

e

f

Fig. 4. *The Gods of the Olmec: Six Primary Images*
  a. Hollow clay figure, Atlihuayan, Morelos. COL. MNAM. Drawing on left from Piña Chán 1960: Fig. 10. Drawing on right RD by PDJ from Covarrubias 1957:Fig. 21 (lower).
  b. Design engraved on an obsidian core, La Venta Offering 1943-G. COL. MNAM. Drawing: Drucker 1952:Fig. 48.
  c. Jade figure, Arroyo Pesquero. COL. DO. Draw-

ing: PDJ. Photo: Benson 1971:Fig. 1. *Left*, front view; *right*, back view.
  d. Basalt Monument 52, San Lorenzo. Drawing: FD. Photo: Easby and Scott 1970:Fig. 34.
  e. Design from a ceramic vessel, Puebla. COL. MNAM. Drawing: RD by PDJ from Piña Chán and Luis Covarrubias 1964:Pls.
  f. Design from a ceramic plaque, Tlapacoya. COL. St. Louis Art Museum. Drawing: EJ.

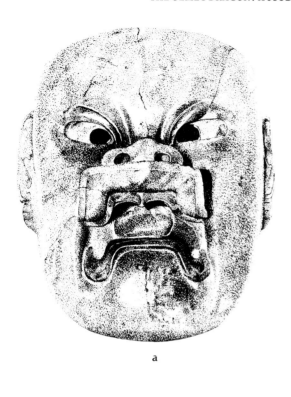

c

d

e

b

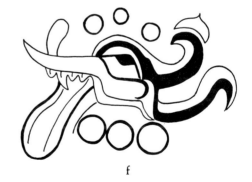

f

Fig. 5. *Mythological Hybridization in Olmec Art*
  a. See Fig. 2c.
  b. Ceramic effigy vessel, Las Bocas. COL. Australian National Museum. Drawing: RD by PDJ from Coe 1965a:Fig. 61. Photo: Coe 1965a:Fig. 61.
  c. Jade serpent, UP. COL. Jay C. Leff. Drawing: PDJ. Photo: Easby 1966:Pl. 9.
  d. Basalt Monument 58, San Lorenzo. Drawing: PDJ.
  e. Design from a ceramic vessel, Tlatilco. COL. MNAM. Drawing: from *Indian Art of Mexico and Central America*, by Miguel Covarrubias, Fig. 9. Copyright © 1957 by Alfred A. Knopf, Inc. Reprinted by permission of the publisher. Photo: de la Fuente 1972a:77.
  f. Painting 3, Oxtotitlan, Guerrero. Drawing: Grove 1970:Fig. 15. Rendering: Grove 1970:Fig. 14.
  g. Relief V, Chalcatzingo, Morelos. Drawing: RD by PDJ from Cook de Leonard 1967:Fig. 4. Photo: Cook de Leonard 1967:Pl. 5.

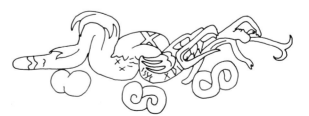

g

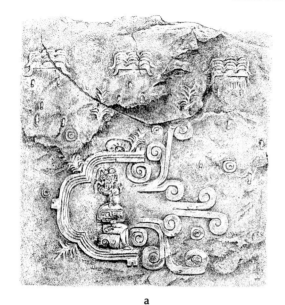

a

b

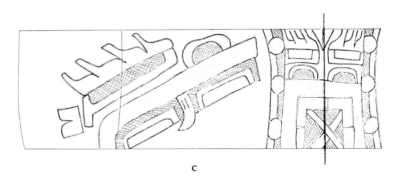

c

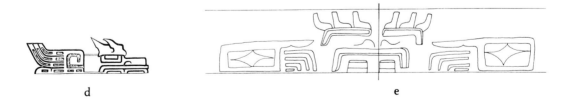

d                                                    e

Fig. 6. *Profiles and Frontal Representations in Olmec
    Art*
   *a.* Relief I, Chalcatzingo, Morelos. Drawing: Gay
        1971:Fig. 11. Photo: Coe 1965a:Fig. 11.
   *b.* Relief IX, Chalcatzingo, Morelos. COL. Munson-
        Williams-Proctor Institute, Utica, New York.
        Drawing: EJ. Photo: Easby and Scott 1970:Fig. 32.

*c.* Ceramic vessel, Tlapacoya. COL. MNAM. Draw-
    ing: EJ. Photo: Aveleyra Arroyo de Anda 1964:
    Pls.
*d.* See Fig. 5e.
*e.* Design from a ceramic vessel, Veracruz. PC.
    Drawing: PDJ.

(Fig. 5d), bird-jaguar-cayman (Fig. 5e), bird-mammal-cayman (Fig. 5f), and bird-cayman-serpent (Fig. 5g).

A second general characteristic of Olmec religious art is the depiction of iconographic images in profile and frontal variants.[2] We cannot be certain if the Olmec generated profiles by bisecting frontal images or if they produced frontal representations by reflecting profile forms through a vertical axis. Whatever the case, Olmec artists frequently portrayed iconographic subjects in profile and frontal positions. Figure 6 illustrates the correlation of three God I profiles with three frontal representations of the same deity. Notice the close correspondence between the paired images.

The tendency to abstract and abbreviate iconographic information is a third characteristic of Olmec art. Although some images do express religious concepts in relatively complete detail, most Olmec works of art present concise and abbreviated symbolic statements. Abbreviated representations are produced by applying the *pars pro toto* principle to complex iconographic images. In the same way that a set of initials can stand for a full name, a set of iconographic features can stand for a primary image.[3] An example of symbolic abstraction is shown in Figure 7. The Olmec Dragon is portrayed in a primary image from Tlapacoya (Fig. 7a). The deity, however, is symbolized in a whole variety of simpler forms (Fig. 7b-$h_1$). Even the glyphlike representations of paw, profile face, eyebrow, mouth and eyes, and skin markings can stand for God. I.

A fourth general characteristic of Olmec religious art is the grouping of four or five complementary images in a single iconographic composition.[4] The usual pattern consists of a central figure flanked by two pairs of additional images. Six such compositions are depicted in Figure 8.

Having described some of the basic characteristics of Olmec religious imagery, let us now examine the symbolic attributes of Gods I and III: the Olmec Dragon and the Olmec Bird Monster.

The iconographic ancestry of God I—the Olmec Dragon—can be traced back to the beginnings of Olmec civilization. Images of the deity have been discovered in early deposits at San Lorenzo in the Olmec heartland and at Las Bocas and Tlapacoya in central Mexico. He is portrayed on objects ranging in size from large stone monuments to small ceramic vessels. His image is rendered in all the major media known to have been used by Olmec artists: basalt, jade, serpentine, clay, paint, and wood. The large number of extant representations of God I indicates that the Dragon was the most important member of the Olmec pantheon.

The Olmec Dragon is a mythological beast with cayman, eagle, jaguar, human and serpent attributes (see Fig. 9). His characteristic features include avian headcrest, flame eyebrows, L- or trough-shaped eyes, bulbous nose, jaws and dentition of a cayman, bifid tongue, hand-paw-wings, and either a mammalian, saurian, or serpentine body. God I is a mythological hybrid par excellence!

Like all dragons, God I is basically a reptilian being. It is not certain, however, if reptilian features are meant to take symbolic precedence over his other faunal attributes. Donald Lathrap has suggested that the dentition and jaw structure of God I are derived from the cayman (he suggests the species *Melanosuchus niger*; I think *Caiman fuscus* is a more likely possibility). He (Lathrap n.d.:15) argues that

a specific combination of features, a shut mouth with a row of upper teeth showing, a markedly fang-like configuration for all of the upper teeth, and a marked diastema between the front tooth and the remainder of the upper tooth row . . . is an accurate inventory of the biological essentials of cayman-ness.

and that since this complex of traits is characteristic of God I, the Olmec Dragon must have the cayman as "its base or chassis" (Lathrap n.d.:15). Lathrap is surely correct in correlating God I's singular dentition with that of the cayman or alligator. It seems to me, however, that the hypothesis that God I is actually a cayman deity is open to question. Figure 9 shows that the Dragon is a polymorphic being who can be embodied in at least three different animal forms. It seems more accurate to label God I a dragon than to apply a specific biological designation to such a composite creature.

God I's primary associations are with earth, water, and agricultural fertility (see Fig. 10, foldout following p. 38). Representations that depict vegetation sprouting from the deity's body suggest that the Olmec identified God I with the earth itself and imagined him as the ultimate source of agricultural abundance (Fig. 10 $j$, $q$, $x$, $y$, $b_1$, $c_1$, $e_1$, $f_1$, $g_1$). The Dragon's gaping mouth symbolizes a cavern, which may represent the entrance to the

c

i

o

g

h

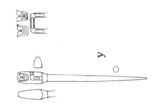

t

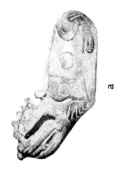

a

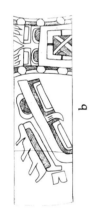

b

f

l

r

x

m

n

s

y

e

k

q

v  w

d

j

p

u

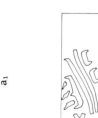

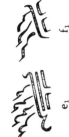

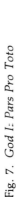

Fig. 7. *God I: Pars Pro Toto*

*a.* Ceramic effigy vessel, Tlapacoya. COL. MNAM. Drawing EJ. Photo: Aveleyra Arroyo de Anda 1964:Pls

*b.* See Fig. 5c.

*c.* See Fig. 1a.

*d.* Design from a ceramic vessel, Tlatilco. COL. MNAM. Drawing: *Indian Art of Mexico and Central America,* by Miguel Covarrubias, Fig. 10. Copyright © 1957 by Alfred A. Knopf, Inc. Reprinted by permission of the publisher. Photo: Covarrubias 1957:Pl. 12.

*e.* Drawing: see Fig. 5e.

*f.* Clay sello, Las Bocas. COL. FVF. Impression: FVF.

*g.* See Fig. 5e.

*h.* Clay sello, Las Bocas. PC. Drawing: Gay 1971: Fig. 35.

*i.* Clay sello, Las Bocas. COL. FVF. Impression: FVF.

*j.* Design from ceramic vessel, Tlatilco. COL. MNAM. Drawing: see Fig. 7d.

*k.* Design from a ceramic vessel, Tlatilco. COL. Jay C. Leff. Drawing: RD by PDJ from Coe 1965a:Fig. 29.

*l.* Clay sello, Las Bocas. COL. FVF. Impression: FVF.

*m.* Portion of a design from a stone monument, Ojo de Agua, Mazatán, Chiapas. COL. Regional Museum. Drawing: PDJ. Photo: Navarrete 1971: Fotos 4–9. See Fig. 10k for the complete design.

*n.* Clay sello, Las Bocas. PC. Drawing: Gay 1971: Fig. 46.

*o.* Clay sello, Las Bocas. COL. FVF. Impression: FVF.

*p.* Stone yuguto, Guerrero. PC. Drawing: PDJ.

*q.* Design from a ceramic vessel, Tlatilco. PC. Drawing: see Fig. 5e.

*r.* Basalt carving, La Venta or San Lorenzo. COL. Dr. Ludwig, Cologne, Germany. Drawing: EJ. Photo: Bolz and Disselhoff 1970:Pl. 4.

*s.* Design from a ceramic vessel, Las Bocas. PC. Drawing: PDJ.

*t.* Clay sello, Las Bocas. COL. FVF. Impression: FVF.

*u.* Design from a ceramic vessel, Las Bocas. COL. MPA. Drawing: RD by PDJ from Coe 1965a:Fig. 36. Photo: Coe 1965a:Fig. 36.

*v.* Design from a ceramic vessel, Tlatilco. PC. Drawing: see Fig. 5e.

*w.* Design from a ceramic vessel, Tlatilco. PC. Drawing: see Fig. 5e.

*x.* Design from a ceramic vessel, Tlatilco. PC. Drawing: SK.

*y.* Jade perforator, UP. PC. Drawing: Covarrubias n.d.

*z.* Design from a ceramic vessel, Las Bocas. PC. Drawing: RD by PDJ from Coe 1965a:Fig. 26. Photo: Coe 1965a:Fig. 26.

*a₁.* Design from a ceramic vessel, Tlatilco. PC. Drawing: see Fig. 5e.

*b₁.* Design from a ceramic vessel, Xochipala, Guerrero. PC. Drawing: PDJ. Photo: Gay 1972:Fig. 31.

*c₁.* Clay sello, Tlatilco. COL. FVF. Impression: FVF.

*d₁.* Design from a ceramic vessel, Las Bocas. COL. Mr. and Mrs. Arthur N. Seiff, New York. Drawing: RD by PDJ from Coe 1965a:Fig. 31.

*e₁.* Design from a ceramic vessel, Tlatilco. PC. Drawing: see Fig. 5e.

*f₁.* Design from a ceramic vessel, Tlatilco. PC. Drawing: see Fig. 5e.

*g₁.* Design from a ceramic vessel, Tlatilco. PC. Drawing: see Fig. 5e. Photo: L'Art Olmeque 1972:Pl. 11.

*h₁.* Design from a ceramic vessel, Las Bocas. PC. Drawing: PDJ.

Olmec underworld (Grove 1970:11, 32). The cave-mouth is commonly depicted as a downturned U (Fig. 10a, b, c, d, g, h, i, j, k, m, n, o, p, t, u, $a_1$, $d_1$), a short limbed cross (Fig. 10q, x, y), or an elongated M (Fig. 10l, r, s). In addition to his identification with earth and soil, God I is associated with water and rain. A polychrome image of God I (Fig. 10l) presides over the stream of water that sometimes flows out of the cave at Oxtotitlan and onto the farmers' fields below (Grove 1970:31). Rain is shown falling from the Dragon's mouth (Fig. 10s), from his eyes (Fig. 10z), and from his bifid tongue (see Joralemon 1971: Fig. 265). God I's connections with agricultural fertility are nicely summarized in Relief I from Chalcatzingo (Fig. 10x). The Dragon's head is watered by sheets of rain which pour from banks of thunderclouds in the sky. Enthroned within the creature's gaping mouth is a figure dressed in an elaborate costume decorated with symbols of raindrops and maize. Corn plants sprout from the Dragon's jaws and clouds of mist roll out of his open mouth. The whole scene celebrates agricultural abundance and natural fertility.

A second set of iconographic associations links God I with fire on the one hand, and with royal lineage and dynastic succession on the other. A common attribute of the Olmec Dragon is the serrated brow or flame eyebrow (see Fig. 9a, b, c, d for examples). Donald Lathrap, following Drucker (1952), has suggested that this motif is derived from the feathered head crest of the harpy eagle, *Harpia harpyja* (Lathrap n.d.:18-20). Lathrap's identification of the flame eyebrow's natural meaning is probably correct, but his interpretation of the design as a generalized celestial symbol is only partially convincing. Ancient Mexicans associated the eagle with the sun as well as the sky.

In central Mexico the eagle was a symbol of the sun and, more particularly, of the priests who officiated at human sacrifices in honor of the sun or as a functionary who carried the sacrificial heart or blood to the sun. Over and over again in Mexican art the eagle is represented as carrying the heart of the victim to the sun. . . . The orders of warriors whose task it was to keep the sun fed with the hearts of victims were known as jaguars and eagles. Finally "Ascending eagle" and "Falling eagle" were names for the sun. Thus in Mexican belief the eagle was a name for the sun itself, and also symbolized the priest, who in some ways functioned as an intermediary between man and that divinity. In the minds of the Maya the eagle or the king vulture also symbolized the sun. (Thompson 1960:82)

Oddly enough, certain reptilian creatures were also related to sky, sun, and fire in ancient Mexican thought. The Aztecs believed that two fire serpents or Xiuhcoatls transported the sun across the sky each day. Images of these igneous creatures are carved around the perimeter of the Aztec Sun Stone (see Caso 1958: Pl. II). They are decorated with designs that have been identified as representations of flames (Beyer 1965:229) and which are formally identical to Olmec flame eyebrows. I would suggest that the Olmec flame eyebrow is a prototype of the later Mesoamerican flame symbol, that the meaning of the motif involves a double entendre between the solar eagle's feather crest and flames, and that the flame eyebrow is one of the attributes of a fiery aspect of God I.

The relationship between the Olmec Dragon and Olmec Royalty has only recently been discovered. Primary evidence for this relationship is found in Olmec sculpture and painting. Two well-known Olmec monuments depict an adult figure emerging from the cave-mouth of God I (Fig. 10j and $d_1$). Other representations portray an Olmec personage enthroned inside the gaping jaws of the Dragon (Fig. 10k, x, y). Finally, two Olmec images show figures seated on Dragon-head thrones (Fgi. 10k and l). These iconographic compositions have convinced David Grove that the Olmec monuments commonly called altars are in fact royal thrones and that the iconography of these monuments deals in part with the supernatural origins of Olmec rulers and the confirmation of their divine rights (Grove 1973). Additional evidence for the Dragon's importance in Olmec political affairs comes from La Venta Stela 2 and from an Arroyo Pesquero celt (Fig. 11). The elaborately attired personage depicted on Stela 2 carries a scepter carved in the likeness of God I. The image has a trough-shaped eye and flame-brow at the head and a scalloped convention at the foot. A similar creature is held in the arms of the profile figure incised on a jade celt from Arroyo Pesquero. In both carvings the image of God I functions as a symbol of power and authority.[6] Michael Coe has offered an explanation of the political elements in Olmec Iconography.

Olmec religion was a royal cult, in general outlines like that of the ancient Egyptians among whom Osiris and his son Horus stood for the deceased and living king respectively. . . . Among the Mesoamericans, including

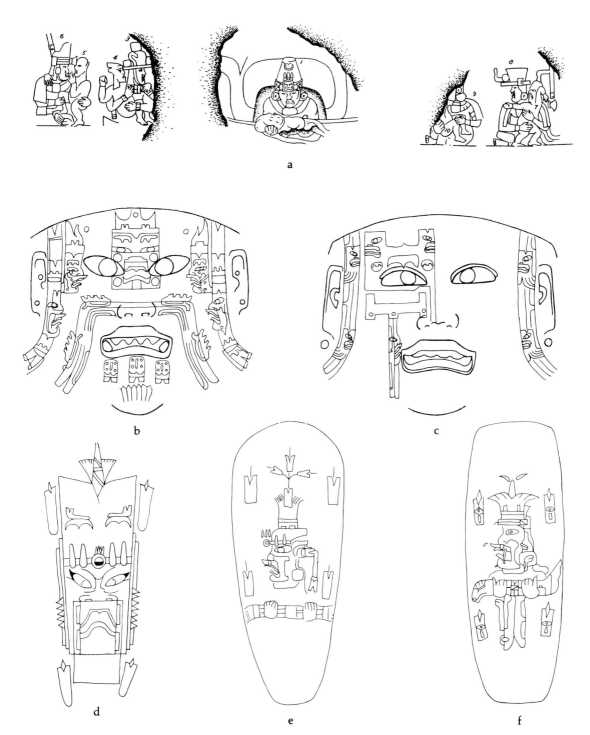

Fig. 8. *Quadruple and Quintuple Patterning in Olmec Art*

a. Basalt Altar 5, La Venta. Drawing: Drucker 1952: Fig. 52. Photo: Stirling 1943a:Pls. 40 and 41.

b. Jade mask, Arroyo Pesquero, Veracruz. PC. Drawing: SK. Photo: Coe 1971: Cover of *Horizon Magazine*.

c. Jade mask, Arroyo Pesquero, Veracruz. PC. Drawing: SK.

d. Jade celt, Arroyo Pesquero, Veracruz. PC. Drawing: PDJ.

e. Jade celt, Arroyo Pesquero, Veracruz. PC. Drawing: SK. Photo: Coe 1972:Fig. 4.

f. Jade celt, Arroyo Pesquero, Veracruz. COL. Museo de Antropología, Jalapa. Drawing: SK.

Fig. 9. *God I: Primary Images*

a. See Fig. 4a.

b. See Fig. 7a.

c. Basalt Monument 6, La Venta. Drawing: RD by PDJ from Covarrubias 1957:Fig. 30. Photo: Kubler 1962:Pl. 27.

d. Jade figure, UP. COL. Brooklyn Museum. Drawing: Covarrubias n.d.

e. Painting 1-c, Oxtotitlan, Guerrero. Drawing: Grove 1970:Fig. 12.

f. See Fig. 5g.

g. See Fig. 5c.

h. Basalt Monument 47, San Lorenzo. Drawing: FD. Photo: Coe 1968b:Fig. 10.

i. Basalt Monument 63, La Venta. Drawing: Joralemon 1971:Fig. 132. Photo: de la Fuente 1973:Pl. 204.

j. Basalt Monument 19, La Venta. Drawing: Drucker, Heizer, and Squier 1959:Fig. 55. Photo: Drucker, Heizer, and Squier 1959:Pl. 49.

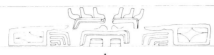

d

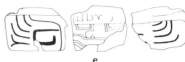

e

k

l

m

s

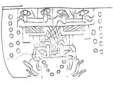

t

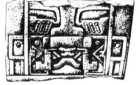

z

a₁

b₁

e₁

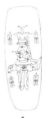

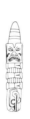

f₁          g₁

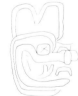

h₁

1₁

x. See Fig. 6a.

y. Relief XIII, Chalcatzingo, Morelos. Drawing: Grove n.d.: Fig. 2.

z. Basalt Stela C, Tres Zapotes. Drawing: Covarrubias 1947:84. Photo: Stirling 1965:Fig. 12a.

a₁. Jade figure, Guerrero. PC. Drawing: PDJ.

b₁. Design from a ceramic vessel, Tlapacoya. PC. Drawing: PDJ.

c₁. See Fig. 9c.

d₁. See Fig. 8a.

e₁. Jade fragment, Paso del Toro, Veracruz. COL. Museo de Antropología de Guatemala. Drawing: Navarrete 1971:Fig. 3a.

f₁. See Fig. 8f.

g₁. Jade object, Ejido Ojoshal, Municipio Cardenas, Tabasco. COL. Museo de Antropología, Jalapa. Drawing: PDJ. Photo: Nicholson 1967:70.

h₁. See Fig. 3e.

i₁. Jade pendant, Guerrero. PC. Drawing: EJ.

the Olmec, the Old Fire God and Tezcatlipoca played the same role. (Coe 1972:11)

Coe equates the fiery aspect of the Olmec Dragon with the Old Fire God himself. Whether Coe's dynastic hypothesis is validated or not, it is clear that there is a close relationship between God I and portrait images of important Olmec personages. The portrayal of ruler figures seated on Dragon-head thrones set within the open jaws of God I and the use of Dragon images as symbols of authority suggest that God I was the protector and legitimator of Olmec kings.

Although many Olmec Dragons are illustrated in Figure 10, there are dozens of other representations of God I which deserve mention. The Dragon deity is frequently portrayed on votive axes and face panels (Figs. 12 and 13). He is usually represented with the typical attributes of

God I: flame eyebrows, L- or through-shaped eyes, pug nose, and snarling mouth with downturned corners. The deity is sometimes shown with toothless gums (Fig. 12a, b, c, d, f, h and Fig. 13b, e), but he is more often depicted with fangs projecting from his upper jaw (Fig. 12e, g and Fig. 13d, g, i). A few images display both an upper and lower set of bifid fangs (Fig. 13c, f, h?). Additional examples of Olmec Dragons are shown in Figure 14. The now familiar characteristics of God I are readily apparent. Figures 14f, h, and j are particularly interesting representations. The Olmec profile in Figure 14f wears a face mask that is an anatomically accurate depiction of the cayman's mouth (Lathrap n.d.: 15). The incised design on the jade spoon from Veracruz (Fig. 14h) shows an x-ray view of an Olmec figure inside the head of God I. The deity's profile has a flame eyebrow on top of its head and

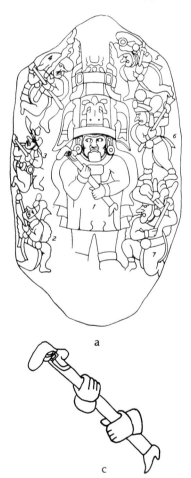

a

c

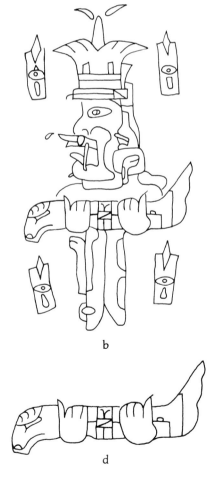

b

d

Fig. 11. *God I: Manikin Sceptor and Ceremonial Bar*
  *a.* Stela 2, La Venta. Drawing: Drucker 1952:Fig. 49.
    Photo: Heizer 1967:Pl. 2.

  *b.* See Fig. 8f.
  *c.* Detail of Fig. 11a.
  *d.* Detail of Fig. 11b.

44                         PETER DAVID JORALEMON

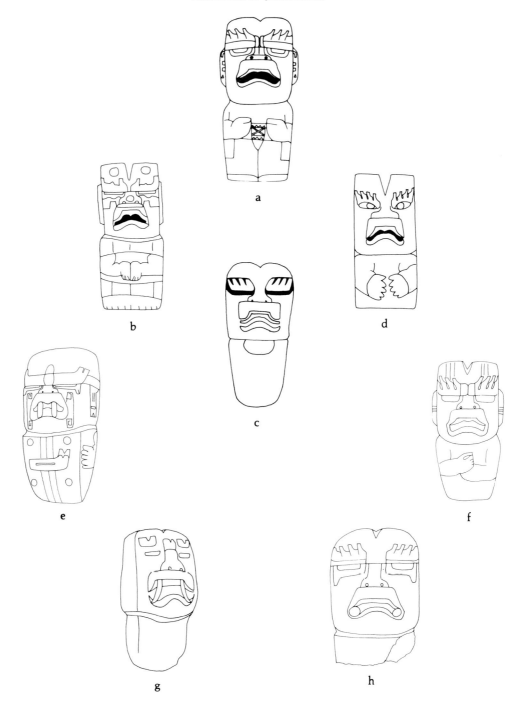

Fig. 12. *God I: Votive Axes*

a. Jade hacha, UP. COL. British Museum. Drawing:
   RD by PDJ from Covarrubias 1946: Lám. 5.
   Photo: Coe 1965a:Fig. 5.

b. Stone hacha, Oaxaca. COL. USNM. Drawing:
   RD by PDJ from Covarrubias 1946: Lám. 5.
   Photo: Coe 1965c:Fig. 28.

c. Jade hacha, La Venta Offering 1943-F. COL.
   MNAM. Drawing: RD by PDJ from Covarrubias
   1946:Lám. 5. Photo: Stirling 1943b:Pl. IV.

d. Jade hacha, the Mixteca, Oaxaca. COL. MNAM.
   Drawing: RD by PDJ from Covarrubias 1946:
   Lám. 5. Photo: Covarrubias 1957:Pl. XVI.

e. Green-black stone hacha, Oaxaca. PC. Drawing:
   PDJ.

f. Basalt hacha, UP. PC. Drawing: PDJ.

g. Stone hacha, UP. COL. USNM. Drawing: PDJ.
   Photo: Judd 1951:Fig. 55.

h. Stone hacha, UP. COL. MNAM. Drawing: PDJ.
   Photo: de la Fuente 1972a:Fig. 43.

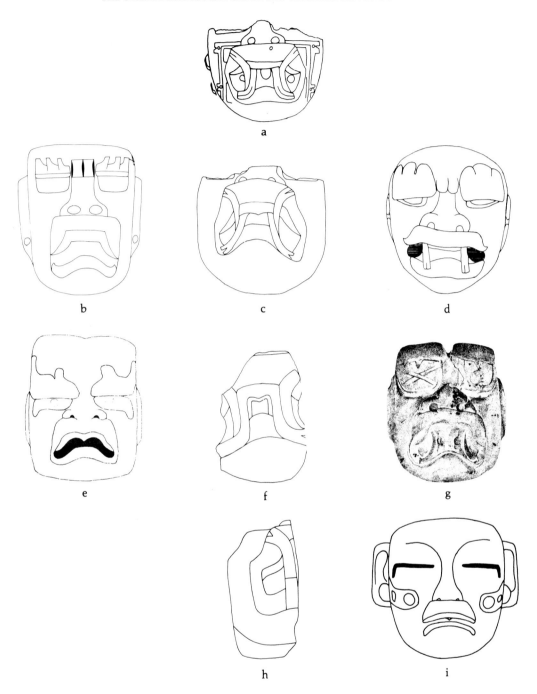

Fig. 13. *God I: Face Panels and Masks*

   *a.* Serpentine mask, UP. PC. Drawing: PDJ.

   *b.* Green stone mask, San Jerónimo, Guerrero. COL. MNAM. Drawing: PDJ. Photo: Piña Chán and Luis Covarrubias 1964:Pls.

   *c.* Serpentine mask fragment, Apoalan, Nochistlan, Oaxaca. COL. MNAM. Drawing: PDJ. Photo: Bernal 1967:Pl. 191.

   *d.* Rock quartz and chalcedony mask, UP. PC. Drawing: PDJ. Photo: Lothrop et al. 1957:Pl. VIII.

   *e.* Stone mask, UP. COL. AMNH. Drawing: PDJ. Photo: Coe 1965a:Fig. 6.

   *f.* Stone mask fragment, UP. COL. MNAM. Drawing: PDJ. Rendering: Drucker 1952:Pl. 66.

   *g.* Jade mask, UP. PC. Drawing: EJ.

   *h.* Stone mask fragment, San Lorenzo. PC. Drawing: PDJ.

   *i.* Wooden mask, Cañon de la Maño, Guerrero. COL. AMNH. Drawing: RD by PDJ from Covarrubias n.d. Photo: Piña Chán and Luis Covarrubias 1964:Pls.

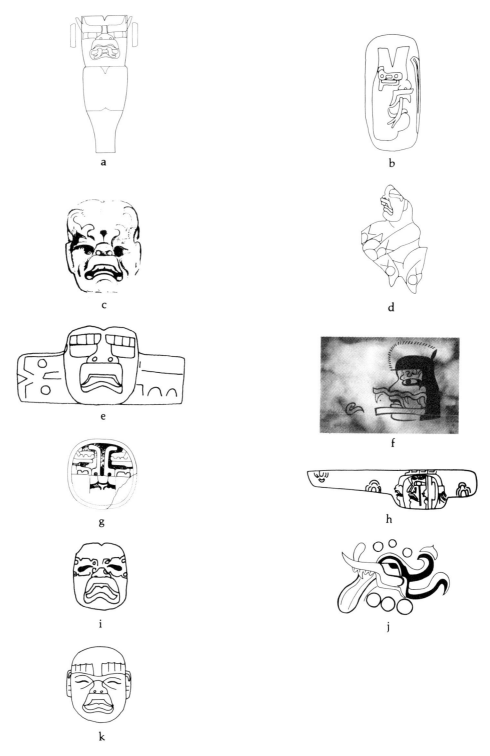

Fig. 14. *God I: Miscellaneous Representations*

    *a.* Jade perforator handle, Guerrero. PC. Drawing: EJ.

    *b.* Jade pectoral, Guerrero. PC. Drawing: PDJ.

    *c.* Head of a serpentine figure, Tabasco. COL. Constance McCormick Fearing, Santa Barbara, California. Drawing: Covarrubias n.d. Photo: Furst 1968:Fig. 3.

    *d.* Jade plaque, Olinala, Guerrero. COL. MNAM. Drawing: RD by PDJ from Covarrubias 1944:Pls. Photo: Bernal 1967:Fig. 183.

    *e.* Jade breast ornament, Oaxaca. COL. MAI. Draw-

ing: PDJ. Photo: Saville 1929:Fig. 93.

    *f.* Painting 7, Oxtotitlan, Guerrero. Drawing: Grove 1970:Fig. 19. Photo: Grove 1970:Fig. 20.

    *g.* Plaque 1, La Venta. COL. MNAM. Drawing: Drucker, Heizer, and Squier 1959:Fig. 62.

    *h.* Jade spoon, Veracruz. PC. Drawing: PDJ.

    *i.* Jade Mask, UP. COL. MNAM. Drawing: RD by PDJ from Covarrubias n.d. Photo: Kelemen 1943, 2:Pl. 245c.

    *j.* See Fig. 5f.

    *k.* Jade head pendant, UP. PC. Drawing: PDJ. Photo: Kelemen 1943, 2:Pl. 245a.

a hand-paw-wing motif suspended from its occipital region. Three jaguar spots decorate the surface of the spoon. The iconography of this piece is probably related to that of the Atlihuayan Figure (Fig. 4a), Mural 1 from Oxtotitlan (Fig. 22a), Painting 7 from Oxtotitlan (Fig. 14f), and Monument 47 from San Lorenzo (Fig. 9h); all depict an Olmec figure "inside" the Dragon's skin. Unfortunately, the meaning of this iconographic theme has yet to be determined.[7] Finally, the God I profile in Figure 14j exhibits biological characteristics of bird, mammal, and reptile. It may represent the date 6 Alligator in the Mexican 260 day divinatory cycle (Grove 1968:32).

It has already been pointed out that Olmec gods are characterized by essentially unique sets of iconographic attributes. Four motifs commonly associated with God I are the hand-paw-wing, the crossed bands in eye, the crossed bands and dotted bracket, and the four dots and bar. Let us consider each of these motifs in turn.

The hand-paw-wing occurs dozens of times in Olmec iconography; it is almost always associated with the Olmec Dragon (see Figs. 15 and 16). The meaning of the motif involves the metaphoric correlation of human hands, jaguar paws, and bird wings. The variant forms of the Dragon's foot can be traced from the complex primary images of God I (Fig. 15a, b) to the simple sello designs of Figure 16. The foot usually has a single spiral (Fig. 15c, d, e, f, g, h, i, j, k, u, v and Fig. 16a, b, c, d, e, f), split spiral (Fig. 15p, q, r) or U design (Fig. 15o, q, t) in its palm. Jaguar spots sometimes decorate the paw. (Fig. 15c, e, g, h, i, l, o, p, u); feline claws are rarely shown (Fig. 15m). The hand-paw-wing is an important constituent of the so-called Jaguar-Dragon Paw-Wing motif that frequently occurs on Olmec ceramic vessels (Fig. 15c, d, v, x, y, z, a₁). The Dragon's foot can also appear as an independent iconographic element. (Fig. 16).

A second symbol associated with God I is the crossed bands in eye motif (Fig. 17). The crossed bands itself is an ancient and widely distributed iconographic element. It is probably polysemic.[8] When the crossed bands design decorates an Olmec image's eye, it apparently identifies the creature as the Dragon. Of the twelve known occurrences of the motif, all but three are located on God I images. Two of the aberrant figures (Fig. 17a, l) are representations of God II, a deity often portrayed with Dragon facial features (see below). The last example is fragmentary and unidentifiable (Fig. 17g).

Closely related to the crossed bands sign is the crossed bands and bracket motif (Fig. 18). Six examples of this symbol have been located in Olmec religious art. It appears on three representations of God I as an eye substitute (Fig. 18a, b, c). The crossed bands and dotted bracket is carved on two complex images of God II (Fig. 18d and e) and on an Olmec jade acrobat (Fig. 18f). Although the meaning of this compound sign has not yet been determined, its association with the Dragon is clear.[9]

Another motif that seems to be related to God I is the four dots and bar symbol (Fig. 19). This iconographic element is represented twenty-four times on a total of eighteen Olmec works of art. It seems to have been especially popular in the vicinity of La Venta: eleven representations of the symbol occur on objects from La Venta itself or from nearby Arroyo Pesquero.[10] Although the sign can stand alone, it usually is associated with six other Olmec motifs: cleft rectangular frame (Fig. 19a, b, c, d, e, f, g, h, i, j, k, n, p), downturned E (Fig. 19b, d, g, i, j, l, m, o), trifid maize (Fig. 19c, g, h?, k?), dripping water (Fig. 19c, d, e), Dragon's jaws (Fig. 19d, g) and feathered diamond (Fig. 19b). In 1971 I suggested that the four dots and bar element might be a sign for God I (Joralemon 1971:45, 64). In a discussion of a Tlatilco sello (Fig. 19f) I pointed out that the four dots and bar symbol and the profile face carved in that composition both had cleft "heads" and double loop conventions just beneath their respective clefts. On the basis of this formal correspondence between sign and image and on the basis of the iconography of a jade celt from La Venta (Fig. 19g) I argued that the four dots and bar motif is a geometric representation of a face. A newly discovered jade mask from Arroyo Pesquero supports this interpretation (Fig. 19d). Between the eyes of the jade mask is carved a frontal image of a were-jaguar: the creature has a pair of dots on either side of his face and a vertical bar extending from his chin to his lower lip. The secondary incising depicts a truncated version of the four dots and bar motif. It is tempting to see this composition as a superimposition of geometric and representational images of the same Olmec deity. The frontal face in Figure 19d, like the profile in Figure 19f, represents God II, the Olmec Maize God. It has already been pointed out that Gods I and II sometimes share facial features. In fact, many representations of God II consist of Dragon heads that sprout maize symbols or

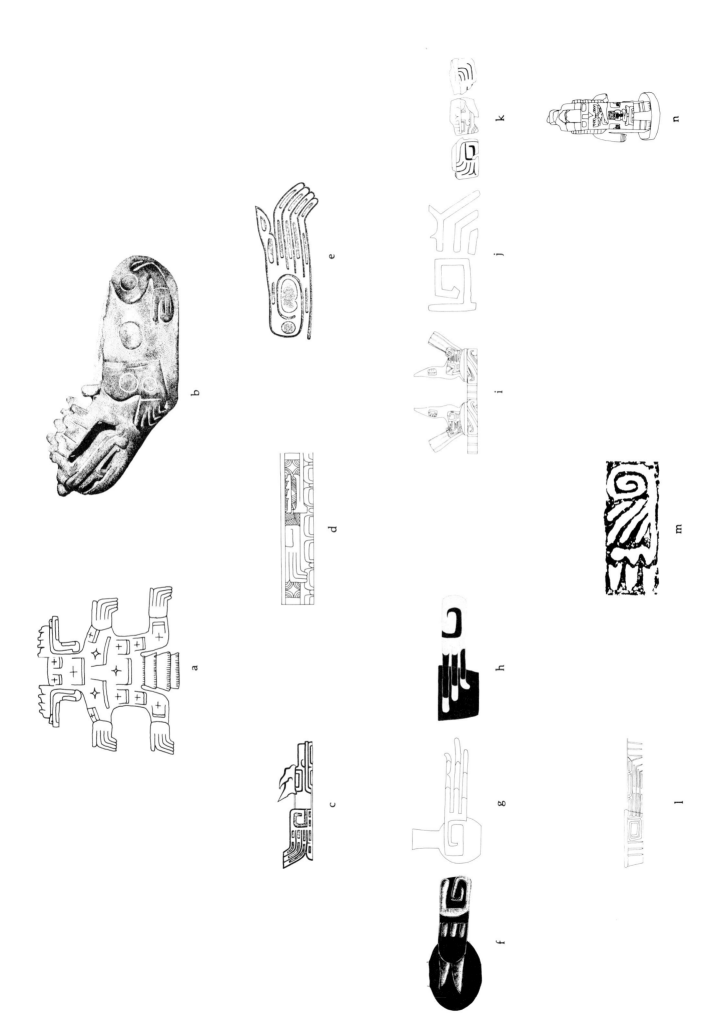

a

b

c

d

e

f

g

h

i

j

k

l

m

n

o

p

q

r

t

u

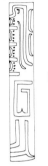

s

v

w

x

y

z

a₁

Fig. 15. *The Hand-Paw-Wing Motif: Selected Examples*

a. See Fig. 4a.
b. See Fig. 7a.
c. See Fig. 5e.
d. Design from a ceramic vessel, Tlatilco. COL. MNAM. Drawing: RD and corrected by PDJ from Covarrubias 1957:78 facing. Photo: Porter 1953: Pl. 6c.
e. See Fig. 7d.
f. Design from a ceramic vessel, Tlatilco. PC. Drawing: SK.
g. See Fig. 7u.
h. Design from a ceramic vessel, Tlatilco. PC. Drawing: SK.

i. See Fig. 5b.
j. Design from a ceramic vessel, Las Bocas. PC. Drawing: PDJ.
k. See Fig. 10e.
l. See Fig. 7z.
m. Clay sello, Tlatilco. COL. FVF. Impression: FVF.
n. See Fig. 7m.
o. Design from a ceramic vessel, Tlatilco. COL. MNAM. Drawing: see Fig. 7d. Photo: Porter 1953:Pl. 6h.
p. See Fig. 7j.
q. See Fig. 7p.
r. Clay sello, Tlatilco. PC. Drawing: Gay 1971:Fig. 36.

s. See Fig. 7h.
t. Clay sello, Las Bocas. COL. Mr. and Mrs. D. Daniel Michel, Chicago. Drawing and Photo: Coe 1965a:Fig. 172.
u. Design from a ceramic vessel, Las Bocas. PC. Drawing: RD by PDJ from Coe 1965a:Fig. 27. Photo: Coe 1965a:Fig. 27.
v. See Fig. 7k.
w. See Fig. 6e.
x. See Fig. 7w.
y. See Fig. 7v.
z. See Fig. 7q.
a₁. See Fig. 7a.

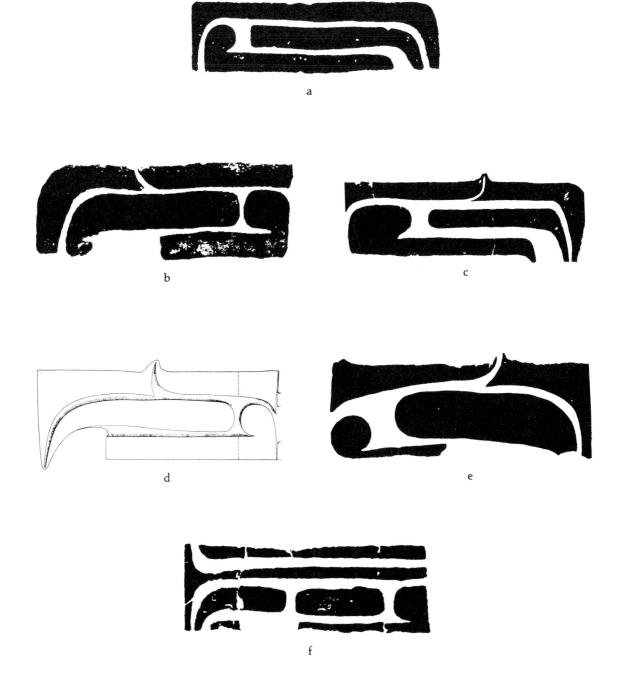

Fig. 16. *The Hand-Paw-Wing Motif: Representations on Sellos*

a. Clay sello, Las Bocas. COL. FVF. Impression: FVF.
b. Clay sello, Remojadas. COL. FVF. Impression: FVF.
c. See Fig. 7$c_1$.
d. Clay sello, Tlatilco. COL. Jay C. Leff. Drawing and Photo: Coe 1965a:Fig. 173.
e. Clay sello, Tlatilco. COL. FVF. Impression: FVF.
f. Clay sello, Las Bocas. COL. FVF. Impression: FVF.

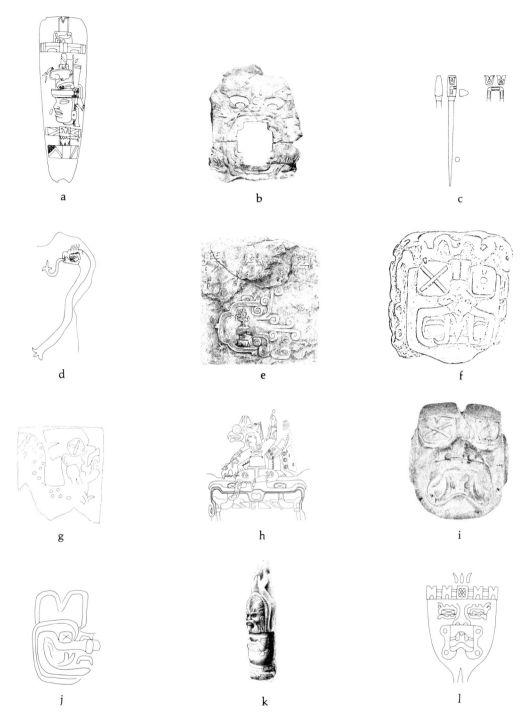

Fig. 17. *The Crossed Bands in Eye Motif*

*a.* Black slate celt, Simojovel, Chiapas. COL. MNAM. Drawing: RD by PDJ from Covarrubias 1944:28. Photo: Coe 1965c:Fig. 17.

*b.* See Fig. 6*b.*

*c.* See Fig. 7*y.*

*d.* Painting 2, Juxtlahuaca, Guerrero. Drawing: PDJ. Photo: Gay 1967:30.

*e.* See Fig. 6*a.*

*f.* See Fig. 10*v.*

*g.* Basalt Monument 30, San Lorenzo. Drawing: RD by PDJ from Coe 1968*b*:Fig. 9.

*h.* See Fig. 10*l.*

*i.* See Fig. 13*g.*

*j.* See Fig. 3*e.*

*k.* See Fig. 10*r.*

*l.* Jade celt, Los Tuxtlas, Veracruz. PC. Drawing: RD by PDJ from Covarrubias n.d.

images of the Maize God himself (see Figs. 3a, 10g, and 11b and Joralemon 1971: Figs. 171, 177, and 184). The same iconographic statement is depicted in Figures 19c, d, g, h, k? where maize symbols are shown sprouting from the four dots and bar motif. I equate the four dots and bar symbol with the face of God I and believe that the motif is the emblem of the Olmec Dragon.

The second member of the pair of mythological beasts we have been considering is God III, the Olmec Bird-Monster (see Fig. 20). This deity is at least as ancient as Olmec civilization itself: representations of the creature have been found at San Lorenzo, Las Bocas, and Tlatilco. The Bird-Monster's image is carved on seventeen small objects of basalt, green and brown stone, jade, serpentine, obsidian, and clay. He shares various formal attributes and functional relationships with God I.

The Bird-Monster is essentially a raptorial bird with reptilian and mammalian features. Like the Dragon, he is a composite being. Most representations of the god have well-delineated flame eyebrows and either L- or trough-shaped eyes. The Bird-Monster's beak is sharply hooked and extends somewhat beyond the end of the lower jaw. Prominently displayed on his beak is a large cere containing the nostrils. While a few God III images are toothless, most have a bifid fang projecting from the beak. Hand-paw-wings are occasionally associated with the Bird-Monster and he may exhibit a ruff of long tail feathers. The deity has talons with three claws and one rear digit (see Fig. 21).

The iconographical similarities between the Dragon and God III are self-evident. Their common features include flame eyebrows, L- or trough-shaped eyes, reptilian dentition and hand-paw-wings. The hybrid nature of both gods is beyond question.

While it is clear that the Olmec Bird-Monster is a raptorial bird, it is not certain if his ancestry includes more than one avian species.[11] Drucker (1952:194-195) and Lathrap (n.d.:19-21) have both argued for the importance of the harpy eagle, *Harpia harpyja*, in Olmec iconography. Lathrap describes the bird's

massive and highly recurved beak with its marked mandibular tooth and the erectile crest of long feathers which from the side typically appears to reduce itself to three long plumes (Lathrap n.d.:19)

and identifies these characteristics on several avian images I consider to be examples of God III (Fig. 20a, j, k). I would accept God III as a harpy eagle deity if it weren't for the various representations of the god which display bifid fangs attached to the eagle's beak (Fig. 20b, e, g, h, j, k, l, n, p). In light of this puzzle, it seems wiser to refer to God III by the general term Bird-Monster than to employ any more specific designation.

God III's primary associations are with the heavens. His avian features indicate that the god's domain is the sky. His flame eyebrows and eagle attributes relate him to the sun and celestial fire.

A second set of iconographic traits links God III to maize and agricultural fertility. On at least two occasions the Olmec Bird-Monster is represented with corn sprouting from his head (Fig. 20c and Joralemon 1971:Fig. 176). The Dumbarton Oaks' Arroyo Pesquero figure is decorated with maize motifs and Bird-Monster iconography (Fig. 4c). The trifid corn symbol atop the figure's headdress extension bears three incised profiles of God III (Fig. 20i). A serpentine celt from Las Bocas depicts a maize motif on top of a sort of feathered cushion (Fig. 20c). God III is also associated with Olmec chinless dwarf figures and their maize symbolism. An extraordinary brown stone dwarf from Tabasco has images of the Bird-Monster carved across both sides of his head (Fig. 20f). The little creature carries a bag filled with ears of corn around his neck. A second Olmec dwarf has corn symbols carved on top of his head (Joralemon 1971: Fig. 19). Thus, there is substantial evidence that God III, maize, and chinless dwarfs are somehow connected in Olmec religious thought.

Finally, the Bird-Monster is probably associated with the spiritual ecstasy produced by ingestion of psychotropic substances. Three lines of evidence lead to this conclusion. First of all, plant forms identified as datura by Peter Furst (personal communication) decorate the tail feathers of the cape worn by the Dumbarton Oaks' Arroyo Pesquero figure (see Fig. 4c and Benson 1971: Fig. 14; for photographs of datura see Schultes 1972: Fig. 13). Four Bird-Monsters are incised on the front of that winged cape (Fig. 20m). Second, God III images are frequently carved on Olmec jade objects that are called spoons (Fig. 20h). Furst has suggested that these spoons might be receptacles for psychotomimetic snuff (Furst 1968:162). Finally, we know that around the world birds are connected with the shaman's ecstatic experience of

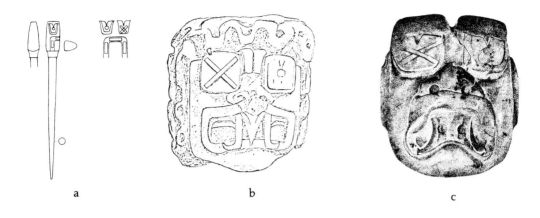

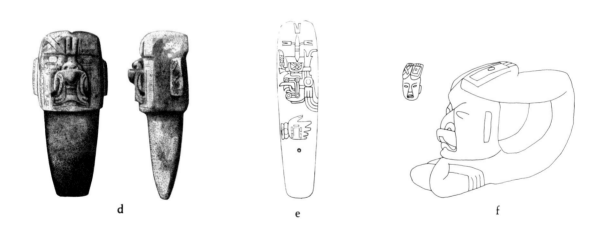

Fig. 18. *The Crossed Bands and Dotted Bracket Motif*
  *a.* See Fig. 7*y.*
  *b.* See Fig. 10*v.*
  *c.* See Fig. 13*g.*

*d.* Basalt hacha, UP. COL. MNAM. Drawing: Covar-
    rubias n.d. Photo: Covarrubias 1957:Pl. XVI.
*e.* See Fig. 10*g.*
*f.* Jade acrobat, UP. PC. Drawing: PDJ.

a

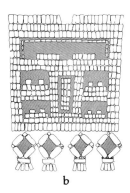

b

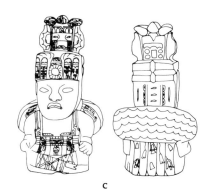

c

f

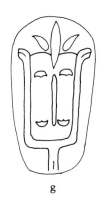

g

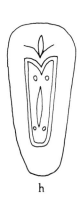

h

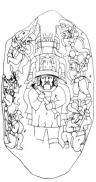

k

n

Fig. 19. *The Four Dots and Bar Motif*

a. Design carved on the arms and legs of a serpentine figure, La Venta. COL. DO. Drawing: PDJ. Photo: Coe 1967:Figs. 1-3.

b. Serpentine mosaic pavement, La Venta. Parque de La Venta. Drawing: Drucker, Heizer, and Squier 1959:Fig. 29. Photo: Drucker, Heizer, and Squier 1959:Pl. 16.

c. See Fig. 4c.

d. See Fig. 8b.

e. See Fig. 10i$_1$.

f. Clay sello, Tlatilco. COL. FVF. Impression: FVF.

g. Jade celt, La Venta Offering 1942-c. COL. MNAM. Drawing: RD by PDJ from Drucker 1952:Fig. 47b. Photo: de la Fuente 1972a:55.

h. Jade celt, La Venta Offering 1942-c. COL. MNAM. Drawing: RD by PDJ from Drucker 1952:Fig. 47c. Photo: de la Fuente 1972a:55.

i. Serpentine celt, Las Bocas PC. Drawing: EJ.

j. Stone hacha, Gulf Coast. COL. Cleveland Museum of Art. Drawing: RD by PDJ from Covarrubias 1957:Fig. 32.

k. See Fig. 11a.

l. Jade celt, Veracruz. PC. Drawing: PDJ.

m. Jade celt, La Venta Offering 2. COL. MNAM. Drawing: RD by PDJ from Drucker, Heizer, and Squier 1959:Fig. 35c. Photo: Coe 1968a:4.

n. Jade celt, La Venta Offering 4. COL. MNAM. Drawing: Drucker, Heizer, and Squier 1959:Fig. 40. Photo: Coe 1968a:68-69.

o. See Fig. 12e.

p. See Fig. 14e.

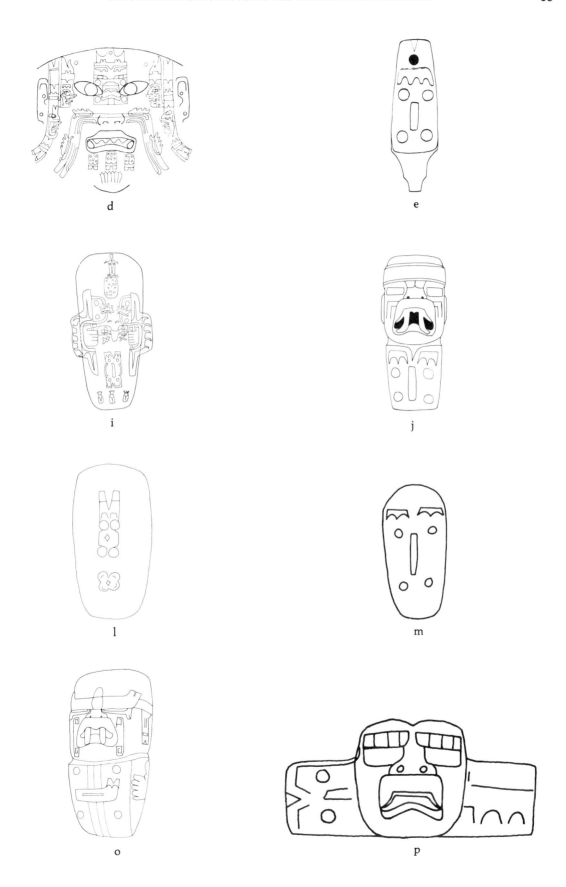

d

e

i

j

l

m

o

p

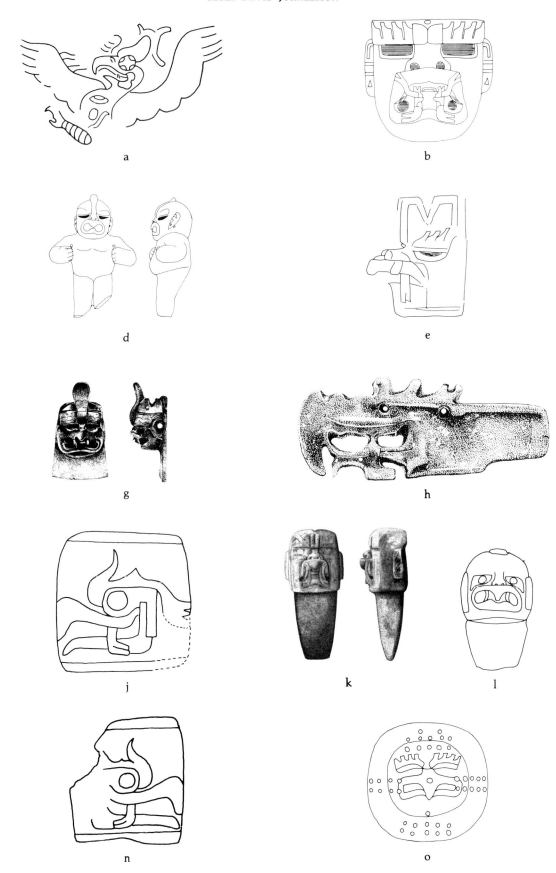

a

b

d

e

g

h

j

k

l

n

o

c

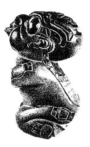

f

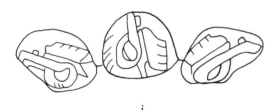

i

Fig. 20. *God III: the Olmec Bird-Monster*

a. See Fig. 4*b*.

b. Serpentine mask, Veracruz. PC. Drawing: PDJ.

c. See Fig. 19*i*.

d. Stone figure, UP. COL. Hamburgisches Museum für Völkerkunde und Vorgeschichte. Drawing: PDJ. Two views.

e. See Fig. 3*c*.

f. Brown stone chinless dwarf figure, UP. PC. Drawing: EJ.

g. Jade pectoral, UP. Two views. PC. Drawing: EJ.

h. Jade spoon, Costa Rica. COL. Frederick R. Pleasants. Drawing: EJ. Photo: Easby 1968:Pl. 64.

i. See Fig. 4*c*.

j. Jade earplug facing, La Venta Offering 1942-A. COL. MNAM. Drawing: PDJ. Photo: Drucker 1952:Pl. 54*b*.

k. See Fig. 18*d*.

l. Stone hacha, UP. COL. Peabody Museum, Harvard. Drawing: PDJ. Photo: Saville 1929:Fig. 89.

m. See Fig. 4*c*.

n. Jade ear plug facing, La Venta Offering 1942-A. COL. MNAM. Drawing: PDJ. Photo: Drucker 1952:Pl. 54*b*.

o. Jade mirror, Guerrero. PC. Drawing: PDJ.

p. See Fig. 4*c*.

m

p

celestial flight. Perhaps the Olmec Bird-Monster had similar associations.

In the preceding pages an analysis of the iconography of the Olmec Dragon and Bird-Monster has been presented. We discovered that God I is a polymorphic dragon whose association include earth, maize, agricultural fertility, clouds, rain, water, fire, and kingship. God III is a raptorial bird-monster related to the sky, sun, maize, chinless dwarfs, and religious ecstasy. If our conclusions about the nature of Dragon and Bird-Monster are correct, what can be said about the relationship between Olmec religion on the one hand and the religious history of Mesoamerica on the other?

Some scholars have argued that Olmec gods, if such beings ever existed, were peculiar to Olmec culture and disappeared with the collapse of Olmec civilization. Other investigators have accepted Miguel Covarrubias's hypothesis that Olmec gods are the prototypes of later Mesoamerican deities (this is the second proposition of the Las Limas hypothesis). I have generally found Covarrubias's continuity theory more productive than hypotheses based on disjunctive views of ancient Mexican religious history.

It is my conviction that there is a basic religious system common to all Mesoamerican peoples.[12] This system took shape long before it was given monumental expression in Olmec art and survived

a

b

c

d

Fig. 21. *God III: Bird-Monster Talons*
   *a.* Carving on the side of basalt Monument 14, San Lorenzo. Drawing: FD. Photo: Stirling 1965:Fig. 21*b*.
   *b.* Relief carving, Xoc, Chiapas. Present whereabouts unknown, believed destroyed. Drawing: Ekholm-Miller 1973:Fig. 15. Photo: Ekholm-Miller 1973:

Figs. 9 and 10.
   *c.* Design from a ceramic vessel, Las Bocas. PC. Drawing: PDJ.
   *d.* Design from a ceramic vessel, Tlatilco. COL. Brooklyn Museum. Drawing: RD by PDJ from Covarrubias n.d. Photo: *Man Eaters and Pretty Ladies* 1971:Pl. 167.

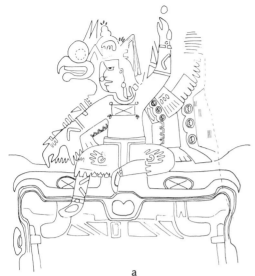

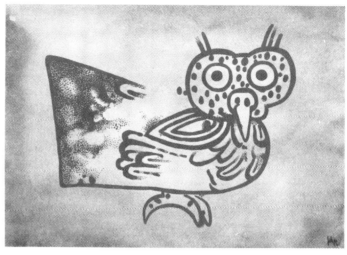

a                                                          b

Fig. 22. *The Owl and the Parrot in Olmec Art*
  *a.* See Fig. 10*l.*
  *b.* Painting 1-e, Oxtotitlan, Guerrero. Drawing:
     Grove 1970:Fig. 9. Photo: Grove 1970:Fig. 10.
  *c.* Basalt Colossal Head 2, San Lorenzo. Drawing:
     FD. Photo: Clewlow et al. 1967:Pls. 19-21.

c

long after the Spanish conquered the New World's
major political and religious centers.[13] Like all
mythological systems it presents an interpretation
of reality. On the one hand, it explains the origins
and organization of the world and the birth of the
gods and creation of mankind. On the other hand,
it establishes the relationship between the gods
and man, between man and his fellows, and
between man and the natural world. This Meso-
american *weltanschauung* exists at the level of
deep structure. Although its occurrence in time
and space makes it subject to the usual historical
processes of innovation and change, its systemic
nature allows it to remain relatively stable.[14]

The survival and evolution of the Dragon is an
interesting example of structural continuity in
ancient Mexican religion and art. I have collected
representations of a number of draconic creatures
with celestial, pluvial, telluric, agricultural, aqua-
tic, igneous, or dynastic associations and organ-
ized them into charts showing the iconographic
history of the Mesoamerican Dragon from Olmec
to Aztec times (Figs. 23-25). The position of the
Dragon in ancient Mexican religious thought can
be reconstructed with the help of Maya and Aztec
sources.

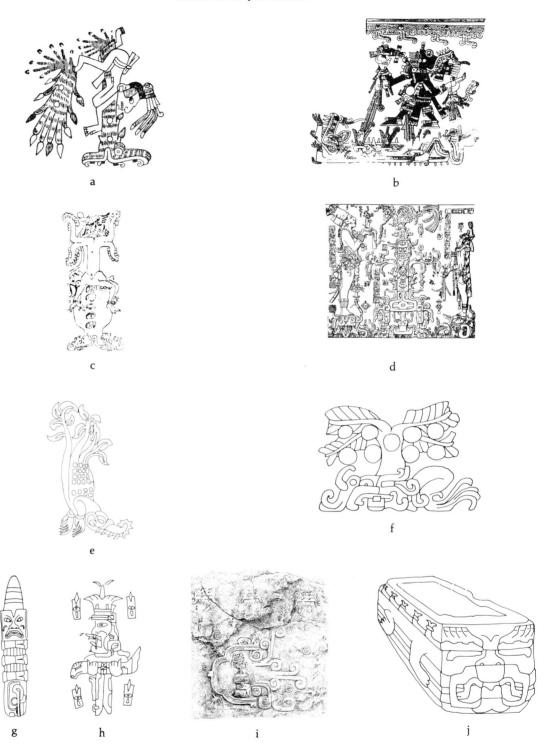

Fig. 23. *Representations of the Dragon in Mesoamerican Art: I*

a. Codex Borgia:24. Drawing: Seler 1963:I:24.
b. Codex Borgia:27. Drawing: Seler 1963:I:27.
c. Codex Dresden:3a. Drawing: Villacorta and Villacorta 1933:3a.
d. Panel of the Foliated Cross, Palenque. Drawing: Maudslay 1889-1902:Vol. IV:Pl. 81.

e. Stela 25, Izapa. Drawing: RD by PDJ from Norman 1973:Pl. 42.
f. Stela 2, Izapa. Drawing: RD by PDJ from Norman 1973:Pl. 4.
g. See Fig. 10g₁.
h. See Fig. 8f.
i. See Fig. 6a.
j. See Fig. 9c.

A careful reading of Eric Thompson's analysis of Itzam Na, the supreme god of the ancient Maya, suggests that this deity belongs to the same mythological family as the Olmec Dragon (Thompson 1970:209-233).[15] Thompson's hypothesis has both literary and representational support. His argument is very detailed and can only be outlined here.

Thompson (1970:212) points out that "Itzam Na means 'Iguana House.' Itzam is defined in the Vienna dictionary as 'lagartos like iguanas of land and water.' Lagarto can mean anything from lizard to crocodile." Despite the saurian component of the god's name, it is clear that the Maya imagined Itzam Na as a hybrid creature; he is portrayed with features of the cayman, lizard, serpent, and deer.

Like the Olmec Dragon, Itzam Na has both celestial and telluric associations. On the one hand, the Maya believed that "Itzam Na dwelt in the sky and sent rain to mankind" (Thompson 1970:212). His body is often decorated with planetary symbols that mark him as both the inhabitant of heaven and the celestial dome itself. He is sometimes depicted with streams of water pouring from his mouth and body. On the other hand, the Maya Dragon has primary associations with the earth and the four directions.

The Maya conceived the world to be set within a house, the roof and walls of which were formed by four giant iguanas, upright but with their heads downward, each with its own world direction and color. (Thompson 1970:214)

However, the Itzam Na concept does not merely embrace four Itzam forming the roof and walls of the world, for the Itzam, when they touch the horizon, turn to form the floor of the house in which our world is set, thus completing the rectangle of Iguana House. Most important, the Itzam take on fresh functions when they exchange their celestial locations for the floor of the world house. Whereas the Itzam in their celestial aspect are senders of rain to earth, in their terrestrial aspect they are the soil in which all vegetation has its being, and now they receive that rain which formerly they dispensed from on high. (Thompson 1970:216)

In addition to this bizarre conception of the universe as an Iguana House, the Maya also believed that the earth is a gigantic saurian monster floating on the surface of the primeval sea.

Strangely enough, Itzam Na also functioned as a fire god. In this aspect he is associated with earthen ovens, the hearth and the ground beneath it—symbolically the center of the world—firewood, and fire itself. He is also closely related to the Maya sun god, Kinich Ahau.

Finally, Thompson has very good evidence that Itzam Na was primarily a god of the Maya hierarchy.

Rulers had themselves portrayed seated in niches set in the roof and walls of Itzam Na. . . . Such representations are rare; it is rather the surfeit of attributes to an extent far beyond the point of monotony which I have in mind—headdresses laden with masks of Itzam Na one above the other, the so-called manikin scepters, the ceremonial bars, the Itzam heads, right way up or upside down, from which flow streams of water, all of which the ruler or priest wears or holds surely to make patent his affinity with the omnipresent and all-powerful iguana god. Clearly those Maya rulers would exalt their fame by clothing themselves in the finery of their maker. (Thompson 1970:232)

If Thompson's interpretation of Itzam Na is correct, that god is entirely homologous with the Olmec Dragon. Both deities are composite mythological beings. The two creatures have celestial and telluric aspects; as sky gods they are associated with the heavens, clouds, and rain and as gods of the earth they are linked to soil, vegetation, agricultural fertility, and the primeval waters. Itzam Na and the Olmec Dragon both function as fire gods and both are closely related to kingship and royal lineage. The Olmec Dragon and the Maya Dragon are iconographic equivalents.

Literary evidence from late Pre-Conquest central Mexico provides additional insight into the nature and function of the Mesoamerican Dragon (see Beyer 1965; Caso 1958, 1967; Anderson and Dibble 1950-1969; León-Portilla 1963, 1969; Nicholson 1971; Soustelle 1940, 1961).

In Aztec belief the Xiuhcoatl or Turquoise Serpent represents one of the celestial aspects of the Dragon. This deity is more properly called a Fire Dragon, for he is frequently depicted with legs and decorated with flame symbols. The Xiuhcoatl carries the sun on its daily journey across the sky and symbolizes the great Fire God, Xiuhtecuhtli. Xiuhtecuhtli is an old god; he is lord of the sun, the domestic hearth, and the sacred, perpetual fire. He also represents the principle of kingship and authority and "serves as the archetype of all rulers" (Nicholson 1971:413).

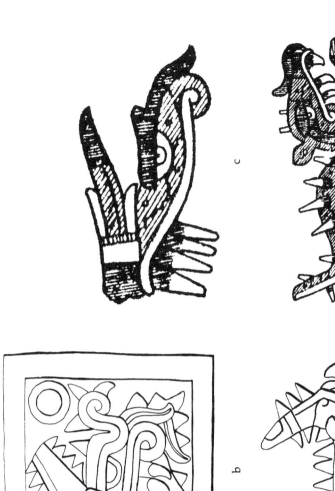

c

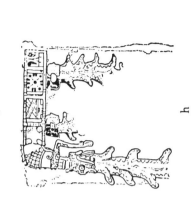

h

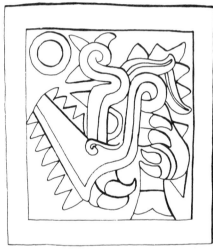

b

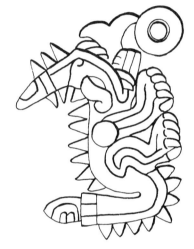

e

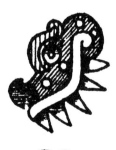

a

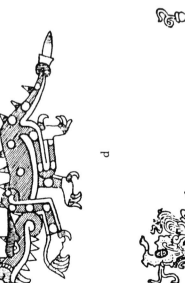

d

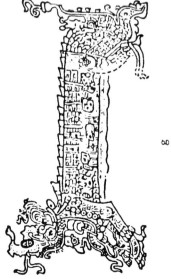

g

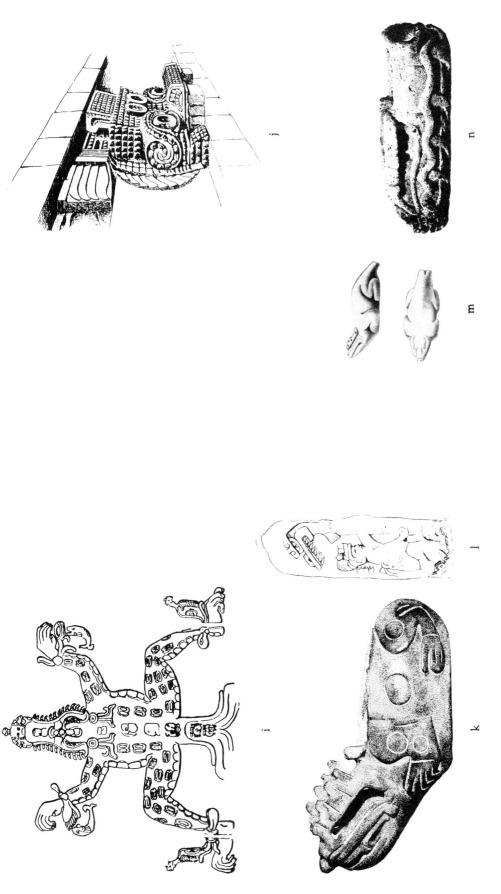

Fig. 24. *Representations of the Dragon in Mesoamerican Art: II*

a. Codex Nuttall:38-39. Drawing: Seler 1902-1923:IV:Figs. 667 and 668, p. 647.

b. Petroglyph of Acalpixcan. Drawing: RD by SK from Beyer 1965:Fig. 11, p. 113.

c. Codex Borgia:2. Drawing: Seler 1902-1923:IV:Fig. 661, p. 647.

d. Codex Nuttall:75. Drawing: Seler 1902-1923:IV:Fig. 669, p. 648.

e. 1 Cipactli, Stone Box. Drawing: RD by SK from Beyer 1965:Fig. 13, p. 115.

f. Codex Borgia:21. Drawing: Seler 1902-1923:IV:Fig. 659, p. 647.

g. Codex Dresden:4b-5b. Drawing: from *Maya History and Religion*, by J. Eric S. Thompson, Fig. 4b. Copyright 1970 by the University of Oklahoma Press.

h. Codex Dresden:74. Drawing: from *ibid.*, Fig. 4.

i. Altar T, Copan. Drawing: Maudslay 1889-1902:I:Pl. 95.

j. Architectural sculpture, Ciudadela, Teotihuacan. Drawing: Caso and Bernal 1952:Fig. 184c.

k. See Fig. 7a.

l. See Fig. 9i.

m. See Fig. 9d.

n. See Fig. 7r.

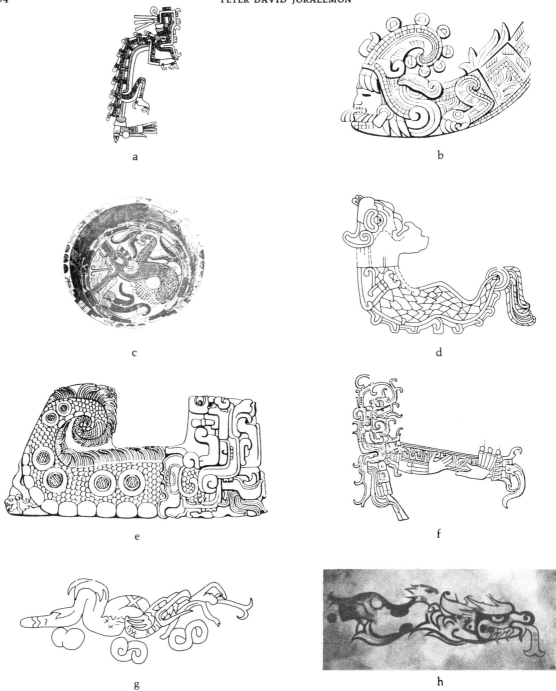

a

b

c

d

e

f

g

h

Fig. 25. *Representations of the Dragon in Mesoamerican Art: III*

a. Codex Nuttall:79. Drawing: Seler 1902-1923:IV: Fig. 707, p. 660.

b. Xiuhcoatl, Sun Stone, Mexico-Tenochtitlan. COL. MNAM. Drawing: from *The Eagle, the Jaguar and the Serpent*, by Miguel Covarrubias, Fig. 13. Copyright © 1954 by Miguel Covarrubias. Reprinted by permission of Alfred A. Knopf, Inc.

c. Ceramic bowl, Los Tuxtlas, Veracruz. COL. AMNH. Photo: *Ancient Mexico and Central America* 1970:72.

d. Panel 3, Pyramid of the Niches, El Tajín. Drawing: RD by PDJ from Kampen 1972:Fig. 6a.

e. Altar O, Copan. Drawing: see Fig. 25b.

f. Ceremonial bar, Stela 10, Seibal. Drawing: from *Maya History and Religion*, by J. Eric S. Thompson, Fig. 5e. Copyright 1970 by the University of Oklahoma Press.

g. See Fig. 5g.

h. See Fig. 9e.

The Mexican Cipactli is one of the telluric aspects of the Dragon. Cipactli is the first of the twenty named days of the Mexican 260 day divinatory cycle (Caso 1967:8-9). The day sign consists of either the Dragon's head with scroll eyebrows, elongated upper jaw, reptilian dentition, and absent lower jaw, or the Dragon's entire body depicted either as a quadruped reptile with spines or scales and a tail or as a spiney fish with Dragon's head, fins, and bifid tail. The patron deity of the day Cipactli is Tonacatecuhtli, Lord of our Flesh and Sustenance. Like the Maya, the central Mexicans imagined the earth as a gigantic spiney monster—Cipactli—floating on the surface of the universal sea. The Aztecs believed that agricultural crops, like all vegetation, grow from the body of the Cipactli.

The Dragon's close relationship with Xiuhtecuhtli and Tonacatecuhtli raises an interesting question. There is good evidence that both these deities were aspects of the Aztec god Ometeotl, Lord of Duality. León-Portilla has shown that ancient Nahua tradition assigned various names and appellations to Lord Two (León-Portilla 1963). Three native texts reveal the nature of the Double God and indicate the multiplicity of his divine titles.

And the Toltecs knew
that many are the heavens.
They said there are twelve superimposed divisions.
There dwells the true god and his consort.
The celestial god is called the Lord of Duality
And his consort is called the Lady of Duality, the celestial Lady;
which means
he is king, he is Lord, above the twelve heavens.

(León-Portilla 1963:81-82)

And it is told, it is said
that Quetzalcoatl would invoke something in the innermost of heaven:
she of the starry skirt (Citlalinicue), he whose radiance envelopes things (Citlallatonac);
Lady of our flesh (Tonacacihuatl), Lord of our flesh (Tonacatecuhtli);
she who is clothed in black (Tecolliquenqui), he who is clothed in red (Yeztlaquenqui);
she who endows the earth with solidity (Tlallamanac), he who covers the earth with cotton (Tlallichcatl).

And thus it was known, that toward the heavens was his plea directed, toward the place of duality, above the nine levels of heaven.

(León-Portilla 1963:29)

Mother of the gods (In teteu inan), father of the gods (In teteu itah), the old god (Huehueteotl)
spread out on the navel of the earth (in tlaxicco), within the circle of turquoise.
He who dwells in the waters the color of the bluebird (in xiuhtotoatica), he who dwells in the clouds.
The old god, he who inhabits the shadows of the land of the dead,
the lord of fire and of time (Xiuhtecuhtli).

(León-Portilla 1963:32)

If Xiuhtecuhtli and Tonacatecuhtli are different aspects of the Dual God and if there is a metaphoric correlation between the Fire God and the celestial Fire Reptile on the one hand and between the Earth Alligator and the Lord of our Flesh and Sustenance on the other, then it is conceivable that Ometeotl, the Nahua Lord of Duality, is in fact the Mesoamerican Dragon.[16] Other evidence points to the same conclusion. The titles of Lord Two indicate that the god had both a celestial-solar manifestation ("the celestial god"; "the celestial Lady"; "she of the starry skirts, he whose radiance envelops things"; "he who covers the earth with cotton"; "he who dwells in the clouds") and a telluric-aquatic aspect ("she who endows the earth with solidity"; "the old god spread out on the navel of the earth within the circle of turquoise, he who dwells in the waters the color of the bluebird").[17] It is precisely this combination of sky and earth attributes that characterizes the Dragon throughout ancient Mexican religious history.[18] The identification of the Mesoamerican Dragon with the Lord of Duality is far from proven. There is, however, enough supporting evidence for the hypothesis to warrant further investigation. Although our study of the Mesoamerican Dragon has been less than exhaustive, it has indicated that this mythological creature may have maintained its identity through more than three millennia. Throughout that time the Dragon retained its primary associations with sky and sun and rain; with earth and water and crops; and with kingship and authority.

## Acknowledgments

This essay is taken from a work in progress on the form and meaning of Olmec art. I would like to take this opportunity to thank Michael Coe, Floyd Lounsbury, and Kwang-chih Chang for the encouragement and advice they have offered throughout my graduate education. I would like to express my appreciation to María Antonieta Cervantes, Susanna Ekholm-Miller, Beatriz de la Fuente, Gillett Griffin, David Grove, Donald Lathrap, Arthur Miller, and Henry Nicholson for their assistance in my iconographic investigations. Finally, I wish to thank all the collectors of Pre-Columbian art who have permitted me to study their collections and who have given freely of their time and knowledge.

## Notes

1. The hypothesis that the jaguar is the predominant animal in Olmec iconography must be reexamined. The jaguar is certainly important in Olmec art, but he is only one of several animals represented by Olmec artists.

2. For iconographic purposes the Olmec tended to see all art forms as two dimensional surfaces upon which images could be carved. The frequency of profile and frontal representations is probably related to this planar predisposition.

3. English grammar furnishes a second analogy for this relationship: Abbreviated Image: Primary Image: Pronoun: Antecedent Noun.

4. This pattern frequently had directional significance in later Mexican art; it may have had a similar meaning in Olmec iconography.

5. A Postclassic example of this iconographic theme is pictured on page 27 of the Codex Borgia (see Fig. 23b). The three images depicting maize plants growing from the head of the Olmec Dragon (Fig. 10$e_1$, $f_1$, $g_1$) are particularly interesting in light of the later Mesoamerican convention of representing maize or other cultigens sprouting from the head of Itzamna or Cipactli (see Fig. 23a, c, d).

6. The ceremonial bar carved in the likeness of the Olmec Dragon may be the antecedent of the Maya ceremonial bar (see Fig. 25f). Or the Dragon scepter may represent the Olmec prototype of the Maya manikin scepter (see Thompson 1970:Fig. 8).

7. Peter Furst has commented on the importance of animal-human transformations in New World shamanism in general and in Olmec iconography in particular (Furst 1968). It is possible that the Veracruz jade spoon represents just such a transformation (see Coe 1972:3, 5 for well-taken reservations about Furst's thesis). The design, however, may mean that the Dragon is the Olmec figure's patron deity, his protector and guardian.

8. Coe (1968a:114) has argued that

in Maya hieroglyphic writing, the sign for "sky" or "heaven" and that for "snake" are the same: a pair of crossed bands like an X within a cartouche. The reason is that in Maya the two words are near homonyms (caan and can), the glyph originating from the crossed bands to be seen on the back of the fer-de-lance and rattlesnake.

Floyd Lounsbury favors a meaning of "center" or "zenith" for the crossed bands sign in the Maya codices when its function is semantic and a reading of tan when its function is phonetic (Lounsbury, personal communication).

9. It is possible that the crossed bands and dotted bracket sign is the Olmec ancestor of the Triadic sign, often associated with Itzamna in Maya iconography. See Kubler 1969 for a discussion of this Maya motif.

10. Elizabeth Benson has suggested that the four dots and bar symbol is a place glyph for La Venta (Benson 1971:27-29).

11. At least two other raptorial species are depicted in Olmec iconography, but neither seems to be related to God III (see Fig. 22). Clewlow et al. (1967:35) have argued that the bird heads carved on the helmet of Colossal Head 2 from San Lorenzo are parrots (Fig. 22c). David Grove has identified the avian creature represented in Mural 1 and Painting 1-e at Oxtotitlan (Fig. 22a, b) as the screech owl, the Muan bird of Maya mythology (Grove 1970:9, 14). Eric Thompson's discussion of the Muan bird's place in Maya thought is extremely interesting. "The Moan bird [is] a deity who lived in the sky, was intimately associated with the celestial dragons and symbolized the cloud filled heavens" (Thompson 1960:115). "There are several cases where an owl is placed on or immediately above celestial dragons [;] if the Moan god represents the 13 layers of clouds or the 13 skies, it would be perfectly natural to place him on or above the celestial dragons who send rain" (Thompson 1960:114-115). Other avian creatures portrayed by Olmec artists include the duck and the quetzal.

12. A religious system is a set of regularly interacting and interdependent ideas, which taken together form a unified conception of the world. The content of the Mesoamerican world view is documented in Pre-Conquest codices and religious art and in ethnohistorical records of the early colonial period (for an excellent summary of the Mesoamerican religious system as it

existed in central Mexico on the eve of the Spanish Conquest see Nicholson 1971). The religious beliefs of the New World's surviving traditional cultures can also provide valuable insights into Pre-Columbian religion (see Furst 1967, 1968, 1971, 1972b; Reichel-Dolmatoff 1971; Wilbert 1972).

13. Donald Lathrap (n.d.:25) has argued "that a large number of generations before the first extant examples of Chavín and Olmec art were carved, the ancestors of these groups of priests and artists were a single ethnic group. . . . I would further suggest that the appearance of these parallel mythical systems in the moist tropical lowlands of southern Mesoamerica and along the eastern face of the Central Andes was due to a gradual outward migration of agricultural colonists with an economic system adjusted to the reverine flood plains of Nuclear America."

14. All systems employ homeostatic mechanisms to preserve their external boundaries and maintain their internal organization. Systems tend to trade changes in surface detail for stability in deep structure: they change enough so that change is unnecessary.

15. Eric Thompson has established the crocodilian nature of Itzam Na (Thompson 1970:209-233), and Donald Lathrap has pointed out that the crocodilian characteristics of the great Maya deity are specifically those of a cayman (Lathrap n.d.). Although David Grove and I have suggested a relationship between the Olmec Dragon and Itzam Na, Lathrap (n.d.) is the first scholar to investigate fully this hypothesis.

16. The possibility that the ancient Mexicans conceived their Dragon in dualistic terms was suggested by a reading of Donald Lathrap's brilliant studies of the Obelisk Tello (Lathrap 1973 and n.d.).

17. Surely "the old god spread out on the navel of the earth within the circle of turquoise, he who dwells in the waters the color of the bluebird" is the Earth Dragon of Maya and Aztec belief who floats in the turquoise

waters of the primeval sea and represents the earth.

18. I am reasonably certain that the double creator god of the *Popol Vuh* should be equated with Ometeotl and the Dragon. The deity's Quiche titles include: "Former and Shaper (Tzakol and Bitol)," "Bearer and Engenderer (Alom and Q'aholom)," "Majesty and Quetzal Serpent (Tepeu and Q'uq'Kumatz)," "Green Plate Spirit and Blue Bowl Spirit (Raxa Laq and Raxa Tzel)" (Edmonson 1971:3-4). Compare the Nahua texts given above with the following verses from the creation story of the *Popol Vuh:*

There was not, then, anything in fact
That was standing there.
Only the pooled water,
Only the flat sea.
All by itself it lay damned.
There was not, then, anything in fact that might
have existed.
It was just still.
It was quiet
In the darkness,
In the night.
All alone the Former
And Shaper,
Majesty,
And Quetzal Serpent,
The Mothers
And Fathers
Were in the water.
Brilliant they were then,
And wrapped in quetzal
And dove feathers.
Thence came the name
Of Quetzal Serpent.
Great sages they were
And great thinkers in their essence. . . .
(Edmonson 1971:10)

# *References*

Ancient Mexico and Central America
    1970    *Ancient Mexico and Central America.* American Museum of Natural History, New York.

Anderson, Arthur J. O. and Charles E. Dibble (eds. and trans.)
    1950-    Florentine codex. General history of the
    1969    things of New Spain. Fray Bernardino de Sahagún. *The School of American Research and the University of Utah, Monographs of the School of American Research* 14, Parts II-XIII.

The Art of Ancient and Modern Latin America
    1968    *The art of ancient and modern Latin America.* The Isaac Delgado Museum of Art, New Orleans.

Aveleyra Arroyo de Anda, Luis
    1964    *Obras selectas de arte prehispánico.* Consejo para la Planeación e Instalación del Museo Nacional de Antropología, Mexico.

Benson, Elizabeth P.
    1968    *Dumbarton Oaks conference on the Olmec.* Dumbarton Oaks Research Library and Collection, Washington. (editor)
    1971    An Olmec figure at Dumbarton Oaks. *Studies in Pre-Columbian Art and Archaeology,* 8. Dumbarton Oaks, Washington.
    1972    *The cult of the feline, a conference in Pre-Columbian iconography.* Dumbarton Oaks Research Library and Collection, Washington. (editor)

Bernal, Ignacio
1967 La presencia Olmeca en Oaxaca. *Culturas de Oaxaca, Publicación 1.* Museo Nacional de Antropología, Mexico.
1969 *The Olmec world.* University of California Press, Berkeley and Los Angeles.

Beyer, Hermann
1965 Mito y simbología del México antiguo. *El México Antiguo* 10. Sociedad Alemana Mexicanista, Mexico.

Bolz-Augenstein, Ingeborg, and Hans D. Disselhoff
1970 Werke präkolumbischer Kunst. Sammlung Ludwig. Aachen. Mesoamerika und Peru. *Ibero-Amerikanisches Institut Preussischer Kulturbesitz, Monumenta Americana* 6, Berlin.

Caso, Alfonso
1958 *The Aztecs: people of the sun.* University of Oklahoma Press, Norman.
1967 Los calendarios prehispánicos. *Universidad Nacional Autónoma de México, Instituto de Investigaciones Históricas, Serie de Cultura Náhuatl, Monografías* 6, Mexico.

Caso, Alfonso and Ignacio Bernal
1952 Urnas de Oaxaca *Memorias del Instituto Nacional de Antropología e Historia* 2, Mexico.

Clewlow, Carl William
1974 A stylistic and chronological study of Olmec monumental sculpture. *Contributions of the University of California Archaeological Research Facility* 19. Berkeley.

Clewlow, C. William, R. A. Cowan, J. F. O'Connell, and C. Benemann
1967 Colossal heads of the Olmec culture. *Contributions of the University of California Archaeological Research Facility* 4. Berkeley.

Coe, Michael D.
1962 *Mexico.* Frederick A. Praeger, New York.
1965a *The jaguar's children: Pre-Classic Central Mexico.* The Museum of Primitive Art, New York.
1965b Archaeological synthesis of Southern Veracruz and Tabasco. In *Handbook of Middle American Indians,* edited by Robert Wauchope and Gordon R. Willey, 3:679-715. University of Texas Press, Austin.
1965c The Olmec style and its distribution. In *Handbook of Middle American Indians,* edited by Robert Wauchope and Gordon R. Willey, 3:739-775. University of Texas Press, Austin.
1967 An Olmec serpentine figurine at Dumbarton Oaks. *American Antiquity* 32 (1):111-113.
1968a *America's first civilization.* American Heritage Publishing Co., in association with the Smithsonian Institution, New York.
1968b San Lorenzo and the Olmec civilization. In *Dumbarton Oaks conference on the Olmec,* edited by Elizabeth P. Benson, pp. 41-78. Dumbarton Oaks Research Library and Collection, Washington.

1971 The shadow of the Olmecs. *Horizon* 12(4): 66-75.
1972 Olmec jaguars and Olmec kings. In *The cult of the feline. A conference on Pre-Columbian iconography,* edited by Elizabeth P. Benson, pp. 1-18. Dumbarton Oaks Research Library and Collection, Washington.
1973 The iconology of Olmec art. In *The iconography of Middle American sculpture,* pp. 1-12. The Metropolitan Museum of Art, New York.

Cook de Leonard, Carmen
1967 Sculptures and rock carvings at Chalcatzingo, Morelos. *Studies in Olmec archaeology, Contributions of the University of California Archaeological Research Facility* 3:57-84. Berkeley.

Covarrubias, Miguel
1942 Origen y desarrollo del estilo artístico "Olmeca." In *Mayas y Olmecas: segunda reunión de mesa redonda,* Sociedad Mexicana de Antropología, pp. 46-49.
1943 Tlatilco, archaic Mexican art and culture. *DYN, The Review of Modern Art* 4-5:40-46.
1944 La Venta, colossal heads and jaguar gods. *DYN, The Review of Modern Art* 6:24-33.
1946 El arte "Olmeca" o de La Venta. *Cuadernos Americanos* 28(4):153-179.
1947 *Mexico south: the isthmus of Tehuantepec.* Cassell and Co., Ltd., London.
1950 Tlatilco: el arte y la cultura preclásica del Valle de México. *Cuadernos Americanos* 51(3):149-162.
1954 *The eagle, the jaguar and the serpent.* Alfred A. Knopf, New York.
1957 *Indian art of Mexico and Central America.* Alfred A. Knopf, New York.
n.d. Covarrubias notebook: fragments of a sketch book of Preclassic Mexican art. Photographic copies of the now lost original are in the possession of P. D. Joralemon and Michael D. Coe.

Drucker, Philip
1952 La Venta, Tabasco: a study of Olmec ceramics and art. *Bureau of American Ethnology, Bulletin* 153.

Drucker, Philip, R. F. Heizer, and R. Squier
1959 Excavations at La Venta, Tabasco, 1955. *Bureau of American Ethnology,* Bulletin 170.

Easby, Elizabeth Kennedy
1966 *Ancient art of Latin America from the collection of Jay C. Leff.* The Brooklyn Museum, Brooklyn.
1968 *Pre-Columbian jade from Costa Rica.* Andre Emmerich, Inc., New York.

Easby, Elizabeth K., and John F. Scott
1970 *Before Cortés; Sculpture of Middle America.* The Metropolitan Museum of Art, New York.

Edmonson, Munro S.
1971 The book of counsel: the Popol Vuh of the Quiche Maya of Guatemala. *Middle Amer-*

*ican Research Institute, Publication* 35. Tulane University, New Orleans.

Ekholm-Miller, Susanna
    1973   The Olmec rock carving at Xoc, Chiapas, Mexico. *Papers of the New World Archaeological Foundation* 32. Brigham Young University, Provo, Utah.

Field, Frederick V.
    1967   Thoughts on the meaning and use of Pre-Hispanic Mexican sellos. *Studies in Pre-Columbian Art and Archaeology* 3. Dumbarton Oaks, Washington.

de la Fuente, Beatriz
    1972a  El arte Olmeca. *Artes de México* 154. (coördinator)
    1972b  Review of Peter David Joralemon's A Study of Olmec Iconography. In *Anales del Instituto de Investigaciones Estéticas* 41:190-193. Universidad Nacional Autónoma de México, Mexico.
    1973   Escultura monumental Olmeca: catálogo, *Instituto de Investigaciones Estéticas, Universidad Nacional Autónoma de México, Cuadernos de Historia de Arte* 1. Mexico.

Furst, Peter
    1967   Huichol conceptions of the soul. *Folklore Americas* 27(2):39-106.
    1968   The Olmec were-jaguar motif in the light of ethnographic reality. In *Dumbarton Oaks conference on the Olmec,* edited by Elizabeth P. Benson, pp. 143-174. Dumbarton Oaks Research Library and Collection, Washington.
    1971   Concepto Huichol del alma. In *Coras, Huicholes y Tepehuanos.* Estudios etnograficos, Colección de Antropología Social del Instituto Nacional Indigenista, Mexico.
    1972a  *Flesh of the gods: the ritual use of hallucinogens.* Praeger Publishers, New York and Washington. (editor)
    1972b  To find our life: peyote among the Huichol Indians of Mexico. In *Flesh of the Gods,* edited by Peter Furst, pp. 136-184. Praeger Publishers, New York and Washington.

Gay, Carlo T. E.
    1966   Rock carvings at Chalcatzingo. *Natural History* 75(7):56-61.
    1967   Oldest paintings of the New World. *Natural History* 76(4):28-35.
    1971   *Chalcacingo.* Akademische Druck-und Verlagsanstalt, Graz, Austria.
    1972   *Xochipala: the beginnings of Olmec art.* Princeton University Press, Princeton.
    1973   Olmec hieroglyphic writing. *Archaeology* 26(4):278-288.

Grove, David C.
    1968a  Chalcatzingo, Morelos, Mexico: a reappraisal of the Olmec rock carvings. *American Antiquity* 33(4):486-491.
    1968b  The Preclassic Olmec in Central Mexico: site distributions and inferences. In *Dumbarton*

*Oaks conference on the Olmec,* edited by Elizabeth P. Benson, pp. 179-185. Dumbarton Oaks Research Library and Collection, Washington.
    1969   Olmec cave paintings: discovery from Guerrero, Mexico. *Science* 164(3878):421-423.
    1970   The Olmec paintings of Oxtotitlan cave, Guerrero, Mexico. *Studies in Pre-Columbian Art and Archaeology* 6. Dumbarton Oaks, Washington.
    1973   Olmec hieroglyphic writing. *Archaeology* 26(4):278-288.
    n.d.   Archaeological investigations at Chalcatzingo, Morelos, Mexico. Proposal submitted to the National Science Foundation. Mimeographed manuscript.

Handbook of the Robert Woods Bliss Collection of Pre-Columbian Art
    1963   *Handbook of the Robert Woods Bliss collection of Pre-Columbian art.* Dumbarton Oaks, Washington.

Heizer, Robert F.
    1967   Analysis of two low relief sculptures from La Venta. *Studies in Olmec archaeology, Contributions of the University of California Archaeological Research Facility* 3:25-55. Berkeley.

Joralemon, Peter David
    1971   A study of Olmec iconography. *Studies in Pre-Columbian Art and Archaeology* 7. Dumbarton Oaks, Washington.

Judd, Neil M.
    1951   A new-found votive ax from Mexico. *American Antiquity* 17(2):139-141.

Kampen, Michael Edward
    1972   *The sculpture of El Tajín, Veracruz, Mexico.* University of Florida Press, Gainesville.

Kelemen, Pal
    1943   *Medieval American art.* 2 vols. The Macmillan Company, New York.

Kelley, David H.
    1966   A cylinder seal from Tlatilco. *American Antiquity* 31(5):744-746.

Kubler, George
    1962   *The art and architecture of ancient America: the Mexican, Maya, and Andean peoples.* Penguin Books, Baltimore.
    1969   Studies in Classic Maya iconography. *Memoirs of the Connecticut Academy of Arts and Sciences* 18. New Haven.

L'Art Olmeque: Source des Arts Classiques du Mexique
    1972   *L'art Olmeque: source des arts classiques du Mexique.* Musée Rodin, Paris.

Lathrap, Donald W.
    1973   Gifts of the cayman: some thoughts on the subsistence basic of Chavín. In *Variations in anthropology: essays presented to John McGregor on his retirement from the University of Illinois.* Illinois Archaeological Survey.
    n.d.   Complex iconographic features shared by Olmec and Chavín and some speculations on

their possible significance. Paper read July 31, 1971, at Primer Simposio de Correlaciones Antropológicas Andino-Mesoamericano, Salinas, Ecuador.

León-Portilla, Miguel
1963    *Aztec thought and culture: a study of the ancient Nahuatl mind.* University of Oklahoma Press, Norman.
1969    *Pre-Columbian literatures of Mexico.* University of Oklahoma Press, Norman.

Lothrop, Samuel K., W. F. Foshag, and J. Mahler
1957    *Pre-Columbian art. Robert Woods Bliss Collection.* Phaidon Publishers, New York and London.

Man Eaters and Pretty Ladies
1971    *Man eaters and pretty ladies. Early art in central Mexico from the Gulf to the Pacific. 1500 B.C. to A.D. 500.* Montreal Museum of Fine Arts, Montreal.

Maudslay, Alfred P.
1889-   *Biologia Centrali-Americana, Archaeology.*
1902    Text and 4 volumes of plates. London.

Madellín Zenil, Alfonso
1965    La escultura de Las Limas. *Boletín del Instituto Nacional de Antropología e Historia* 21:5-8.

Melgar, José M.
1869    Antigüedades mexicanas, notable escultura antigua. *Boletín de la Sociedad Mexicana de Geografía y Estadística,* época 2, 1:292-297.
1871    Estudio sobre la antigüedad y el origen de la Cabeza Colosal de tipo etiópico que existe en Hueyapan, del Cantón de los Tuxtlas. *Boletín de la Sociedad Mexicana de Geografía y Estadística,* época 2, 3:104-109.

Metropolitan Museum of Art
1973    *The iconography of Middle American sculpture.* The Metropolitan Museum of Art, New York.

Miles, Suzanna W.
1965    Sculpture of the Guatemala-Chiapas Highlands and Pacific Slopes and associated hieroglyphs. In *Handbook of Middle American Indians,* edited by Robert Wauchope and Gordon R. Willey, 2(1):237-275, University of Texas Press, Austin.

Navarrete, Carlos
1971    Algunas piezas Olmecas de Chiapas y Guatemala. *Anales de Antropología* 8:69-82. Instituto de Investigaciones Históricas, Universidad Nacional Autónoma de México, Mexico.

Nicholson, Henry B.
1971    Religion in Pre-Hispanic central Mexico. In *Handbook of Middle American Indians,* edited by Robert Wauchope, Gordon Eckholm, and Ignacio Bernal, 10:395-446. University of Texas Press, Austin.
1973    The late pre-hispanic central Mexican (Aztec) iconographic system. In *The iconography of Middle American sculpture,* pp. 72-97. The Metropolitan Museum of Art, New York.

Nicholson, Irene
1967    *Mexican and Central American mythology.* Paul Hamlyn, London.

Norman, V. Garth
1973    Izapa sculpture, part 1: album. *Papers of the New World Archaeological Foundation* 30. Brigham Young University, Provo, Utah.

Piña Chán, Román
1960    *Mesoamérica.* Instituto Nacional de Antropología e Historia, Mexico.

Piña Chán, Román, and Luis Covarrubias
1964    *El pueblo del jaguar.* Consejo para la Planeación e Instalación del Museo Nacional de Antropología, Mexico.

Porter, Muriel Noe
1953    Tlatilco and the Pre-Classic cultures of the New World. *Viking Fund Publications in Anthropology* 19. Wenner-Gren Foundation for Anthropological Research, New York.

Reichel-Dolmatoff, Gerardo
1971    *Amazonian cosmos: the sexual and religious symbolism of the Tukano Indians.* University of Chicago Press, Chicago.

Saville, Marshall H.
1929    Votive axes from ancient Mexico, parts 1 and 2. *Indian Notes* 6:266-299, 335-342. Museum of the American Indian, Heye Foundation, New York.

Schultes, Richard Evans
1972    An overview of hallucinogens in the Western Hemisphere. In *Flesh of the gods,* edited by Peter Furst, pp. 3-54. Praeger Publishers, New York and Washington.

Seler, Edward
1902-   *Gesammelte Abhandlungen zur Amerika-*
1923    *nischen Sprach- und Alterthumskunde.* 5 vols. Verlag A. Asher and Verlag Behrend, Berlin.
1963    *Comentarios al Códice Borgia.* 3 vols. Fondo de Cultura Económica, Mexico and Buenos Aires.

Soustelle, Jacques
1940    *La pensée cosmologique des anciens Mexicains.* Hermann, Paris.
1961    *The daily life of the Aztecs on the eve of the Spanish conquest.* Wiedenfeld and Nicholson, London.

Stirling, Matthew W.
1939    Discovering the New World's oldest dated work of man. *National Geographic Magazine* 76:183-218.
1940    An Initial Series from Tres Zapotes, Veracruz, Mexico. *Contributed Technical Papers, Mexican Archaeology Series* 1(1). National Geographic Society, Washington.
1943a   Stone monuments of southern Mexico. *Bureau of American Ethnology, Bulletin* 138.
1943b   La Venta's green stone tigers. *National Geographic Magazine* 84:321-332.
1955    Stone monuments of the Rio Chiquito, Veracruz, Mexico. *Bureau of American Ethnology, Bulletin* 157, *Anthropological Papers* 43:1-23.
1957    An Archaeological Reconnaissance in Southeastern Mexico. *Bureau of American Ethnology, Bulletin* 164, *Anthropological Papers* 53:213-240.
1965    Monumental Sculpture of Southern Veracruz

and Tabasco. In *Handbook of Middle American Indians*, edited by Robert Wauchope and Gordon R. Willey, 3:716-738. University of Texas Press, Austin.

Thompson, J. Eric S.
  1960    *Maya hieroglyphic writing: introduction.* University of Oklahoma Press, Norman.
  1970    *Maya history and religion.* University of Oklahoma Press, Norman.
  1973    Maya rulers of the classic period and the divine right of kings. In *The iconography of Middle American sculpture*, pp. 52-71. The Metropolitan Museum of Art, New York.

Villacorta C., J. Antonio, and C. A. Villacorta
  1933    *Códices Mayas. Dresdensis-Peresianus-Tro-Cortesianus.* Guatemala.

Wicke, Charles R.
  1972    *Olmec: an early art style of Pre-Columbian Mexico.* University of Arizona Press, Tucson.

Wilbert, Johannes
  1972    Tobacco and shamanistic ecstasy among the Warao Indians of Venezuela. In *Flesh of the Gods*, edited by Peter Furst, pp. 55-83. Praeger Publishers, New York and Washington.

Willey, Gordon R.
  1973    Mesoamerican art and iconography and the integrity of the Mesoamerican ideological system. In *The iconography of Middle American sculpture*, pp. 153-162. The Metropolitan Museum of Art, New York.

Williams, Howel, and Robert F. Heizer
  1965    Sources of Rocks Used in Olmec Monuments. *Contributions of the University of California Archaeological Research Facility* 1:1-39. Berkeley.

# The Relationship of Izapan-Style Art to
# Olmec and Maya Art:
# A Review

JACINTO QUIRARTE

College of Fine and Applied Arts
The University of Texas at San Antonio

There are few definitive works in the study of Pre-Columbian art. Our views are constantly being changed as new materials are discovered and as new interpretations and evaluations of the known bodies of work are presented. What was once considered an overwhelmingly inviolable body of work such as the Classic Maya is now seen to be closely related to other groups in Mesoamerica. The long-held image of a hermetically sealed cultural unit remained unchanged until recently, even though data indicating extensive inter-Mesoamerican contacts have been known for some time. The earliest recognized intrusion into the Maya area—that of the Toltecs into Yucatan during the Postclassic period—did not, however, alter the image of a unique *classic* Maya art. Even the recognition of Early Classic Teotihuacán intrusions far to the southeast in the Guatemala Highlands at Kaminaljuyu by Kidder (1946) did not appreciably change the situation. More recent studies by the University of Pennsylvania team working at Tikal from 1956 on through to the late sixties have revealed a central Mexican presence at that site during the latter part of the Early Classic period (W. Coe 1965).

The evidence of a central Mexican presence in the Maya area during the Classic and Postclassic periods is clearer than ever before. Yet other influences corresponding to the Preclassic and Formative periods and traceable to Olmec and Izapan sources have not been fully assessed. One reason is that the latter bodies of work have been known for a relatively short period of time. It is not surprising then that Olmec art and Izapan-style art have barely infringed upon our consciousness of Maya art.

Maya art has been studied extensively for more than a hundred years. Its designation as a distinct style has never been questioned. The existence of Olmec art, in contrast, was only recognized 30 or 40 years ago, even though one of many colossal heads had been known for more than eighty years (M. Coe 1968). The emergence of Izapan-style art[1] is even more recent and is still in the process of being defined (Quirarte 1973). What relationship this style has with Olmec art and with Maya art in particular is the concern of this paper.

The relationship of Izapan-style art to Olmec and Maya art can be established by determining to what extent similar systems of meaning are retained because formal parallels are slight. Themes, motifs, and elements must be studied to determine the extent and nature of the contacts between these cultures. The first step in this process entails making a catalog of all known elements in each body of work. Their placement within units or motifs, which in turn comprise themes, the prime carriers of meaning, must then be studied very closely.

How the themes in each body of work are formulated will determine what is designated as Olmec, Izapan, or Maya in style. There is no longer any question that each is distinct in form even though conceptual parallels are readily found. The same elements appear over and over again in all three cultures. Differences begin to appear in motifs and are more pronounced when themes are enumerated.

Joralemon (1971) lists the numerous examples of crossed bands, diagonal bands, as well as U-shaped elements found in Olmec monuments. Their appearance in Izapan and Maya monuments is also well-known. In some cases, contexts in which these are found are the same. In Olmec and Izapan examples crossed bands and diagonals are used prominently on top-line designs and occasionally within narrative scenes. U elements appear in prominent positions and are also incorporated into narrative scenes. By the time we get to Early Classic Maya materials we find that all of these have been relegated to insignia, emblems, and glyphs. Antecedents for these are also found in Izapan-style monuments.

Among distinctive motifs found in Izapan-style monuments are fruit trees, birds, and fishes swimming in water. There are several Izapan themes not found in Olmec or Maya examples, such as the curing of a jaguar skin over a fire shown on Stela 12[2] or the tapping of a crocodile with a tree growing from its tail, shown on Stela 64 (Proskouriakoff, correspondence). Other celebration scenes not found elsewhere are those with pairs of seated figures facing each other with incense burners placed between them, shown on

Stelae 5 and 18 and bird impersonators also shown on Stela 5. All of these are late in Izapa (Quirarte 1973). They have more complicated top-line designs; relationship of figure to ground changes drastically from that seen in earlier pieces; these much smaller figures are now crowded onto even larger visual surfaces; the scenes are complicated; the articulation of parts and treatment of the surface differ from that seen on earlier stelae.

Among the more universal themes represented are the decapitation scene on Stela 21 and the long-lipped head as a terrestrial symbol found on Stela 2. Other distinctive Izapan motifs and themes like the downward flying figures and downward peering heads, all represented on the upper portions of the narrative scene, may be echoed in Early Classic Maya stelae (Tikal Stelae 4 and 29).

## TOP-LINE DESIGNS

One of the very well-known parallels in Olmec and Izapan art is the emergence of a human figure from the mouth of a composite creature as in La Venta Altar 4 and others at that site. The same concept is given different form in Izapa. In contrast to the Olmec jaguar monster "masks" analyzed by Drucker (1952:Fig. 58), the Izapa top-line designs are more abstract and do not have the obvious reference to the mouth, eyes, and eyebrows of the easily identified mask found in Olmec representations. The Izapa top-line designs probably represent the "jaguar mask" panels seen by Stirling (1943). But like those in the Olmec area the Izapan designs are more than a singular reference to a feline creature. Drucker (1952:194) noted that "in most, though perhaps not all cases,

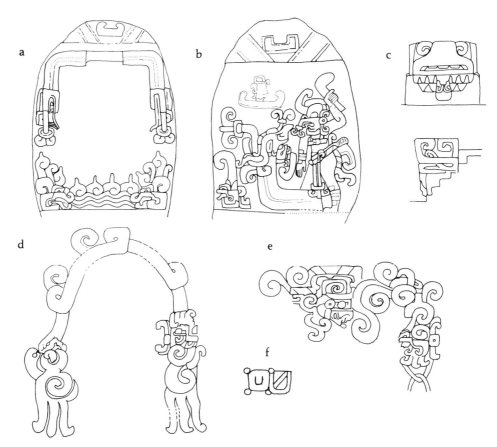

Fig. 1. Double-headed compound figures I: Serpents and scroll-eyed heads:
    *a.* Izapa, Stela 23, redrawn from Norman 1973:Part 1, Pl. 38
    *b.* Izapa, Stela 3, redrawn from Norman 1973:Part 1, Pl. 6
    *c.* Uaxactun, Structure E-VII Sub, lower zone mask

(front and profile views) after Ricketson and Ricketson 1937:Fig. 39
    *d.* Kaminaljuyu, Stela 19 (drawn from a photograph), after Proskouriakoff 1968:Fig. 4
    *e.* El Baul, Stela 1 (drawn from a photograph), after Parsons 1968:Fig. 3
    *f.* Tuxtla Statuette, glyph, (drawn from a photograph), after Pijoan 1958:Fig. 420.

the being represented is a monster who combines jaguar, bird, and snake traits." A similar breakdown can be found in Izapa (Figs. 1a and b, 2e, 3a and b, 5g). The Izapan artist elaborated on the basic elements symbolizing the upper jaw of the feline-serpent figure to create a number of top-line designs (Quirarte 1973:Figs. 2, 3, 4).

Although top-line designs are normally associated with sites in the Chiapas-Guatemala Highland and Pacific Slope sites, an example is found as far north as Tikal, painted on the outer walls of Tikal Structure 5D-Sub. 10-1st (W. Coe 1965: 18-19). The design is similar to Izapan-style prototypes. Arrows, however, are used instead of the usual diagonal bands and there are two U elements instead of one in the center. Its assigned date of 25 B.C. (W. Coe 1965:19) places it within the great Preclassic horizon for all of these

sculptures. The figures directly below the design demonstrate very distinct Izapan features. They wear Izapan-type scroll ear plugs and beaded bracelets which are similar to the anklets worn by the Kaminaljuyu Stela 4 figure. The scrolls that frame each figure are reminiscent of those found on Izapan-style monuments.

The abstracted top-line designs seen on Izapan-style monuments are references to a composite feline-serpentine creature. Diagonal bands are definitely the markings on the body of this creature. These are seen on the double-headed serpent used as a frame on Stela 12 (Fig. 2e). A jaguar is suspended from the upper portion while two small seated figures fan a fire directly below it. Here the creature as a frame is very explicit. This did not deter the artist, however, from including an elaborate top-line design that is yet

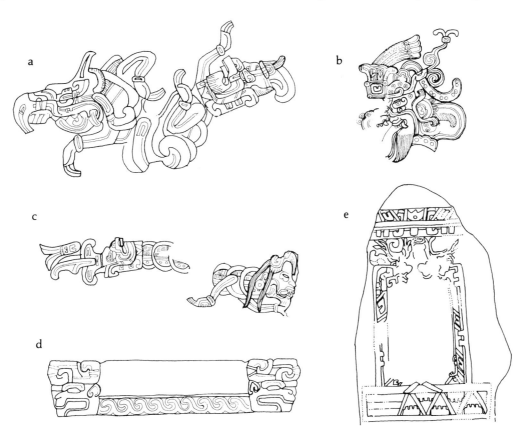

Fig. 2. Double-headed compound figures II: Feline-serpent-saurian creatures:
  a. Chiapa de Corzo, Bone 1, after Agrinier 1960:Fig. 1
  b. Kaminaljuyu, Stela 10 (drawn from a photograph and rubbing) after Miles 1965:Fig. 13 and Greene 1967:2
  c. Chiapa de Corzo, Bone 3, after Agrinier 1960: Fig. 11
  d. Medellín, Veracruz, Yoke, after Covarrubias 1961:Fig. 76
  e. Izapa, Stela 12, redrawn from Norman 1973:Part 1, Pl. 24.

another reference to the same creature. The double brackets used on Stelae 5 and 12 are repeated on the body of this double-headed serpent (Fig. 5g). The use of slanted U shapes framed by diagonal bars in lieu of the regular double opposed diagonals seen in other Izapan-style monuments are also repeated on the body of this serpent. These are probably feline references within a predominantly serpentine context. U elements are also found on the body of the double-headed creature depicted on Chiapa de Corzo Bone 1 (Fig. 2a).

The top-line designs can therefore be read as follows: The double opposed diagonal bands are references to the serpent-saurian creature.[3] The U element is a reference to the jaguar. This is the essential unit of meaning in these monuments. So basic is this reference that a glyphic presentation of it may be found in the inscription on the right side of the Tuxtla Statuette: two main signs

comprised of a U element and a diagonal band (Fig. 1f).

## BASE-LINE DESIGNS

The base-line designs of Izapan style stelae are more elaborate than the top-line designs and also exhibit greater differences in makeup and meaning (Quirarte 1973:Figs. 5, 6, 7). One of the base-line designs is identical to the "collar" worn by a bearded feline creature depicted on Chiapa de Corzo Bone 1 (Figs. 2a, 3a). Another design on Stelae 23 and 1 is definitely a representation of water (Fig. 1a). The wavy lines of Stela 1 contain fishes. Other designs seen on Stelae 5 and 12 are associated with a feline-saurian creature (Figs. 5g and 2e). The prototypal head for this design is seen on Tres Zapotes Stela C (Quirarte 1973:Fig. 7a). The triangular units with stepped and notched

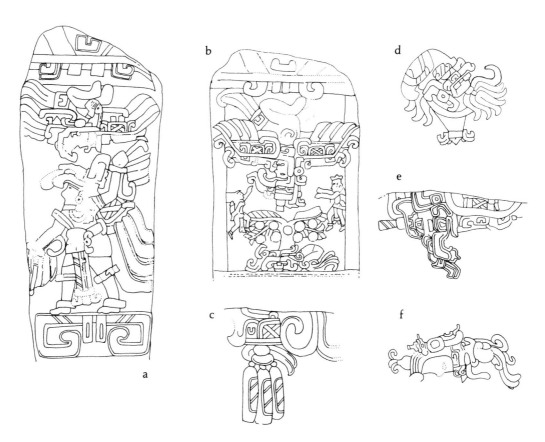

Fig. 3. Downward flying figures:
  a. Izapa, Stela 4, redrawn from Norman 1973:Part 1, Pl. 8.
  b. Izapa, Stela 2, redrawn from Norman 1973:Part 1, Pl. 4.
  c. Bilbao, Monument 42, after Parsons 1968:Figs. 2, 9e.
  d. Kaminaljuyu, Stela 19, after Proskouriakoff 1968: Fig. 4.
  e. Kaminaljuyu, Stela 11, after Miles 1965:Figs. 3g, 15a.
  f. Tikal, Stela 29, after W. Coe 1962:Fig. 5a.

element with circles placed within them are found on the cheeks of this creature. Continuous scroll forms, another aspect of this feline creature, can be used singly as on Tres Zapotes Monument C or in conjunction with the triangular elements as on Stela 5, or with water as on Stela 23. These scrolls are associated with a feline represented on a yoke found in Medellín, Veracruz (Fig. 2d). Continuous scroll forms are found in numerous Teotihuacán paintings as frames and associated with representations of water. The same motif even appears in the Postclassic Codex Selden always as a top frame on sectional representations of bodies of water similar to the base-line design of Stela 23.

## TERRESTRIAL LONG-LIPPED HEADS

Base-line designs are not always abstracted, however. There is a long-lipped head with a fruit tree growing from it on Stela 2, shown at the bottom but still within the narrative frame (Fig. 3b). Other examples of this terrestrial dragon are seen on Abaj Takalik Stela 3, and Bilbao Monument 42 (Fig. 5e). A similar long-lipped head is worn at belt level by the Kaminaljuyu Stela 11 figure. All three examples have diagonal bands prominently displayed as well as U elements placed within the supraorbital area or stylized eyebrows. Izapa Stela 2 also has a diagonal band seen to the right of the head.

## BIFURCATED TONGUES

Although the area defined by the top- and base-line designs is normally reserved for a narrative scene, it is sometimes used for nonfigurative representations as on Stelae 19 and 20. The elements of the unit comprising the narrative scene on Stela 20 are a long stem designated as a; buffer area, b; a rectangular central element, c; and

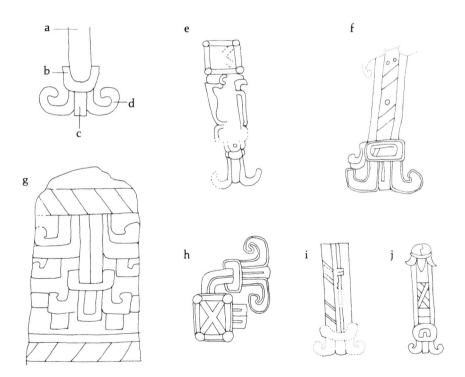

Fig. 4. Bifurcated serpent tongues: Prototype:
  a. Stem.
  b. U shaped.
  c. Bracket.
  d. J-form scrolls. Examples:
  e. Izapa, Stela 18, redrawn from Norman 1973:Part 1, Pl. 28.
  f. Kaminaljuyu, Stela 11, belt sash, after Miles 1965: Fig. 152.
  g. Izapa, Stela 20, after Stirling 1943:Pl. 57b.
  h. Kaminaljuyu, Stela 11, earplug, after Miles 1965: Fig. 15a.
  i. Izapa, Stela 4, belt sash, redrawn from Norman 1973:Part 1, Pl. 8.
  j. Leiden Plate, probably Tikal, belt sash, after Covarrubias 1961:Fig. 92.

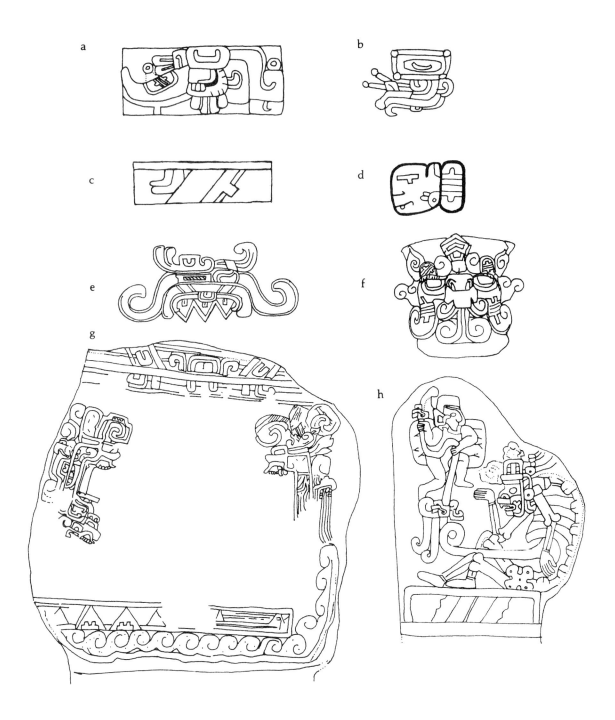

Fig. 5. T-shaped elements:

*a.* Kaminaljuyu, Mound B, Burial I, Bowl, black, stuccoed, painted, after Kidder, Jennings, and Shook 1946:Fig. 186a.

*b.* Kaminaljuyu, Mound A, Burial A-VI, stuccoed cylindrical tripod, painted, Serpent X, after Kidder, Jennings and Shook 1946:Fig. 97a.

*c.* El Baul, Stela 1, base-line design, after Bernal 1969:Pl. 94.

*d.* Dresden Codex, Glyph T-668 with Affix T-103, after Thompson 1972:Fig. 4s.

*e.* Bilbao, Monument 42, after Parsons 1968:Fig. 8h.

*f.* Zegache, vase, after Paddock 1966:101 (Fig. 21).

*g.* Izapa, Stela 5, redrawn from Norman 1973:Part 1, Pl. 10.

*h.* Izapa, Stela 50, redrawn from Norman 1973:Part 1, Pl. 50.

double scrolls, one on either side, designated as *d* (Fig. 4). This is shown as emerging from the mouth of a large serpentine head on Stela 3 (Fig. 1*b*). The first reaction here is to identify this element as simply a serpentine tongue complete with its bifurcated elements. A close look at Stela 20, however, demonstrates that aside from the usual J forms directly below the upper diagonal bands there is an extension of the unit described above (Fig. 4*g*). It is actually an extension of the top-line design; it is literally an invasion of the narrative scene.

"Naturalistic" representations of a bifurcated tongue do not contain the central element *c* or the rectangular element dividing the two J-like forms. Element *b* may be a U-shaped element. This is supported by the absence of this element from Stela 20. Regardless of whether this is the U element usually seen in top-line designs, the significant thing is that the appearance of this same unit emerging from the mouth of the serpentine figure in Izapa Stela 3 signals the suppression of the lower part of the top-line design (Fig. 1*b*). The same thing happens on Stela 23 in which a similar motif is represented: bodiless heads and "tailless" serpents.

Other examples of the compound serpentine bifurcated tongue with possible feline references are found on Kaminaljuyu Stela 11. It is used as a loincloth shown emerging from the mouth of a long-lipped head worn at belt level (Fig. 4*f*); it is also attached to the ear plug worn by the large figure on this stela (Fig. 4*h*). Crossed bands in this case may be a reference to the serpent. It is worn as a loincloth by the Stela 4 figure and by the figure represented on the Leiden Plate (Fig. 3*a*, 4*i* and *j*). In the latter piece, crossed bands are placed within element *a*, an inverted U element is placed within a cartouche in the element *b* position and elements *c* and *d* are exactly the same.

This very brief survey of the iconographic programs demonstrates that there is a fascinating amalgamation of recurring elements leading to the articulation of several compound creatures in Izapan-style monuments. The basic elements are parallel and double-opposed diagonal lines, U elements, crossed bands—all associated with compound creatures comprised of varying dosages of feline, serpentine, and possibly saurian characteristics. These may be readily recognized as polymorphic units. At other times they are so completely abstracted that relationships are difficult to establish. They may be found in top- and base-line designs and sometimes incorporated into the attire worn by figures represented within narrative scenes. Because similar elements are associated with apparently different compound creatures placed in various parts of the stelae, it is difficult to assign a specific meaning to each of these elements. The double-opposed diagonal bands, for instance, may appear as an unvarying indispensable unit of Izapan style top-line designs and on occasion will also appear at the base-line, although the latter is rare. They are found within two examples of the collar-type of base-line design seen on Stelae 4 and 18. They also form an integral part of the recognizable terrestrial dragon seen on Bilbao Monument 42 (Fig. 5*e*). Plain diagonal bands going in one single direction are more common. These are also associated with long-lipped heads.

The collar designs with double opposed diagonal bands and the highly abstracted long-lipped heads placed at base-line are variations on the terrestrial dragon. In the Izapan examples, the entire head defines the narrative frame—these are the top and base-line designs. So, initially, the reference is to the head as a point of reference for actions depicted on the stelae with the narrative frame possibly representing the open mouth of the creature. Later these references are abbreviated, as on Bilbao Monument 42. The elements seen earlier with top- and base-line design context are now incorporated into a single representation placed at base-line. Another good example is the base-line design seen on Abaj Takalik Stela 3. The bearded feline creature represented on Chiapa de Corzo Bone 1 may be the same creature represented on most of the Izapa stelae. Although in all of these stelae the reference is to a creature with very strong feline characteristics, serpentine traits are also present.

## DOUBLE-HEADED COMPOUND CREATURES AND WINGED FIGURES

A clue to the possible meaning of the feline and serpentine references on these pieces may be found on Kaminaljuyu Stelae 19 and 4 (Quirarte 1973: Fig. 11*a*). A bearded feline shown on Stela 19 holds a double-headed serpent above his head (Fig. 1*d*). A realistically portrayed serpent head is seen at one end and a scroll-eyed head with strong feline traits is seen at the other. The scroll-eyed head is shown upside down and is attached to the tail of the serpent. An identical scroll-eyed head is held by the figure depicted on Kaminaljuyu Stela

4. The major changes are the three scrolls flowing downward and attached to the bottom of the head. The head now appears to be severed from the serpent body. Both compound figures are practically identical. Small serpents are tied around the ankles and at the upper part of the thigh. Both wear identical notched wings seen to the left at waist level. Stela 19 figure wears diagonal bands prominently displayed within broadly framed cartouches on legs, forearm, hat, and stylized eyebrow.

Another winged feline creature, now sky bound shown on Stela 64 (Fig. 5h), is vigorously pulling on a serpent body emerging from the rib cage of a large skeletal figure. A blind head is seen in the upper left side of the stela and another is attached to the body of the serpent directly below the flying figure. An identical blind head is seen in the lower left-hand side of Stela 3 directly in front of the large serpent discussed above.

The scroll-eyed head is seen at base-line on Stelae 1 and 23 (Fig. 1a). The inward-facing heads appear to be the source of the water with fishes swimming in it on Stela 1. The same arrangement on Stela 23 with the added continuous scroll band with blips brings it closer to the Medellín, Veracruz yoke. Another scroll-eyed head is seen on El Baul Stela 1, attached to the back of the striding human figure (Fig. 1e). This scroll-eyed head is extended upward and definitely associated with innumerable scrolls that finally encompass a bracketed element with double opposed diagonal bands placed in the upper portion of the stela. This frames a downward-peering head. This may be the "head" of the compound double-headed serpentine-feline creature. The human head would therefore be shown emerging from or placed under the protective cover of the mouth of the compound creature. Abaj Takalik Stela 2 may be another example of this motif (Quirarte 1973:Fig. 1k).

The downward-peering head is a curious phenomenon. It is difficult to determine whether the head represented on El Baul Stela 1 has the closed eye of death. It does seem to occur on Abaj Takalik Stela 2. Although it is tempting to read these heads as references to deities, I am more inclined to interpret them as references to lineage and therefore related to secular power. If a relationship between these heads and their appearance on later Maya stelae can be established, then we can be more reasonably sure that this is so.

How are these polymorphic units to be analyzed? Where and how are the patterns to be established? Are all double-headed compound creatures related? Are these in turn related to the sky bound winged figures? They all share some traits. The elements discussed above are found in all of them—U shapes, diagonal bands, crossed bands, and a few others that have not even been discussed here. It is also unclear how the compound creatures relate to the top-line and base-line designs seen in most of these stelae. It is apparent that some of the compound creatures may form the basis for designs framing the narrative scenes on all of these stelae. The concept of the open mouth is not carried over into Maya sculpture in precisely this fashion, although the stela-altar complex does bear some relationship to Izapan-style antecedents. The open mouth of a compound creature is as old as the Olmec culture. It is retained in the Izapan area and it crops up during the Classic period in some parts of the Maya area in the well-known temple entrances identified as the mouth of a large compound figure found in Chenes architecture. These may represent conceptual rather than formal survivals.

Other conceptual survivals must be found within the double-headed compound creatures and their relationship to the flying figures bearing similar traits. A key motif in the configuration of the double-headed compound creatures is the scroll-eyed head used as a tail on Kaminaljuyu Stelae 19 and 4. Variations on the same head designated as "blind" in this paper are found on Stelae 3 and 50 (Fig. 5h). A bearded feline creature with wings is involved with the double-headed compound creature in all cited examples except Stela 3 (Fig. 1b). The latter appears to have a closer relationship to the serpentine end of the scale for he has a small bifurcated tongue placed at the end of his long upper lip. An identical bifurcated tongue is seen on the first level stuccoed heads of Uaxactun Structure E-VII Sub (Fig. 1c). To complicate matters even further, we find that the profile view of this head bears some striking resemblance to the regular scroll-eyed heads depicted here. This and so many other examples indicate a puzzling interchangeability of traits. First a creature appears under one guise and then in the next moment under another, while another comes on stage with the earlier creature's apparel. Not only is there an amalgamation of traits within independent units but there appears to be some

interrelationship between their appearance in narrative scenes and in the frames for these.

There are none of the usual elements directly associated with any of the double-headed compound creatures reviewed so far. The exception may be the representation of possibly the same creature on El Baul Stela 1 (Fig. 1e). The scroll-eyed head is shown as an intermediary between the human figure placed within the narrative frame and a human head placed in the upper zone of the stela. I have interpreted the protective bracket with double opposed diagonal bands as the head of the serpent-saurian creature. If this is so, then this represents the earliest occurrence of a detached head emerging from the mouth of a double-headed compound creature. We could carry this reading further and say that this polymorphic unit literally attached to the back of the human striding figure lends some authority to him and may indicate either a title or his place in that society. This may be ancestral to the power-conferring ceremonial serpent bars carried at chest level by figures represented in Maya stelae. The same line of reasoning could just as easily lead us to speculate on the possible origin of the equally important mannequin scepter held by many figures represented in Maya stelae. The realistically portrayed serpent head—usually represented as an extension of one of the mannequin scepter's legs—is also seen at one end of the upraised compound creature represented on Kaminaljuyu Stela 19 (Fig. 1d). The feline references can be found at the other end of each example.

What special powers do these polymorphic units confer upon the wearer? The feline serpentine reference may be found in the loincloth worn by these figures as on the Leiden Plate. This same figure carries the double-headed compound creature or more properly identified as the ceremonial serpent bar. Later Maya pieces demonstrate that a mannequin scepter is held in one hand by secular leaders. Other Maya figures wear back ornaments that are comprised of avian, feline, and serpentine traits. These are the celestial dragons that appear on the upper portions of relief sculptures (back of Copan Stela H; Tikal Temple 4, Lintel 3; Palenque House E; and others).

Another slightly more complicated double-headed compound creature is represented on the Chiapa de Corzo carved femurs. The feline-serpentine references are still there but crocodilian traits are added. The creature sprouts crocodilian

claws at both ends on Bone 1 and at only one end, presumably the head, on Bone 3 (Fig. 2a and c). Plant forms are depicted as growing out of or attached to the head of the feline "tail" on Bone 3. The same creature may be represented on a celt from La Venta listed by Joralemon (1971:Fig. 183) as God IIE or a maize god. In Chiapa de Corzo Bone 1 one of the heads is a bearded feline while the other is comprised of a saurian creature (Fig. 2a). The double brackets placed within the upper lip and directly beneath the eye of the saurian head are also seen in the top-line design and on the serpentine-feline bodies used as a frame on Stela 12 (Fig. 2e). The same creature is used in a similar fashion on Stela 5 (Fig. 5g). Plants sprout from the compound creature heads in both stelae. The saurian creature, represented as if seen from above, accompanies the two-headed creature represented on Chiapa de Corzo Bone 3 (Agrinier 1960:Fig. 9).

It may be possible that the Chiapa de Corzo Bone 1 figure is related to the downward-flying figure shown on Stela 4 (Fig. 3a). The bearded head seen on Chiapa de Corzo Bone 1 has a bunlike hat and a small three-element unit directly above his forehead (Fig. 2a). Agrinier (1960:8) points out that the jaguar figure with arms and claws similar to those on the feet of Kaminaljuyu Stelae 4 and 19 seems to be moving upward and indeed there seems to be some relationship between these upward-moving jaguar figures and those shown on Stelae 2 and 4 (Fig. 3a and b). The flying figure on Stela 4 wields a weapon as does the human striding figure shown in the narrative scene standing on the feline creature's collar. Both figures wear crossed bands under their arms. Diagonal bands and jaguar fangs comprise the loincloth worn by the human figure while the U element is used in lieu of these in the loincloth of the flying figure.

*What ties the downward-flying figure of Stela 4 to Kaminaljuyu Stela 19 and Chiapa de Corzo Bone 1 is a triangular-shaped element seen in all three* (Figs. 2a, 3a and d). This element is missing in the flying figure on Stela 2. He also does not wield a weapon and has clawlike extensions on the outer portions of his outstretched wings. He is not bearded although he does have the same element on the uppermost part of his headdress which is seen on the headdress of Chiapa de Corzo Bone 1. This is carried over into the downward-peering long-lipped head seen in the upper portion of

Kaminaljuyu Stela 11 (Fig. 3e). This head has the diagonal bands inscribed on it. Attached to the head is a unit that may be an abbreviated form of the outstretched wings. Crossed bands are placed inside it and a U element directly beneath it within a stylized eyebrow. An even more abbreviated reference to these compound creatures with U elements, crossed bands, and diagonal bands is worn as a belt with attached pendants by the figure depicted on Bilbao Monument 42 (Fig. 3c). Other downward-peering heads are found on Tikal Stelae 29 and 4 (Fig. 3f) and possibly the complicated downward-peering head shown on Tikal Stela 31 (Quirarte 1973:Fig. 13h and i).

## T-SHAPED ELEMENTS

There is one other element associated with the Izapan-style monuments that has not been discussed: the double oblique opposed T's inscribed on the forehead of the bearded feline head depicted on Chiapa de Corzo Bone 1 (Fig. 2a). The same element is extended and placed on either end of the upper portion of the collar worn by this creature. The T element is represented several times on the snout and in the eyebrow of the saurian half of this compound creature. It is also represented within the cartouche placed in front of and above the bearded feline head depicted on Kaminaljuyu Stela 10 (Fig. 2b). The same creature may form the basis for some of the base-line designs discussed above. An example is found on the base-line design of El Baul Stela 1 (Fig. 5c).

The same element is associated with long-lipped heads found in the Izapan area. Kidder (1946) found a stuccoed and painted subhemispherical black bowl in Kaminaljuyu Burial I that has a long-lipped head painted three times on the walls of the vessel (Fig. 5a). The head bears a striking resemblance to Kidder's Serpent X except that aside from the U element placed in the supraorbital area the double oblique opposed T-element is placed within a cartouche on top of the long lip (Fig. 5b). This element is also found in other parts of Mesoamerica. The Zegache vase (Oaxaca) is probably an early representation of the same creature discussed above. The T element is found on the cheek area as well as above the eyes (Fig. 5f).

The parallels between Izapan and Maya examples may be found in the use of the double T element. Among the identifying features of the Maya rain deity is a T element placed in the eye of

the deity's name glyph (T-668) and repeated back to back on the affix (T-103). This affix is like a small bundle comprised of the oblique double opposed T elements (Fig. 5d). It could be that the terrestrial sphere is symbolized by this affix. In this respect the Izapan-style examples cited here are ancestral to the later Maya God B or the rain god.

## SUMMARY

I have tried to show how the Olmecs, Izapans, and Maya participated in related traditions, each arriving at different formal and thematic solutions to basically similar world views. In a way it is discouraging to find that so much of what has been reviewed here ends up being related in one way or another with a feline bearing serpentine and/or saurian attributes.

1. A feline-serpent figure appears on most stelae as the open mouth or frame for the narrative scenes. Antecedents for these top- and base-line designs are found in Olmec monuments. Sometimes the serpentine features are extended into the narrative portions as on Stelae 19 and 20.

2. A related creature with added crocodilian traits is used as a frame on Stelae 5 and 12. It also appears in the top- and base-line designs on both stelae. The same creature is depicted on Tres Zapotes Stela C and on Chiapa de Corzo Bone 1.

3. In several examples the entire feline-serpent-saurian reference is contained in an abbreviated top-line design, comprised of a U element and double opposed diagonal bands.

4. The suppression or exclusion of the lower-most elements of the top-line designs—bifurcated serpent tongue—signals the inclusion of a double-headed serpent within narrative scenes as on Stelae 3 and 23. A scroll-eyed head is sometimes attached to the tail of this serpent as on Kaminaljuyu Stela 19. Perhaps the same motif is intended on El Baul Stela 1 with the scroll-eyed head attached to the back of the human figure being the tail of a multiscrolled serpent that has as a termination the double opposed diagonal bands serving as a protective cover for the downward-peering head.

The relationship of Izapan units of meaning to those found in the Maya area has barely been scratched.

5. The downward-peering heads of the Early Classic monuments are reminders of an Izapan tradition.

6. The U element, diagonals, and crossed bands appearing in figural and glyphic contexts are faint echoes of an Olmec and Izapan tradition.

7. Antecedents for the Maya Serpent Bar and possibly the Mannequin Scepter are the double-headed compound creatures found in Izapan-style monuments.

8. Not as directly related is the ubiquitous bird-serpent-feline creature or Celestial Dragon found throughout the Maya area, worn as back ornaments and often on the upper portions of sculptured panels.

9. And, finally, the T element as a terrestrial symbol is associated with one aspect of the later Maya God B, a rain deity.

## Notes

1. Izapan-style art is named after the Mexican site of Izapa near the Guatemalan border and applied to works of art found primarily in the Chiapas-Guatemala highland and Pacific slope sites.

2. Whenever a stela is identified by number only, the reference is to the monuments found at the site of Izapa.

3. As in all references to specific animals in Izapan-style art the identification of this creature primarily as a serpent is used for purposes of classification only. Serpent is used because it appears to have been the model for at least the body and head of a creature that had saurian characteristics as well. This creature, often used to symbolize the earth in Izapan style monuments, is probably related to the later terrestrial dragons found throughout Mesoamerica.

## References

Agrinier, Pierre
1960    The carved human femurs from Tomb I, Chiapa de Corzo, Chiapas, Mexico. *Papers of the New World Archaeological Foundation 6, New World Archaeological Foundation, Orinda, California*, Pub. 5.

Bernal, Ignacio
1969    *The Olmec world*. University of California Press, Berkeley and Los Angeles.

Caso, Alfonso, and Ignacio Bernal
1952    Urnas de Oaxaca. *Memorias del Instituto Nacional de Antropología e Historia 2.* Mexico.

Coe, Michael D.
1957    Cycle 7 monuments in Middle America: a reconsideration. *American Anthropologist* 59:597-611.
1965    The Olmec style and its distribution. *Handbook of Middle American Indians*, edited by Robert Wauchope and Gordon R. Willey, 3:739-775. University of Texas Press, Austin.
1968    *America's first civilization*. American Heritage Publishing Co., in association with the Smithsonian Institution, New York.

Coe, William
1962    A summary of excavation and research at Tikal, Guatemala: 1956-1961. *American Antiquity* 27:479-507.
1965    Tikal. *Expedition* 8(1):5-56. University Museum, University of Pennsylvania, Philadelphia.

Covarrubias, Miguel
1961    *Arte indígena de México y Centroamérica.* Universidad Nacional Autónoma de México, Mexico.

Drucker, Phillip
1952    *La Venta, Tabasco: a study of Olmec ceramics and art. Bureau of American Ethnology, Bulletin 153.*

Ekholm, Susanna M.
1969    Mound 30a and the Early Preclassic ceramic sequence of Izapa, Chiapas, Mexico. *Papers of the New World Archaeological Foundation 25.* Brigham Young University, Provo, Utah.

Greene, Merle
1967    *Ancient Maya relief sculpture*, Introduction and notes by J. E. Thompson. Museum of Primitive Art, New York.

Heizer, Robert F.
1967    Analysis of two low relief sculptures from La Venta. *Studies in Olmec archaeology, Contributions of the University of California Archaeological Research Facility* 3:25-55. Berkeley.

Joralemon, Peter David
1971    A study of Olmec iconography. *Studies in Pre-Columbian Art and Archaeology 7.* Dumbarton Oaks, Washington.

Kidder, A. V., H. D. Jennings, and E. Shook
1946    Excavations at Kaminaljuyu, Guatemala, *Carnegie Institution of Washington, Publication 561.*

Kubler, George
    1969    Studies in Classic Maya iconography, *Memoirs of the Connecticut Academy of Arts and sciences* 18. New Haven.

Lowe, Gareth
    1965    Desarrollo y Función del Incensario en Izapa. *Estudios de Cultura Maya*, Universidad Nacional Autónoma de México: Seminario de Cultura Maya 5:53-64.

Miles, Suzanna W.
    1965    Sculpture of the Guatemala-Chiapas Highlands and Pacific Slopes, and associated hieroglyphs. In *Handbook of Middle American Indians*, edited by Robert Wauchope and Gordon R. Willey 2:237-275. University of Texas Press, Austin.

Norman, V. Garth
    1973    Izapa sculpture, part 1: album. *Papers of the New World Archaeological Foundation* 30. Brigham Young University, Provo, Utah.

Paddock, John
    1966    Oaxaca in ancient Mesoamerica. In *Ancient Oaxaca*, edited by John Paddock, pp. 87-242. Stanford University Press, Stanford.

Parsons, Lee
    1967    An early Maya stela on the Pacific Coast of Guatemala. *Estudios de Cultura Maya*, Universidad Nacional Autónoma de México: Seminario de Cultura Maya 6:171-198.

    1969    Bilbao, Guatemala: an archaeological study of the Pacific Coast Cotzumalhuapa Region, vol. 2, *Publications in Anthropology* 12. Milwaukee Public Museum, Milwaukee.

Pijoan, José
    1958    *Summa artis. Historia general del arte, vol. X. Arte precolombino, Mexicano y Maya.* Tercera edición. Espasa-Calpe, Madrid.

Proskouriakoff, Tatiana
    1950    A study of Classic Maya sculpture. *Carnegie Institution of Washington, Publication* 593.

    1968    Olmec and Maya art: Problems of their stylistic relation. In *Dumbarton Oaks Conference on the Olmec, October 28th and 29th, 1967*, edited by Elizabeth P. Benson, pp. 119-134. Dumbarton Oaks Research Library and Collection, Washington.

Quirarte, Jacinto
    1973    Izapan-style art: a study of its form and meaning. *Studies in Pre-Columbian Art and Archaeology* 10. Dumbarton Oaks, Washington.

Ricketson, Oliver G., Jr., and E. B. Ricketson
    1937    Uaxactun, Guatemala, Group E, 1926-1931. *Carnegie Institution of Washington, Publication* 477.

Stirling, Matthew
    1943    Stone monuments of southern Mexico. *Bureau of American Ethnology, Bulletin* 138.

Thompson, J. Eric S.
    1943    Some sculptures from southeastern Quetzaltenango, Guatemala. *Carnegie Institution of Washington, Division of Historical Research, Notes on Middle American Archaeology and Ethnology*, 17:100-112.

    1962    *A catalogue of Maya hieroglyphs.* University of Oklahoma Press, Norman.

    1972    *Maya hieroglyphs without tears.* The British Museum, London.

# Olmec-Maya Relationships:
# Olmec Influence in Yucatan

L. R. V. JOESINK-MANDEVILLE
and SYLVIA MELUZIN

Department of Anthropology
California State University, Fullerton

The sherd illustrated in Figure 1 is an anthropomorphically modeled vessel rim stemming from the Nebanche[1] ceramic complex at Dzibilchaltun, the earliest complex known for this site.

This specimen is of the greatest interest owing to its uniqueness and its provenience and its reflection of an influence of the Olmec civilization in northwestern Yucatan during Middle Formative times (Fig. 2). This piece of evidence, numbered M-720-5 (Joesink-Mandeville 1968:Prelim. Fig. 139), was recovered from the fill of Structure 500 (Andrews 1962:Fig. 8c), one of the many Formative acropoli in the northwestern section of the Dzibilchaltun archaeological zone. This structure, an impressive acropolis begun during the Middle Formative, achieved its ultimate size before the close of the Late Formative.

This specimen is a well-modeled human face on the wide-everted rim of a small shallow dish. The dish if whole would measure about 11.5 cm in diameter at its rim. The overall feeling to the face is Olmec. The common head shape found on many La Venta stone figurines involves a broad, high forehead and a massive jaw (e.g., Drucker, Heizer, and Squier 1959:Pls. 33-36). The forehead on this face is rather low and small, but the Olmec feeling is there in the elongated face and the prominent jaw. The mouth lacks the Olmec were-jaguar snarl; it is more a frown or is at least downturned. There is a frown line in the forehead near the eye. On La Venta sculptures there is little or no space between the lower portion of the nose and the thick upper lip. We see the same style here. The lips are thick and the nose flat. The mouth, nostril, eye, and frown line on our specimen are accentuated by holes, pseudo drill holes. It would appear then that the elongated head, the jaw, lips, frowning or downturned mouth, nose, frowning brow, the holes, and flat profile are very Olmec.

But stylistic comparisons also show certain differences. In regard to the rendering of eyes, the Nebanche eye is a rounded protuberance, almost like an eyeball, with the pupil indicated by a hole. The eye is not a hollowed-out almond-shaped pit as in almost all La Venta stone

figurines. With respect to ears, none are shown on the Nebanche specimen. And finally, concerning the treatment of the forehead, we see that the frown is accentuated by a hole. Thus the treatment of the eye and the frown line is less typical of the Olmec style.

Further discussion seems warranted here concerning the detection of Olmec influence on art. M. D. Coe (1965:772) points out that the basic features of the Olmec style can be absent, but the "whole artistic feeling" of an art work may nonetheless reveal some Olmec influence or reveal it to be ultimately Olmec derived. In addition to an overall Olmec flavor and the particular traits mentioned, the specimen reveals that certain aspects of the Olmec art style, although not completely understood by the Nebanche artist, were nevertheless well handled in the modeling of the face on the dish rim.

A feeling for curved lines and rounded shapes is typical of Olmec art as is also the flattened face profile. Whether in the carving of a figure in the round or in the rendering of a profile, both of these attributes are apparent on the majority of examples. A skilled Nebanche artist would have had no problem in going one step further in modeling a vessel rim with a face and yet would have sacrificed nothing, simply because he was working in the Olmec style, which would be to his advantage in such an endeavor. It is difficult to prove beyond doubt the model the Nebanche artist used, whether it was art in the round, such as a figurine, or two-dimensional art, such as relief or incision on stelae or celts, or even decoration on an earplug where the profile has been drawn to fit into the curvature of the plug (Fig. 3). Covarrubias (1957:55) believed that the Olmecs did not appear to have developed different techniques for carving jade and modeling clay. He suggested that possibly clay modeling was a secondary technique to them, that jade carving was their primary technique. He postulated that in carving an Olmec face "strategic holes" were drilled "to establish the depressed areas" such as the mouth corners, the nostrils, the corners of the eyes, and, although less so, the ends of the eyebrows above

Fig. 1. A Nebanche vessel modeled in the Olmec style. (Redrawn from Joesink-Mandeville 1968, Middle American Research Institute.)

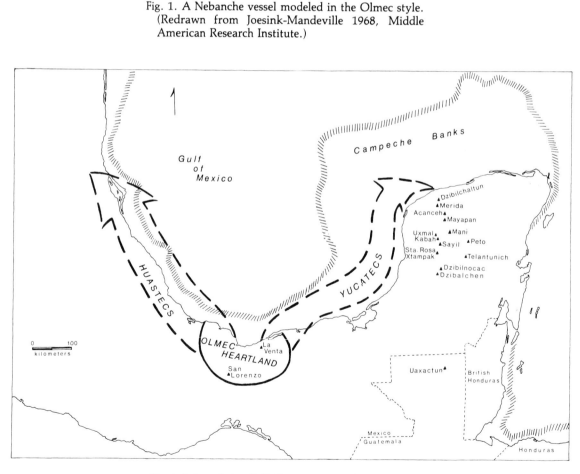

Fig. 2. Map of the Gulf Coast region, showing Olmec area and suggested paths of migration of the Yucatecs and the Huastecs. (Map by Sylvia Meluzin.)

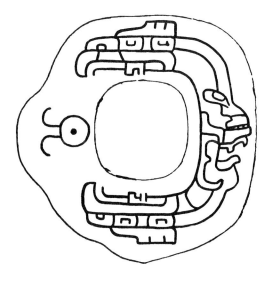

Fig. 3. Incised decoration on jade earplug from La Venta. (After *Mexico South: the Isthmus of Tehuantepec*, Covarrubias 1946:94, left; with permission of Alfred A. Knopf, Inc., copyright 1946.)

the nose (Fig. 4). The holes on the Nebanche specimen provide a major reason why we may infer that a stone figurine, an Olmec one, served as the model for the local artist. We reason thusly. Holes on Olmec pottery figurines are punctate holes that do not resemble drill holes, for the features thus made by these holes are not further modeled or shaped (e.g., Drucker 1952: Pls. 28*b*; 37*i*; 39 *left*, *c*; 40*a*). Drill holes on Olmec stone figurines tend only to accentuate the particular feature involved because the polishing of the stone to shape the features tends to

smooth down the hole and thereby lessen its prominence. Thus the Nebanche specimen is more similar to stonework pieces than to any of the Olmec pottery figurines because the holes appear to have been added only to touch up the features. The Nebanche holes are delicate, like the modeled-over holes on the stone figurines rather than like the blunt, gaping holes of the pottery figurines.

## CERAMIC AFFINITIES

The possibility of Olmec influence in Yucatan has until now been largely discarded by most interested investigators. Thus Bernal (1969:184) notes the apparent near absence of Olmec art and artifacts in Yucatan and assumes that Olmec influence, like Teotihuacán influence during the Early Classic, never penetrated Yucatan. He has concluded that while the Olmec civilization was truly *the* Formative culture to the various regional Classic period civilizations of Mesoamerica, Yucatan was excluded. But the Dzibilchaltun evidence suggests otherwise.

The modeling of this face on the M-720-5 vessel rim is especially useful to us in that, unlike a portable object or a colossal head, the Nebanche specimen occurs in a stratified context; the vessel type is a component of a ceramic sequence, thereby placing the Olmec influence in northwestern Yucatan more exactly in time. The vessel typologically belongs to the Nebanche complex, with respect to modal characteristics of form, slip appearance, and paste. The wide-everted rim is a variant of the Nebanche style of

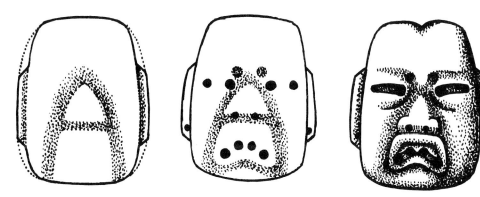

Fig. 4. Probable technique suggested by Covarrubias for carving an Olmec face. (After *Indian Art of Mexico and Central America*, Covarrubias 1957:Fig. 20; with permission of Alfred A. Knopf, Inc., copyright 1957.)

92          L. R. V. JOESINK-MANDEVILLE AND SYLVIA MELUZIN

rim, a key diagnostic of the phase's late facet. The "opaque" slip and fine-textured paste relate to Nebanche Red-orange-brown Thin-wall monochrome (Joesink-Mandeville 1968; 1970). And microscopic analysis of the sherd-tempered paste reveals nothing to suggest a nonlocal place of origin. This opaque slip is indeed indigenous to the northern area, probably having originated somewhere within the northwestern portion of this extensive region during Middle Formative times. We are therefore led to believe that this specimen was made either in the Dzibilchaltun vicinity or somewhere not too far afield during Late Nebanche times.

The affinity with the Olmec climax region of the Gulf Coast suggested by the art style of this modeled face is considerably reinforced by comparative analysis of Formative complexes in southern Mesoamerica wherein the Nebanche pottery was found to show close resemblances with Complex A ceramics at La Venta (Joesink-Mandeville 1970). These correspondences range from generic or modal resemblances to the level of type identification. Such ceramic counterparts include a common type of unslipped storage and cooking jar and well-burnished slipped or wash-covered wares in red, orange, brown, buff, and black. For example, certain specimens of excised Nebanche blackwares compare closely with La Venta Black Raspada. Correspondences also extend to certain modes of decoration and vessel forms, such as vertical unbridged spouts on gourdlike jars (Andrews 1968:40, upper figure; Joesink-Mandeville 1972:Fig. 1). There are indeed striking correspondences in slip and paste characteristics, vessel form, and decoration between Nebanche Red-orange-brown, including the thin-wall component to which the M-720-5 specimen pertains, and certain La Venta pottery. The same may also be said with regard to the buffwares of these respective complexes. There are even some La Venta specimens that could be sorted out from a Nebanche collection only with the greatest difficulty, if at all.

Fig. 5. Stone figure, "mujer de la culebra," at Kabah.
(After Andrews 1939:Pl. 2a-b; with permission of
Carnegie Institution of Washington.)

Many of the ceramic traits shared by the La Venta and Nebanche ceramic complexes also pertain to the list of modal traits often cited as evidence of Tlatilco-La Venta-Playa de los Muertos ceramic relationships (e.g., Porter 1953; Covarrubias 1957; Coe 1961). La Venta-Nebanche ceramic relationships, however, are more specific. Many of these correspondences are also shared with the Conchas 1 phase of the Pacific coast of Guatemala. We believe that these linkages with the Soconusco region are of the greatest significance, providing a topic for future discussion. But certain early traits present in the La Venta ceramic complex, such as rocker-stamping, the heavy unslipped *tecomates*, ceramic figurines, and the bottle form of jar (absent at Dzibilchaltun but reported elsewhere in Yucatan, e.g., Mani Cenote), are either absent in the Nebanche complex or occur but rarely, such as the filling in of incised grooves with red paint, the outlining of painted zones with grooving, and white-rimmed blackware. But at Dzibilchaltun we do find a counterpart to white-rimmed blackware in the highly distinctive Nebanche Red-on-black, wherein the buff rim was covered with red paint to make a rim band. The ceramic picture thus indicates that while the two ceramic complexes show considerable evidence of temporal overlap, the Complex A architectural-ceramic sequence of La Venta obviously began earlier than the Nebanche phase in northwestern Yucatan. Therefore, if we place the beginning of Complex A activities at La Venta (the Late Olmec type site) at about 800 B.C. then sometime between 700 and 600 B.C. would see the start of the Nebanche phase. The Nebanche 2 subphase would consequently begin by 450 B.C. and end at about 350-300 B.C. Dzibilchaltun's Formative absolute chronology is discussed at length elsewhere (Joesink-Mandeville 1970:317-318), as is also its relative chronology and comparative analysis with other Formative complexes and components in Yucatan and farther afield in southern Mesoamerica (Joesink-Mandeville 1970:199-302; 1973).

## OTHER EVIDENCE OF OLMEC INFLUENCE IN THE NORTHERN AREA

The uniqueness of the M-720-5 specimen cannot be overemphasized. No Formative figurines have been found at Dzibilchaltun. Nor have any identifiable Formative ceramic figurines been found elsewhere in Yucatan or the Chenes region, as far as we know. Nor can we find reference to any such figurines in the northern area in any of the works by the late George W. Brainerd (1951; 1958). The modeled face on specimen M-720-5 is thus the closest thing to a Formative figurine one can find at Dzibilchaltun. Moreover, M-720-5 is quite possibly the only known example wherein a human face modeled in the Olmec style adorns the wide-everted-rim top of a vessel.

It would be appropriate at this point to review what other evidence of Olmec influence has been cited for the Yucatan Peninsula, at least in the northern area. Of the portable objects there are the serpentinite were-jaguar found by Maler in 1887 at Dzibalchen (Metcalf and Flannery 1967), the green stone head from Mayapan (Smith and Ruppert 1953:Fig. 9c), and two stone figurines and one stone head purchased in Mérida for private collections (Kidder 1942:39d-f). Of the nonportable evidence there are sculptures from Telantunich, Kabah, and Sayil (Andrews 1939; Drucker 1952:224-225).

It would appear very likely, as Drucker (1952: 224-225) and Bernal (1969:184) have both suggested, that if any of the sculptures were related to Olmec art they would be in a very degenerate style. But we think this more so of the three monuments from Telantunich (Andrews 1939: Figs. 2 and 3; Pl. 1e) and the one from Sayil (Pl. 2c and d). The Kabah statue, called *mujer de la culebra*, "woman of the snake," (Fig. 5) should be considered apart from these others because it, a fairly good example of provincial art (provincial in regard to the Olmec region), does recall Monument 12 (Fig. 6), a not very good specimen of the Olmec style but nevertheless one recovered from La Venta itself, in the upper sand from the Ceremonial Court, A-1. This Kabah evidence consists of a stone human head, left arm and hand, upper part of right arm only, and the body from the waist up along with a snake. It now stands 1.34 meters high and apparently stood higher originally. There is a fluidity to the Kabah statue owing to its head shape and the undulating form of the snake. Even the arm has a bit of free form about its lines, and the face was carved far more skillfully than those on the Telantunich and Sayil sculptures. The elongated heads, especially with the

slightly bulging forehead, on the Kabah figure and on Monument 12 are very similar. We would therefore leave the question open as to whether the Olmec world had affected the Kabah sculpture. It may be indebted to Olmec thinking while Olmec civilization was still a dynamic, potent force, and distance (from Olmec regions) may account for the diluted Olmec feeling; or, both distance and time may have been responsible for the effect, because Olmec ideas had become only partially understood relics from an earlier age, as quite possibly is the explanation for these other four sculptures. We cannot prove the Kabah statue to be early but we do know that there was a Middle Formative occupation at the site (Brainerd 1958:Fig. 60a, 9-10, 12; Joesink-Mandeville 1970:209-210; Joesink-Mandeville 1973:Fig. 15). Iconographically the important element here is the appearance of a snake.

Of all the portable evidence, the Mayapan head (Fig. 7) is the only specimen other than M-720-5 recovered from a bona fide excavation. It measures 7.0 cm high by 6.5 cm wide and depicts an anthropomorphic face wearing earplugs and having a very pronounced classic Olmec mouth with rectangular, flaring upper lip, drooping lower corners, and toothless gums. Whether it is supposed to be human or divine is unclear, and therefore the subject matter is uncertain.

From the date of acquisition written on the Dzibalchen serpentinite figure (Fig. 8) we can be

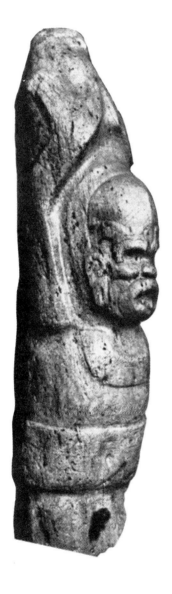

Fig. 6. Monument 12 from La Venta, a stone carving of a monkeylike figure. (After *La Venta, Tabasco: a study of Olmec ceramics and art*, Drucker 1952:Pl. 62a; with permission of Smithsonian Institution.)

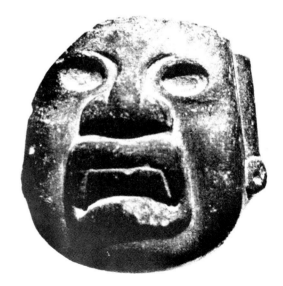

Fig. 7. Green stone face from Mayapan. (After Smith and Ruppert 1953:Fig. 9c; with permission of Carnegie Institution of Washington.)

reasonably certain that it did indeed come from Dzibalchen. It is a well-carved, reclining, feline body having a human face with its gaze thrust upward. It measures 21.6 cm long with a maximum width of 8.2 cm and a total height of 8.7 cm. Flames rise from its eyebrows and its full-lipped mouth is downturned at the corners. We are obviously dealing here with a true were-jaguar concept.

Of the three specimens in private collections, the figurine head (Fig. 9), so much like the jade and serpentine figurines from La Venta (Drucker 1952:Pls. 47, *3*; 49; 50, *8*, *9*; Drucker, Heizer, and Squier 1959:Pls. 33-36), quite possibly came from the Olmec heartland although whether in ancient times or quite recently cannot be ascertained. Kidder (1942:36-37) believed the figurine (Fig. 10) said to have been found near Peto could very well have come from there since there is no well-known ruin in the area and therefore no famous name purposely evoked to enhance the piece in the eyes of any prospective buyer. It is an anthropomorphic figure holding between its hands a rectangular panel with the Saint Andrews cross on it. There are two attachment holes at the back of the neck. The face shows a definite Olmec style, especially in regard to its mouth, face shape, and oval eyes. The headdress-helmet may reveal an incised maize symbol, thereby depicting Joralemon's God II, a maize deity (Joralemon 1971:59), or else the head ornament may actually be a head-band along with plain ear covers, thus recalling the dwarf Olmec deity, Joralemon's God IV (1971:71). It is difficult to determine accurately any ear covers because of the nature of the published drawing. The third specimen (Fig. 11) is a little figurine with a neckless head on a stumpy body with no hands shown on the arms and its legs tucked under the body. This figurine also has two attachment holes like the Peto example. There possibly may be a flattened headdress indicated. The "hand"-arm position and the face with its drill holes are reminiscent of the Olmec style. No place of origin is noted. In light of M-720-5, however, it is quite possible that this piece did originate in Yucatan. One of the notable differences between the Olmec style and the one evident on the Nebanche face is the treatment of the frown accentuated by a pseudo drill hole. It is interesting that on this little figure above the nose and between the eyes (because of

the lack of a forehead) there are two prominent holes, appearing not to belong to the eye outlines and yet not accentuating any other feature, as do the other holes on this head. These two holes are as evident as the frown line hole on the ceramic M-720-5 face and seem, as with M-720-5, to have been added for an effect whose purpose was apparently unclear in the mind of the carver. Nothing can be said with certainty about the significance of the subject matter of this specimen and the M-720-5 face.

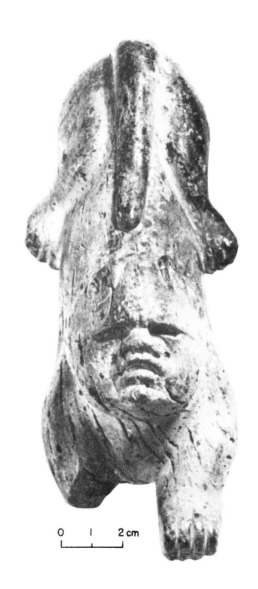

Fig. 8. Serpentinite figure from Dzibalchen, Campeche. (After Metcalf and Flannery 1967:Fig. 1; with permission of the Society for American Archaeology.)

## ETHNOLOGICAL SIGNIFICANCE

Swadesh's (1953) pioneering research in glotto-chronology suggests that the Huastecs left the Maya heartland, that is, split off from the main Mayan stock, around 3,200 years ago.[2] Apparently they did so before the Olmec civilization emerged during the Early Formative with the rise to prominence of San Lorenzo. So also the Yucatan peninsula was peopled by groups of Yucatecs from the Maya heartland or its periphery during the first half, if not the first quarter, of the first millennium B.C. But while the Huastec area is so situated as to be easily inundated by non-Maya elements from the adjacent highlands during post-Formative times the Yucatec area is isolated owing to its geographical position and was therefore not "incorporated" into a prominent political sphere imposed from without until Toltec times, with Classic Maya influence coming in only by nonforceful dissemination from the Peten. If the early Middle Formative (ca. 900-800 B.C.) saw the shift of importance from San Lorenzo to La Venta, then this is an appropriate time to hypothesize a dispersal of peoples eventually arriving in Yucatan. It has already been suggested that this interregnum was a time of dispersals and widespread migrations (Green and Lowe 1967). In very broad terms, especially when considering the dispersal of Huastecs and Yucatecs (and all the other Mayan-speaking groups), it would seem appropriate to view the Olmec heartland as the early Maya heartland rather than accept the

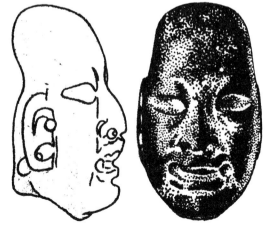

Fig. 9. Black stone head, purchased in Mérida, apparently broken from figurine body. (After Kidder 1942:39d; with permission of Carnegie Institution of Washington.)

widely held position favoring the western highlands of Guatemala (e.g., McQuown 1956; Coe 1966b:32). Such a view best satisfies both the existing archaeological data, including currently available radiocarbon determinations, *and* the linguistic evidence provided by glottochronology. By "heartland" we are of course referring to the district wherein the ancestral Mayan or Macro-Mayan[3] group first achieved a sustenance economy efficient enough to permit sedentary village life and the requisite population expansion to motivate concentration of economic and political power, which in turn presumably provoked military rivalries and dispersals from time to time. These conditions were obviously fulfilled shortly before the time of the San Lorenzo-Cuadros ceramic horizon; and the Huastec migration out of the heartland (ca. 1300-1200 B.C.) documents the initial period of political rivalry and dispersals immediately preceding the rise of the Olmec civilization. Thus there seems little doubt that the Olmec were a Mayan-speaking people, as previously suggested by W. Jiménez Moreno (1942a; 1942b), J. E. S. Thompson (1954:53), M. D. Coe (1962; 1968), and others.

Comparative ceramic analysis leads us to view the Yucatan Formative cultures as fitting a general Gulf Coast pattern, especially during the Middle Formative. Only the middle to late Middle Formative is known at Dzibilchaltun, but early Middle Formative is apparently present elsewhere in Yucatan, for example, Mani Cenote. This Gulf Coast pattern enveloped a broad ceramic sphere even though it apparently included great contrasts on the sociopolitical level, that is, the sophisticated Olmec climax area in the west and a series of relatively simple village-oriented communities in the east in Yucatan with much of the intervening region (Campeche) still remaining largely an archaeological blank with respect to the Formative.

Towards the end of Middle Formative times the Yucatan communities began the transformation into temple-oriented chiefdoms (e.g., Dzibilchaltun and Santa Rosa Xtampak) because of, we believe, direct Olmec stimulation. Let us not completely dismiss the Olmec because of lack of evidence; it is there, but appears very slowly, and, more important, has not been properly evaluated. The extreme reluctance of the Mayanists in the past to view the Olmec objectively has been discussed at length elsewhere (e.g., Coe

1968), and this conservatism (e.g., Thompson 1941)[4] made the topic of Olmec-Maya relationships an unnecessarily delicate issue.

Olmec contacts with Yucatan were most likely by the coastal waters of the Gulf of Mexico and therefore differed from the land and river routes to the Pacific. Journeys to the Pacific would have meant passing through other people's territory, but voyages to Yucatan on the Gulf could have very well involved little or no land contacts but merely a series of landings along the coast. It is now believed that Olmecs from the climax area traveled and traded all the way to the Pacific Coast and southwards at least as far as El Salvador. The Olmecs were most assuredly water-oriented, as rivers would have afforded the only means of travel in their frequently flooded rain-forest homeland. Their awareness of the Gulf (upon which their heartland bordered) and the neighboring areas adjacent to it and their skill in water transportation are seen in their transporting by water great stone masses such as the volcanic basalt from the Tuxtlas to San Lorenzo and La Venta. And, since the land

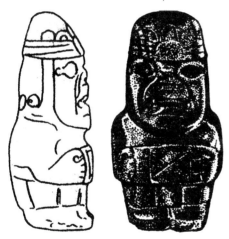

Fig. 10. Jadeite figurine, found near Peto, Yucatan. (After Kidder 1942:39f; with permission of Carnegie Institution of Washington.)

intervening between the climax area and Yucatan is very swampy and therefore not suited for overland explorations, it appears logical that curiosity towards the east would be satisfied by water travel. In addition, it is not unreasonable to suppose that the Olmec were aware of Yucatan long before it was peopled; they were most likely aware of the fishing off the Campeche Banks, which in turn would have led them to the peninsula and its coastal marine resources.

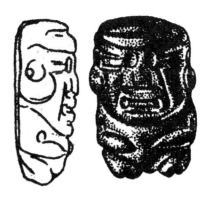

Fig. 11. Green stone figurine, purchased in Mérida. (After Kidder 1942:39e; with permission of Carnegie Institution of Washington.)

All of this could have involved fish for food, shellfish for food and shells to be worked, shark for food, oil, and teeth, and sting ray for the spine. Turtles would provide food and their shells could be put to many uses. It would seem then, as Lange (1971) has recently emphasized, that the position of Yucatan as a peninsula demands that its marine aspect be analyzed as much as its terrestrial realm. The gathering of the natural products of the peninsula would have involved more effort and time than fishermen could spend, and, therefore, most likely these resources were known to the Olmec only after the peninsula was settled later in the Middle Formative, thereby establishing a basis for communication between the peoples of the two regions. Natural resources such as copal and honey, feathers, and pelts would have most assuredly attracted Olmec traders. Salt, a common reason for later Postclassic traders to come to Yucatan, was probably more valuable to the Olmec as a trade item since their diet in a marine environment would have supplied a sufficient quantity. It is impossible at this time to know whether any cultural products of these relatively simple villagers, like cloth, could have interested the more sophisticated Olmec. It is worth noting that the most likely candidates as trade items from the natural wealth of the land all could have religious significance. And it is in the religious sphere with its sociopolitcal ramifications that the Olmec influence sparked a change in the complexity of Yucatan culture.

In making an impression on the Yucatan people (or at least some of them) of such magnitude as to stimulate them to begin temple mound

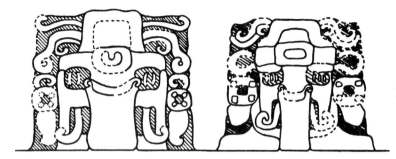

Fig. 12. Mask 17 (left) and Mask 18 (right) from E-VII-sub, Uaxactun. (After Ricketson and Ricketson 1937: Figs. 49a and 50; with permission of Carnegie Institution of Washington.)

building, with all its consequences, means that contact from the Olmec involved more than just one visit. An analogy might be drawn with the Viking fishermen and the Spanish explorers in their contacts with the New World. The Vikings certainly knew of the New World and visited it frequently for its marine resources; yet they apparently effected no changes upon the natives. In contrast, contact with the indigenous peoples by the Spanish explorers and trading missions, representing the government of western Europe's most powerful and closely-knit political state, was of such an order as to cause great, often drastic, change. We can assume that to effect this change in the sociopolitical fabric of the Yucatan villages of such intensity as to motivate the rise of chiefdoms, more than fishermen from the Olmec area were known to the Yucatecos. We can also assume that important emissaries were eventually sent out.

There appears to have been contact, therefore, during Nebanche times but little or no contact afterwards, as evidenced by the ceramic (and thereby inferred cultural) divergences developing between Dzibilchaltun and the Olmec Gulf Coast region during the Late Formative. This situation supports the thesis of political disintegration in the Olmec heartland, which of course would have caused the contacts to cease. The subsequent post-La Venta period (post-400 B.C.) was a time of new dispersals, but by peoples carrying more sophisticated ideas with them than the earlier waves from, or peripheral to, the Olmec heartland.

The late Chicanel E-VII-sub temple mound at Uaxactun (Ricketson and Ricketson 1937) reveals that the previous void of monumental art in the Peten was now being filled by ultimately Olmec-derived concepts. The stucco faces on the Peten-like pyramid at Acanceh (Seler 1911) also reveal

Olmec-derived ideas during these upheavals, thereby indicating an influence that this time quite possibly came by land from the south up into northern Yucatan. Similar to these two structures is the more recently excavated Chuen-Cauac Structure 5D-Sub. 1-1st at Tikal (Coe 1965). A very important feature common to these three temple-mounds is that very large stucco masks adorn the flanking terrace-facings within which the ascending stairway is slightly recessed. These masks apparently depict a composite creature.

In regard to the major theme of this symposium we would like to discuss a possible interpretation of the Uaxactun masks, specifically Masks 17 and 18 of the Upper Zone (Fig. 12), and the Acanceh (Fig. 13)[5] and Tikal (Fig. 14) masks. The usual description of the eighteen Uaxactun masks categorizes them as being either jaguar (or were-jaguar) or serpent. We prefer to go beyond this two-fold classification and believe a third entity is portrayed by Masks 17 and 18. Indeed they seem to reveal a man's head and face with

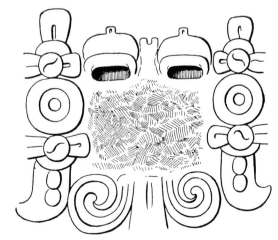

Fig. 13. Remains of one of the giant stucco masks at Acanceh. (From Seler 1911:Abb. 2.)

a mask on the lower portion, a duckbill mask similar to that on the Tuxtla Statuette (Fig. 15). Mask 18 is more important in our analysis than 17 since 18 clearly shows a head upon shoulders and therefore emphasizes the lengthy projection of the duckbill attachment. Mask 18 and the Acanceh mask appear more human than Mask 17 or the Tikal examples. Masks 17, 18, and the Acanceh faces have prominent ear ornaments and a curved fang at each corner of the mouth. The projection still remaining on the badly damaged Tikal specimens could have been a duckbill mask; the side of the faces where there could have been ear ornaments, however, seems to have been treated differently so as possibly to suggest an added attribute to the creature and/or priest portrayed. If the duckbill priest were intended in each case it is appropriate that, if only one deity was represented at Acanceh and Tikal, it was the same one that had the most important position at Uaxactun (at the top of the stairway). These structures, therefore, were probably especially important in this deity's (and priest's) rituals.

The Tuxtla Statuette shows such a priestly functionary during the early part of Cycle 8, in Izapan times, while in the classic Olmec period Altar 7 (Fig. 16) at La Venta could possibly have portrayed a man with a duckbill mask although the key area has been badly damaged. It is also interesting that on the reverse side of Altar 7

Fig. 15. Nephrite statuette, from San Andres Tuxtla, Veracruz. (From Morley 1956:Pl. 14a.)

another avian aspect, the predatory one, is represented by owls (Drucker 1952:182-184, Pl. 65a). Considering that calendrics for ritual and almanac purposes were making ever forward strides during Formative times and considering that many ducks are migratory, it would be quite appropriate that astronomical studies and the sighting of migratory, seasonal birds could have overlapped. The astronomical features of E-VII in relation to E-I, E-II, and E-III, all on the East Mound, were discussed in the first Uaxactun excavation report (Ricketson and Ricketson 1937:45, 105-109). One of the important points of observation was determined to be about fifteen feet up the stairway of E-VII; this was to clear the height of the opposite East Mound. It apparently was not discussed that this point, however, in addition to arbitrarily falling on a spot along the featureless E-VII stairway, also falls upon the stairway of the underlying E-VII-sub, approximately the upper half (in close proximity to Masks 17 and 18) and that the East

Fig. 14. Structure 5D-Sub. 1-1st at Tikal, showing masks unrestored. (From Coe 1965:Fig. 4; with permission of *Science*, copyright 1965 by the American Association for the Advancement of Science.)

Mound along with at least E-II and perhaps E-I and E-III were in existence during much of the time that E-VII-sub was in use (Ricketson and Ricketson 1937:137-138, Fig. 98d-e). Therefore, we believe that the astronomic and/or geomantic significance of Group E must originally date to this earlier period (Chicanel) and not be considered only in relation to E-VII of Early Classic times. This situation strengthens our hypothesis that the chief deity and priest-functionary of E-VII-sub was the duckbill-masked court-priest astronomer-astrologer. That the Acanceh and Tikal structures do not face east (but south) does not deter us from suggesting that the chief functionary was the duckbill-masked astrologer, who, even if he did not delve into calendrical observations, at least as the "court astrologer" was probably in charge of the sacred almanac.

Another example of nonportable art is found at the Cave of Loltun (Thompson 1897), namely the well-known ceremonially dressed figure carved in low relief at one of the entrances (Fig. 17). This figure is shown in the Izapan style that became dominant during the post-La Venta period. The inscriptions and pottery of this cave should be rescrutinized in light of our new understanding of Olmec-inspired art, especially in regard to caves (e.g., Grove 1970). For example, an intriguing sherd illustrated in the original cave survey (Thompson 1897:24, Pl. VII, Fig. 1h) was labeled as a "leg" and yet looks (from the photograph, at least) suspiciously like a vertical unbridged spout (here shown upside down) which is a Nebanche diagnostic, therefore hinting at cave use in Yucatan at a time even earlier than this carving.

Fig. 16. Altar 7 from La Venta. (After *La Venta, Tabasco: a study of Olmec ceramics and art*, Drucker 1952:Pl. 65b; with permission of Smithsonian Institution.)

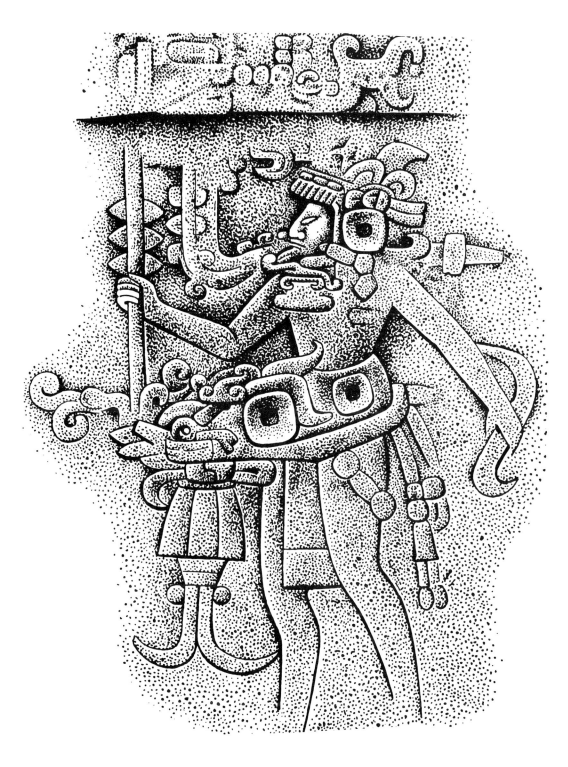

Fig. 17. Bas-relief on wall near one of the entrances to
Cave of Loltun. (After Proskouriakoff 1950:155;
with permission of Carnegie Institution of Wash-
ington.)

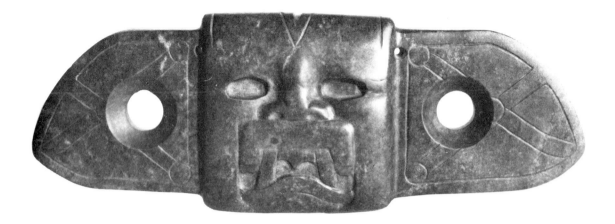

Fig. 18. Green quartzite pectoral, from Yucatan Penin-
sula. *Upper*, front; *lower*, back. (After Coe 1966:Figs.
1-2; courtesy of Dumbarton Oaks Collections.)

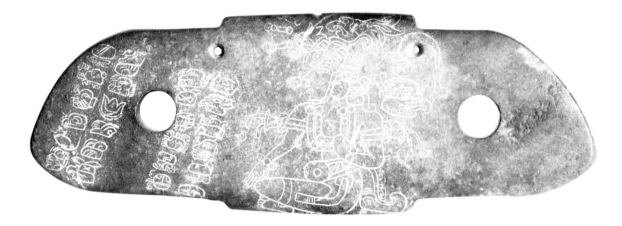

With a stone pectoral (Fig. 18) originally from a private collection and acquired somewhere in the Yucatan Peninsula, M. D. Coe (1966a) has shown that the object with its carved were-jaguar face and Saint Andrews crosses probably originated in late Olmec times and that, through further incised embellishment on the reverse depicting a costumed, seated figure along with twenty-four hieroglyphs, it continued in use through the post-Olmec and into the early Maya eras. Since Yucatan did indeed experience Olmec and Izapan influences, and especially in light of the Loltun Cave carvings, the Izapan-Maya style figure on this pectoral could very well have been incised somewhere in the northern Maya lowlands.

An attempt to label the peoples moving about during the post-La Venta upheavals is in fact a semantic problem compounded by our lack of sufficient evidence. What was classic Olmec had ceased to exist. What was to become Maya was yet to be. There are similarities in the situation in Mesopotamia when the Sumerian culture was being supplanted by the Akkadian culture, a slow but sure process, with the result that the Sumerian mark was definitely there (but had to be read by the trained eye) and for practical purposes this *identity* survived only as "Church Latin." The supposition that a feeling for the Olmec style had never completely died out but could later occasionally even reemerge rather

strongly may be demonstrated by the existence (Fig. 19) of a Tzakol phase wooden statue. The word Mesopotamian has meaning in a strict geographical and cultural sense, as does also Egyptian, for example. What would be an appropriate term in our case? Mesoamerican would connote too broad a meaning; "decadent Olmec-incipient Maya" best describes the transition in the Maya lowlands, exhibited as it is by the Izapan art style. That something as great as the Olmec civilization had been and that something as important as the Classic Maya culture (and other contemporaneous regional cultures) was to follow makes this transitional period vitally important in understanding the dynamics of Mesoamerican culture history.

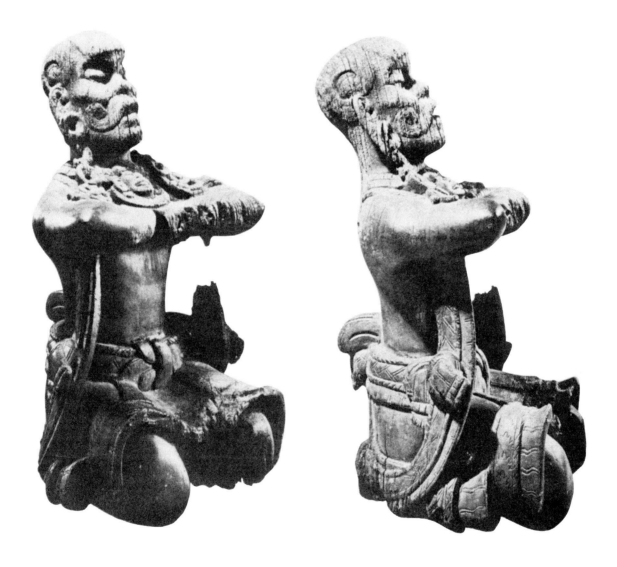

Fig. 19. Wooden figure, said to have come from border area of Tabasco and Guatemala. (After Ekholm 1964:6, right, and 7, left; with permission of Museum of Primitive Art; photographs by Charles Uht.)

## Acknowledgments

We wish to express our gratitude to the late E. Wyllys Andrews IV for permission to use the M-720-5 material. We are also particularly grateful to Clifford Evans and Kent V. Flannery in providing access to the Gulf Coast collections in the Smithsonian Institution in 1965. These collections, especially those from La Venta, Tabasco, provided the basis for the comparative analysis of ceramics summarized in this paper.

The material on the Nebanche specimen (M-720-5) which forms the nucleus of this paper was first presented at the 1971 meeting of the Southwestern Anthropological Association in Tucson (Joesink-Mandeville 1971).

## Notes

1. At the Guatemala City Conference on Lowland Maya Ceramics in 1965 E. Wyllys Andrews IV substituted names for the Roman numerals previously assigned by Joesink-Mandeville to the phases of the Dzibilchaltun Formative preliminary sequence formulated on incomplete analysis. Phase I was thus relabeled Zacnicte, roughly corresponding to the early facet of the Nebanche phase and complex in the final sequence.

2. We are aware that many present-day linguists do not accept the validity of glottochronology, and among those who do there are some who question the accuracy of Swadesh's (1953; 1960) reconstructions concerning the Mayan languages.

3. Here we are using the term in its earlier and narrower meaning (e.g., Wolf 1959:chap. 3).

4. But we must hasten to call attention to Thompson's (1970:269) current view wherein he now recognizes the Olmec heritage in the Maya "rain cult, with world color and directional features and with quadripartite deities deriving from or fused with snakes."

5. We do not agree with Fernández' restoration of the Acanceh faces (Marquina 1951:800, 802, Lám. 242). For our hypothesis we are working with the earlier rendering (Seler 1911) of the masks' remains.

## References

Andrews, E. Wyllys
  1939    A group of related sculptures from Yucatan. *Carnegie Institution of Washington, Publication 509.*
  1962    Excavations at Dzibilchaltun, Yucatan, 1956-1962. *Estudios de Cultura Maya,* Universidad Nacional Autónoma de México: Seminario de Cultura Maya 2:149-183.
  1968    Dzibilchaltun: a northern Maya metropolis. *Archaeology* 21:36-47.

Bernal, Ignacio
  1969    *The Olmec world.* University of California Press, Berkeley and Los Angeles.

Brainerd, George W.
  1951    Early ceramic horizons in Yucatan. In *The civilizations of ancient America,* edited by Sol Tax; Selected papers of the XXIXth International Congress of Americanists 1:72-78. University of Chicago Press, Chicago.
  1958    The archaeological ceramics of Yucatan. *University of California Publications, Anthropological Records* 19. University of California Press, Berkeley and Los Angeles.

Coe, Michael D.
  1961    La Victoria: an early site on the Pacific coast of Guatemala. *Papers of the Peabody Museum of Archaeology and Ethnology. Harvard University* 53.
  1962    *Mexico.* Frederick A. Praeger, New York.

  1965    The Olmec style and its distribution. In *Handbook of Middle American Indians,* edited by Robert Wauchope and Gordon R. Willey, 3:739-775. University of Texas Press, Austin.
  1966a  An early stone pectoral from southeastern Mexico. *Studies in Pre-Columbian Art and Archaeology* 1. Dumbarton Oaks, Washington.
  1966b  *The Maya.* Frederick A. Praeger, New York and Washington.
  1968    *America's first civilization.* American Heritage Publishing Co., New York.

Coe, William R.
  1965    Tikal, Guatemala, and emergent Maya civilization. *Science* 147:1401-1419.

Covarrubias, Miguel
  1946    *Mexico south: the isthmus of Tehuantepec.* Alfred A. Knopf, New York.
  1957    *Indian art of Mexico and Central America.* Alfred A. Knopf, New York.

Drucker, Philip
  1952    La Venta, Tabasco: a study of Olmec ceramics and art. *Bureau of American Ethnology, Bulletin* 153.

Drucker, Philip, R. F. Heizer, and R. J. Squier
  1959    Excavations at La Venta, Tabasco, 1955. *Bureau of American Ethnology, Bulletin* 170.

Ekholm, Gordon F.
  1964    A Maya sculpture in wood. *Museum of*

*Primitive Art, Studies* 4. Museum of Primitive Art, New York.

Green, Dee F., and Gareth W. Lowe
1967 Altamira and Padre Piedra, Early Preclassic sites in Chiapas, Mexico. *Papers of the New World Archaeological Foundation* 20. Brigham Young University, Provo, Utah.

Grove, David C.
1970 The Olmec paintings of Oxtotitlan cave Guerrero, Mexico. *Studies in Pre-Columbian Art and Archaeology* 6. Dumbarton Oaks, Washington.

Jiménez Moreno, Wigberto
1942a El enigma de los Olmecas. *Cuadernos Americanos* 1(5):113-145.
1942b Relación entre los Olmecas, los Toltecas y los Mayas, según las tradiciones. In *Mayas y Olmecas: segunda reunión de mesa redonda sobre problemas antropológicos de México y Centro América.* Sociedad Mexicana de Antropología, Tuxtla Gutiérrez.

Joesink-Mandeville, L. R. V.
1968 Formative stage ceramic types and their sequence at Dzibilchaltun, Yucatan, Mexico. Unpublished field report, Middle American Research Institute, Tulane University, New Orleans.
1970 *The comparative cultural stratigraphy of Formative complexes in the Maya area: a reappraisal in light of new evidence from Dzibilchaltun, Yucatan.* Ph.D. dissertation, Tulane University, New Orleans. (Ann Arbor, University Microfilms 71-8058.)
1971 The Olmec gulf coast region and northwestern Yucatan during the Middle Formative. Paper presented to the 1971 annual meeting of the Southwestern Anthropological Association, Tucson.
1972 The importance of gourd prototypes in the analysis of Mesoamerican ceramics. *Strata* 1:30-36; *Katunob* 8(3):n.p. (1973).
1973 Yucatan and the Chenes during the Formative: a comparative synthesis. *Katunob* 8(2): 1-38.

Joralemon, Peter David
1971 A study of Olmec iconography. *Studies in Pre-Columbian Art and Archaeology* 7. Dumbarton Oaks, Washington.

Kidder, Alfred V.
1942 Archaeological specimens from Yucatan and Guatemala. *Carnegie Institution of Washington, Notes on Middle American Archaeology and Ethnology* 9. Washington.

Lange, Frederick W.
1971 Marine resources: a viable subsistence alternative for the prehistoric lowland Maya. *American Anthropologist* 73:619-639.

Marquina, Ignacio
1951 Arquitectura prehispánica. *Memorias del Instituto Nacional de Antropología e Historia* 1. México.

McQuown, Norman A.
1956 The classification of the Mayan languages. *International Journal of American Linguistics* 22:191-195.

Metcalf, George, and Kent V. Flannery
1967 An Olmec "were-jaguar" from the Yucatan peninsula. *American Antiquity* 32:109-111.

Morley, Sylvanus G.
1956 *The ancient Maya.* (3d ed. revised by G. W. Brainerd.) Stanford University Press, Stanford.

Porter, Muriel N.
1953 Tlatilco and the Pre-Classic cultures of the New World. *Viking Fund Publications in Anthropology* 19. Wenner-Gren Foundation for Anthropological Research, Inc., New York.

Proskouriakoff, Tatiana
1950 A study of Classic Maya sculpture. *Carnegie Institution of Washington, Publication* 593.

Ricketson, Oliver G., and E. B. Ricketson
1937 Uaxactun, Guatemala, Group E, 1926-1931. *Carnegie Institution of Washington, Publication* 477.

Seler, Eduard
1911 Die Stuckfassade von Acanceh in Yucatan. *Sitzungsberichte der Königlich Preussischen Akademie der Wissenschaften* 47:1011-1025.

Smith, A. Ledyard, and Karl Ruppert
1953 Excavations in house mounds at Mayapan: II. *Carnegie Institution of Washington, Department of Archaeology, Current Reports* 10. Washington.

Swadesh, Morris
1953 The language of the archaeological Huastecs. *Carnegie Institution of Washington, Notes on Middle American Archaeology and Ethnology* 114. Washington.
1960 Interrelaciones de las lenguas Mayenses. *Anales del Instituto Nacional de Antropología e Historia* 13(42):231-267.

Thompson, Edward H.
1897 Cave of Loltun, Yucatan: report of explorations by the Museum, 1888-1889 and 1890-1891. *Memoirs of the Peabody Museum of American Archaeology and Ethnology, Harvard University,* 1(2). Peabody Museum, Cambridge.

Thompson, J. Eric S.
1941 Dating of certain inscriptions of non-Maya origin. *Carnegie Institution of Washington, Theoretical Approaches to Problems* 1. Washington.
1954 *The rise and fall of Maya civilization.* University of Oklahoma Press, Norman.
1970 *Maya history and religion.* University of Oklahoma Press, Norman.

Wolf, Eric R.
1959 *Sons of the shaking earth.* University of Chicago Press, Chicago.

# Early Steps in the Evolution of Maya Writing

Michael D. Coe

Department of Anthropology
Yale University

What sets off the Mesoamerican Indians from all other pre-Columbian peoples of the New World is their possession of writing, which has carried to its highest degree of refinement by the ancient Maya of southeastern Mexico and adjacent Central America. For almost a century, the study of the Maya script has been so synonymous with the analysis of their extraordinarily complex calendrical system that until recently there have been few attempts to work out the meaning and the decipherment of the noncalendrical texts on Maya monuments and in books.

Unfortunately, these attempts have suffered in that very few students of Maya writing have also been students of writing systems in general. They have tended, as did Sylvanus Morley (1946:259-260), to accept uncritically the a priori evolutionary scheme in the development of scripts put forward in the nineteenth century by E. B. Tylor. According to this theory, all such systems necessarily passed through a series of stages that began with pictographic or picture writing, followed by so-called ideographic scripts (with Chinese wrongly assigned to this category); these in turn were succeeded by phonetic writing, with syllabic first and alphabetic last. It has been the Soviet scholar Y. V. Knorosov (n.d.) who has correctly pointed out that all three of these so-called stages often coexist in the same script, as with Chinese and Egyptian writing.

Knorosov prefers to call these "mixed" systems *hieroglyphic*, and calls attention to some of their characteristics. First of all, in hieroglyphic writing there are *ideograms*, which denote words and thus have both phonetic and conceptual reference; it is unimportant whether these signs appear as realistic pictures of objects, stylized pictures, or conventional symbols. *Key signs* have only conceptual significance; these elements, called "radicals" in Chinese writing and "determinatives" in ancient Near Eastern writing, help narrow down ambiguity in signs that otherwise might have more than one reading. *Phonetic signs* in hieroglyphic scripts usually only approximately indicate the "true" reading, and

often are employed as phonetic complements: redundant phonetic indicators that also reduce ambiguity. And, finally, it is very common to find an *inversion of reading* for calligraphic purposes; this is quite usual for Egyptian, for instance.

Perhaps Knorosov's most important point is that the peculiarities of a particular hieroglyphic system are determined by the nature of the phonetics and morphology of the language being recorded. In Egyptian, for instance, the basic meaning of a word is given by the sequence of consonants, so one finds that vowels are generally absent in the script. In Maya, one finds a rather similar situation in what he calls "nonconsecutive synharmonism," with examples of parallel forms like *kikil* and *kikel*, both meaning "bloody." Therefore, he postulates that vowels are not always written in Maya and that vowels in syllabic signs might vary. This is an important component in the writing system that he has proposed for the lowland Maya, taking off from the famous "ABC" transcribed by the sixteenth-century Franciscan Fray Diego de Landa.

It can thus be expected that in the decipherment of the Maya script most or all of the foregoing traits of hieroglyphic systems will present themselves. In addition, Lounsbury (n.d.) suggests that extensive borrowing from one system and language into another might well occur on an early time level, leading to the use of several multivalued signs; this has happened over and over again in Mesopotamian writing systems, for instance.

Knorosov's theory that phoneticism in Maya writing coexists with ideographic and even picture writing has by no means been accepted by all students of the subject, although many, such as myself, believe that he is correct. It should be kept in mind that his system has been worked out using the Postclassic codices and is by no means demonstrated for the inscriptions of the Classic Period from A.D. 300 to 900, although there is some evidence in favor for it (i.e. a phonetic reading for the "capture" glyph as *chucah*).

The Maya script is but one of thirteen writing systems that can be detected in pre-Spanish Mesoamerica (Fig. 1). It is most closely allied with the Southern Veracruz system, from which it may have evolved. Long Count dating is confined to these two. Other scripts are those of Teotihuacan, Xochicalco, Huajuapan (sometimes called Ñuiñe), and Monte Albán, all of which are in some way connected with each other; the Borgia Group, known from ritual codices of the central Mexican highlands, and the related Mixtec writing of northern Oaxaca; Aztec in the Valley of Mexico and Cotzumalhuapa on the Pacific slope of Guatemala, both of which may be derived from the Borgia Group system; Toltec, which has a relation to Xochicalco, particularly in numeration style; and Tajín in Veracruz, known only from a few glyphs and possibly in the Borgia Group-Mixtec column. Most aberrant of all is the writing on Stela 10 at Kaminaljuyu, which seems unrelated to any other script.

All of these may be hieroglyphic in Knorosov's sense. Certainly, none of them are purely pictographic in Tylor's use of the term. All share a common calendar, based upon the permutation of a highly ritual 260-day count with a "Vague Year" consisting of 365 days, producing a 52-year Calendar Round. The similarity in the meanings of the sequence of twenty days within

the 260-day count and even of month names in the 365-day Vague Year suggests that this calendar is of high antiquity, probably predating the earliest known writing. Resemblances between specific hieroglyphs indicate some borrowing on a very ancient time level between the precocious Monte Albán script and whatever might be the ancestor of the Aztec script, on the one hand, and between Monte Albán and early Maya writing, on the other. Probably extensive loans may be detected on a much broader basis. It may be significant that the use of bar-and-dot numeration is universal.

## THE CLASSIC MAYA SYSTEM

We are concerned here with the writing of the Classic Maya and how it might have evolved. First of all, I would like to outline the elements of a "typical" Classic Maya inscription from the Central Area.

1. *Writing order.* The glyphs generally appear in vertical columns, and these are so lined up that the reading is from left to right and top to bottom, in pairs of glyphs.

2. *Initial Series.* The Initial Series is a date in the Long Count system in which glyphs for cycles including baktuns, katuns, tuns, uinals, and kins are given along with their numerical coefficients. This date is calculated from the base 13.0.0.0.0 4 Ahau 8 Cumku, a day in the year 3114 B.C. The Introducing Glyph has the T.125 superfix, "comb' affixes on either side, the patron god of the month infixed, and the tun sign. The Calendar Round date that follows gives both the day in the 260-day count (tzolkin) and the day in the 365-day count (haab). For this and any other Calendar Round dates the signs are in cartouches.

3. *Numeration.* Coefficients are expressed by bar-and-dot numeration, the bars appearing between the dots and the glyph. There is a quatrefoil sign standing for completion or zero. Head or full-figured variants may be used for coefficients.

4. *Supplementary Series.* This immediately follows the tzolkin position, and precedes the haab position. The first glyph is G, with nine variants in a series of Nine Lords of the Night, followed by Glyph F, which is probably a title of the Glyph G god. The succeeding glyphs are lunar, presenting information on the moon age, the position of this lunation in a series of six, and whether the lunation is of 29 or 30 days.

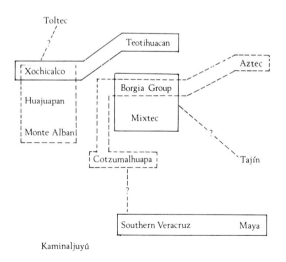

Fig. 1. Relationship between writing systems of Mesoamerica.

5. *Other calendrical information.* Other kinds of dates that may appear in an inscription are Period Ending dates, Distance Numbers (both positive and negative), Anniversaries, and points in a cycle of 819 days that is connected with colors and directions.

6. *Noncalendrical texts.* It is now generally agreed, following the discoveries of Proskouriakoff (1960) and Berlin (1958), that the content of Maya inscriptions is largely, although not entirely, historical. Passages have been identified on Classic monuments dealing with such matters as the birth, accession, and possibly marriage of the rulers of the Maya realm. Conquests are recorded and perhaps the death of these leaders. Emblem Glyphs are characteristic of the great centers, and might either be place names or lineage names. Many ritual activities such as bloodletting have been associated with specific action glyphs.

7. *Typology of the Classic Maya script.* Maya writing falls into Knorosov's hieroglyphic category, with some straightforward picture writing, many ideograms, and a degree of phoneticism. It is likely that many signs have multiple values. A highly distinctive feature of the Maya system is the employment of what Thompson (1950:37) calls main signs and affixes. Incipient affixing may exist in Monte Albán, and is surely present in the Southern Veracruz script, but it is taken to its highest degree of elaboration among the Maya. Functionally, affixing is probably employed to express ideograms (such as the colors), semantic determinatives, and phonetic information.

There can be little doubt that the Classic Maya writing system did not spring into being at once, but that it evolved as a result of individual innovations over a long period of time. It is therefore to be expected that the farther back one can trace this script the fewer Classic Period characteristics will be found and the more it will resemble the non-Maya scripts of Mesoamerica. There have been many attempts to work out the origin of the Maya calendar and writing system, such as those of Spinden (1924:152-163), Morley (1946:262-265), Jakeman (1947), Satterthwaite (1961), and Knorosov (1971); most of these are highly speculative, based not so much on archaeological information as upon internal peculiarities of the fully evolved system. For instance, both Jakeman and Knorosov postulate an original lunar calendar from the importance of the lunar calculations on the Classic monuments and from the

names used for the 20-day months. I would like to adopt another approach, namely that of examining inscriptions that surely date from the Formative Period (ca. 1500 B.C.-A.D. 250) or to the very first centuries of the Early Classic so that some sort of an evolutionary scheme, however fragmentary, can be worked out.

## THE OLMEC CIVILIZATION

Although once a totally heretical point of view, it has now become a dogma that Maya writing and calendar were actually originated by the Olmec of southern Veracruz and Tabasco during the Formative Period. It may come as a surprise to some that there is little or no evidence for this. If writing always conforms to a written language, then quite probably the Olmec were illiterate or preliterate. During the Early Formative phase (1200-900 B.C.) of Olmec civilization, and in the succeeding Middle Formative phase (900-400 B.C.) when La Venta had replaced San Lorenzo as the most important Olmec center, a wide variety of objects were embellished with a highly sophisticated symbolic "language" that has been worked out by David Joralemon (1971). Functionally, these symbols conformed to the *pars pro toto* principle, whereby each element expressed a larger but invisible whole. For instance, the well-known "wing-paw" element, so common on San Lorenzo and highland Olmec ceramics, is probably a shorthand expression for the all-important God I.

Out of all these Olmec symbols, only four appear to have been transmitted to the later Maya script. These are all of astronomical nature: (1) the U sign, a symbol of the moon, (2) the kin sign, standing for the sun, (3) the Lamat sign, a symbol for Venus, and (4) the crossed-bands element, which at least among the Maya appears in celestial bands, whatever its other meanings might be. The extraordinary incising on the Humboldt Celt (Fig. 2), probably made during the ascendancy of La Venta, exhibits *pars pro toto* "pseudo-writing" in its most developed form, and surely must have conveyed a complex message. It is not writing, however, any more than are the "winter counts" of the Plains Indians.

Only two Olmec objects known to me might have an early and contemporary kind of writing. These are Monument 13 at La Venta, the so-called "Ambassador," showing a striding person accompanied by three glyphs that might represent his

name and a footprint probably indicating a journey; and a jade plaque in the British Museum incised with two glyphs that might also be nominal but which could have been inscribed at a much later date.

No calendrical inscriptions are known for the Olmec, although Altar 7 at La Venta has three dots accompanying a crossed-bands sign which could have been a day glyph in this case. In summary, the Olmec may be dismissed from consideration in this matter on purely archaeological grounds, although it remains highly probable that the 52-year Calendar Round was already in existence as early as 1200 B.C.

Fig. 2. The Humboldt Celt, from Hatch 1971:Fig. 36.

## THE ORIGIN OF THE LONG COUNT AND INITIAL SERIES

The crucial region in the development of the Maya system was southern Veracruz and the Grijalva Depression of Chiapas during the first century B.C. By this time, the Olmec civilization had been extinct for three centuries, although Olmec traits continued to reappear in Veracruz until the end of the Early Classic. Following the Thompson correlation, the starting point of the Long Count is 3114 B.C., but of course this point in time is a projection backwards made by calendar priests at a far later date when the Long Count was initiated. Archaeological data indicate that this event took place in the latter half of the first century before Christ.

The oldest dated monument in Mesoamerica thus far is Stela 2 from Chiapa de Corzo, Chiapas, a fragmentary stone slab (Fig. 3) that was discovered in a later context (Lowe 1962:193-195). Unfortunately, the top coefficient is broken off, and the second is badly damaged, but enough remains to reconstruct this as a Long Count date (7.16.) 3.2.13, reaching the position in the tzolkin, or 260-day count, of 6 Ben. We cannot know whether an Introducing Glyph stood at the head of the column to make this an Initial Series, but it exhibits some interesting and very early traits. As in other early inscriptions that we shall examine, the cycle signs are missing and the coefficients stand alone; the day sign more closely resembles the corresponding sign in the Aztec and Borgia Group scripts (Acatl) than it does the Classic Maya form, which accords with one of my postulates; and the month position is not expressed. Accepting this as a contemporary date in the "Maya" system (and there are no compelling reasons not to), it would correspond to a day in the year 37 B.C., some 328 years before the earliest dated stela known for the lowland Maya area.

Some four years later, at the site of Tres Zapotes in Veracruz, the famous Stela C was carved (Fig. 4). Until recently, only the lower half of this monument was known, and the reconstruction of the inscription by Stirling (1940) as a Long Count date in Baktun 7 aroused storms of protest from orthodox Mayanists. The upper half has now been located, enabling us to say that Stela C has on it an Initial Series date of 7.16.6.16.18, reaching the day 6 Etz'nab, exactly as Stirling had claimed. As with the monument from Chiapa de Corzo, there are no

cycle signs and the month position is suppressed. The Introducing Glyph is the earliest known, superfixed with the 125 element, and infixed with the patron deity of the month Uo (the Jaguar God of the Underworld, but lacking the curlicue element over the nose). There are two columns of glyphs, and the columnar arrangement might have been adopted from early Monte Albán; while some of these are noncalendrical, however, there is no pairing of columns and they read from top to bottom but not right to left.

A peculiarity of Stela C is that a noncalendrical text appears above the Initial Series, a distinctly non-Maya arrangement. This apparently became a tradition in southern Veracruz writing, for in the fifth and sixth centuries A.D. the same trait, along with absence of cycle glyphs, can be seen on the stelae of Cerro de las Mesas.

The Long Count system was eventually adopted by centers along the Pacific slope of Guatemala during the first century after Christ. Stela 1 at El Baul (Fig. 5), for instance, is carved with a standing figure in a scene that conforms to the Izapan style, the dominant artistic pattern in southeastern Mesoamerica during the Late Formative and Protoclassic. While the inscription is badly damaged, it may be reconstructed, (Coe 1957:600-603) as 7.19.15.7.12, corresponding to a day in the year A.D. 37. Again there are no cycle signs, and the month position is suppressed. The day position, 12 Eb, however, here appears at the

a

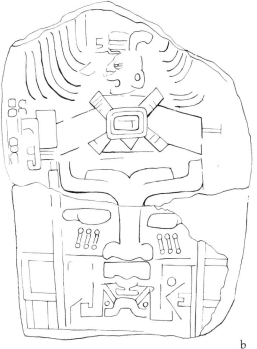

b

Fig. 4. Stela C, Tres Zapotes, Veracruz.
a. Front view.
b. Back view.

Fig. 3. Stela 2, Chiapa de Corzo.

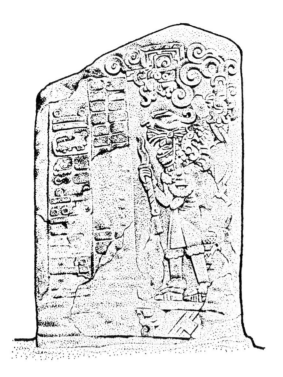

Fig. 5. Stela 1, El Baul.

noncalendrical texts. The first is a green quartzite pectoral at Dumbarton Oaks which is said to have been collected in Quintana Roo (Coe 1966). The obverse bears an Olmec were-jaguar face but probably is rather late in the Olmec sequence. On the reverse (Fig. 7), however, is incised a richly garbed seated figure in Izapan style; in costume and other details there are many resemblances to carved and painted representations of the Late Formative period in both the highland and lowland Maya areas. At his shoulder is the head of the mythical Moan Bird, topped by a crossed-bands sign with two earlike projections. To his left are 24 carefully incised glyphs, arranged in two pairs of columns of six glyphs each. There is no question that these are to read in Classic Maya fashion, and that they *are* Maya, since affixing is a prominent trait and some can be identified. Nevertheless, some signs, as at A5, recall Monte Albán glyphs. In two places, at B6 and at C2-D2, appears the same combination of signs that we have seen at the personage's shoulder. I take this to be his name, the first sure evidence we have for nominal glyphs in the Maya area.

very top of the date column. The form of the day sign is far closer to the Borgia Group sign Malinalli, which misled the discoverer of the stela, T. T. Waterman, to label it as "Aztec." The noncalendrical text appears as only a series of cartouches; perhaps the signs themselves were painted rather than carved. Nonetheless, a very important Maya trait can be seen here: the pairing of glyphs in adjacent columns. Quite probably the text was to be read in orthodox Maya fashion.

Further west along the Pacific slope, at the site of Colomba or Abaj Takalik, Stela 2 (Fig. 6) has many resemblances to the monument from El Baul, including a face looking down from swirling clouds (Coe 1957:604;605). In front of the standing figure is a very badly damaged calendrical text consisting of cycle coefficients only, beginning with 7. At the top of the column is an Introducing Glyph in which the month patron is missing but which has the 125 superfix and, more importantly, a tun sign, marking the first known appearance of this glyph.

Even more convincing evidence for the pairing of glyph columns around the time of Christ comes from two portable objects with delicately incised,

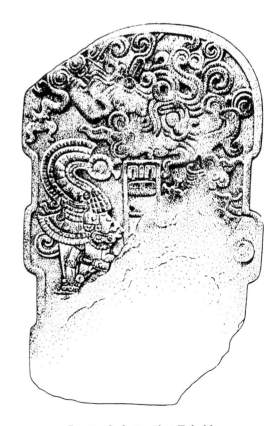

Fig. 6. Stela 2, Abaj Takalik.

The second object is a small, black stone statue of an Izapan were-jaguar. On its back is incised a text (Fig. 8), which in style is very near the Dumbarton Oaks pectoral and must have been executed by the same school of scribes. There are two columns, paired as in the former case, of eight glyphs each. Again, the text is noncalendrical. The head at A1 is identical with B2 and C1 on the Dumbarton Oaks object, and I take this to be the head of a god.

These two pieces indicate that there was a real tradition of writing among the Maya. Considerable variation, however, must already have existed. A celt excavated by Eric Thompson (1931: Pl. 33) at Hatzcap Ceel, British Honduras, has extremely early glyphs (Fig. 9), noncalendrical, incised in much the same style, with affixing evident. On this celt, though, the columns are not paired.

I am excluding the well-known Stela 10 at Kaminaljuyu (Fig. 10), in the Guatemalan highlands, from this discussion, although it is probably contemporary. My reason is that I do not believe the inscription on it to be Maya, but in another system. The glyph columns are not paired, and there are practically no resemblances with Maya glyphs of the Classic period, with the exception of the unbiquitous U sign. It is the only member thus far of its unique class.

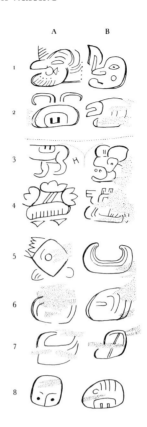

Fig. 8. Text on back of small stone were-jaguar. Private collection, New York.

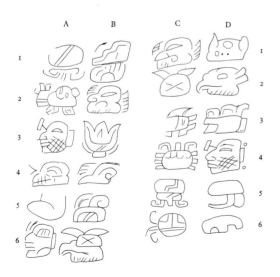

Fig. 7. Dumbarton Oaks Pectoral, reverse.

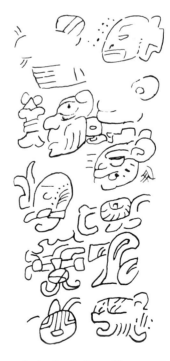

Fig. 9. Text on incised celt from Hatzcap Ceel, British Honduras, after Thompson 1931:Pl. 33.

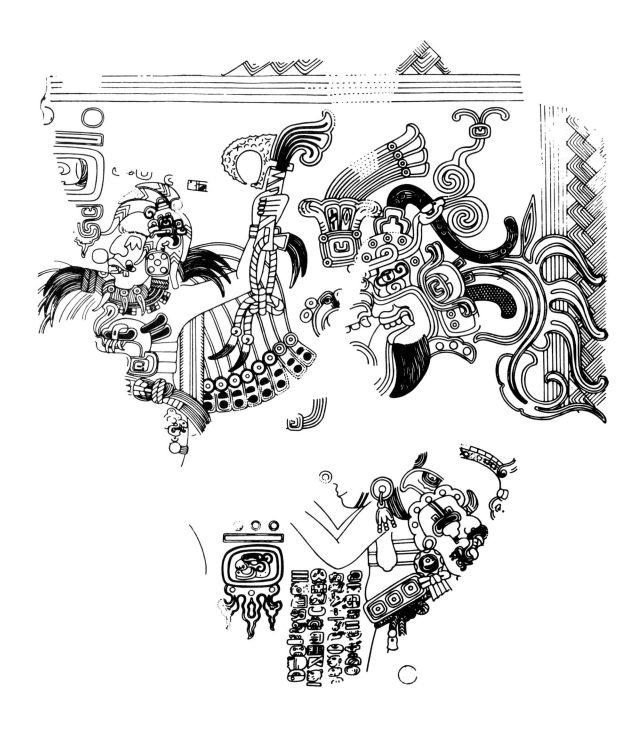

Fig. 10. Stela 10, Kaminaljuyu, Guatemala, from Girard 1962:Fig. 242.

Fig. 11. Columns of glyphs on the Tuxtla Statuette, from Covarrubias 1947:85.

Far more Maya in character, style, and content is the well-known Tuxtla Statuette (Covarrubias 1947:85-86), found near San Andrés Tuxtla in Veracruz. This object, a strange, duckbilled and winged personage, has incised upon it nine columns of glyphs executed in a somewhat angular, noncursive style (Fig. 11). The Initial Series is typically Southern Veracruz, and reads 8.6.2.4.17 8 Caban, with the month position omitted, corresponding to A.D. 162. Typically, the cycle signs are missing, and there is a rectangle in the Introducing Glyph instead of a tun sign. The 125 superfix is extremely stylized, and there may be a month patron.

A possible 8 Muluc might appear in column C, but the remainder of the inscription is noncalendrical. There is much affixing, and individual glyphs and glyph combinations are repeated, demonstrating that this is a highly codified system along Maya lines (Fig. 12). Affixes include both superfixes and subfixes. Two of the latter I feel can be identified with T.23, read as na or an by Knorosov and others, and T.74, Landa's ma, both phonetic signs. I think that there can be little question that this is a Maya text. I would also like to speculate that the combination in column D, a bearded god head with superfix and subfix (Fig. 12e), is to be read as Itzamná, the supreme deity among the Maya. Perhaps the archaic features of the Tuxtla inscription, such as nonpairing columns, and the lack of tun sign in the Introducing Glyph, are because it was incised on the then western border of the Maya area, in which Southern Veracruz traditions remained strong. Its importance is that we might have here the first evidence for phoneticism in Maya script, in the mid-second century after Christ.

An inscription with glyphs that are extremely close to the Tuxtla Statuette appears on a jade celt from El Sitio, a Guatemalan site near the Chiapas border, on the Pacific plain (Fig. 13; Navarrete 1971:78-80). The pictorial motif appears to be a maize god, with an ear of corn placed in the headdress, incised in an indubitably Olmec style, which Navarrete compares with the Humboldt Celt. On the reverse are ten glyphs (or glyph elements) arranged in a column. The first, second, and seventh of these are identical with glyphs on

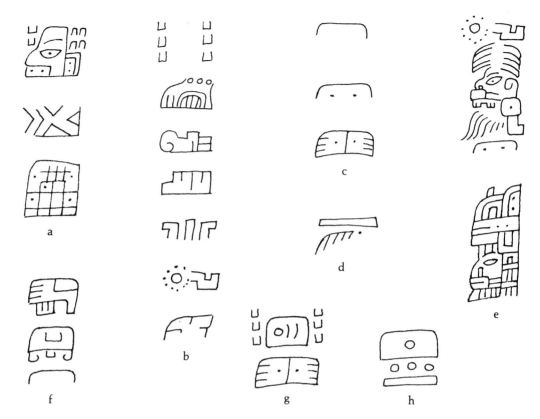

Fig. 12. Tentative analysis of glyphs from Tuxtla Statuette: *a.* possible main signs; *b.* various affixes; *c.* subfixes; *d.* possible subfix; *e.* probable heads of gods; *f, g.* repeated glyph combinations; *h.* 8 Muluc.

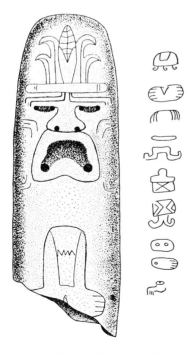

Fig. 13. Incised glyphs on Olmec celt, El Sitio, Guatemala, from Navarrete 1971:Fig. 5.

the Tuxtla Statuette, as Navarrete notes, and I presume that both texts are contemporary; I would conclude from this that either the Olmec style lasted into the second century A.D., which is unlikely, or that the text is much later than the incising on the obverse. At any rate, it indicates that the writing system of the Tuxtla Statuette probably had a fairly wide dissemination.

Thus far, we have hardly mentioned the lowland Maya area, even though literacy was widespread there by the closing decades of the Late Formative. For instance, above the early relief carved at Loltun Cave in Yucatan (Proskouriakoff 1950:Fig. 38*b*), several glyphs appear above a standing figure; my students Barbara Rich and Allen Turner rephotographed this inscription (Fig. 14) and have demonstrated that a 260-day position of 3 Chuen is recorded, presumably the calendrical name of the personage.

Stela 29 at Tikal (Fig. 15; Shook 1960), carved towards the end of the third century A.D., marks a giant step forward in the development of the Classic Maya system and, in fact, opens the Early Classic period. On it appears the Initial Series date

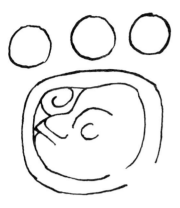

Fig. 14. Day glyph above the standing figure in the relief of Loltun Cave, Yucatan, drawn after photograph by Allen Turner and Barbara Rich.

8.12.14.8.15 ( A.D. 292), but it is broken below the kin position. Here for the first time the cycle glyphs accompany the coefficients, a rule that is very seldom broken in Classic Maya inscriptions. The Introducing Glyph has the tun sign and the 125 superfix, but otherwise is archaic in that it lacks the comb elements that surround later Introducing Glyphs. The month patron is given, corresponding to Zip. On Stela 29 appears the first Emblem Glyph, the sign for Tikal that is worn on a god head carried by the richly attired personage on the other side of the stela. Apparently this trait, like that of the cycle signs, is a Tikal innovation.

Early in the fourth century after Christ, the jade plaque known as the Leiden Plate (Fig. 16) adds a new element to the Maya system. The Initial Series

a

b

Fig. 15.  *a, b.* Stela 29, Tikal, from Shook 1960:32, 33.

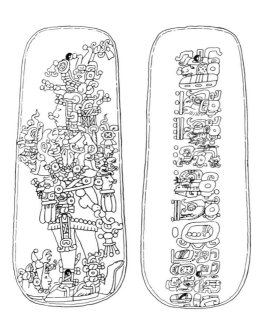

Fig. 16. Leiden Plate, inscription, from Morley and Morley 1938:Fig. 2.

reads 8.14.3.1.12 (A.D. 320), leading to the day 1 Eb; the month sign Yaxkin is now given, but without coefficient. Both Introducing Glyph and cycle signs conform to the tradition established by Stela 29. Most significantly, following the day sign appears what is surely G5, one of the Nine Lords of the Night, the first move towards establishing the Supplementary Series. Other glyphs are also given and are paired, but they appear to be noncalendrical; among them the sign for "sky" is evident. In the possession of Dumbarton Oaks is a jade plaque (Fig. 17), unhappily cut off at the top in ancient times, which is closely similar to the Leiden Plate, with an incised figure in a like pose and costume. On the reverse, fourteen glyphs appear in two paired columns of seven each. These are surely early Maya and add to our inventory of archaic Maya signs, but their meaning is unknown; there may have been a calendrical statement at the top.

There are several other inscriptions that might be added to this inventory, but it is difficult to place these in the absence of a firmly fixed glyphic chronology. Included in this group are an Olmec plaque in the A. B. Martin Collection with early Maya glyphs incised on the reverse; a stone bowl in

Izapan style with glyphs on the spout; a small relief cylinder; the six god heads carved upon a remarkable stone bowl in the Sáenz Collection; a small jade pendant in the Art Institute of Chicago, said to come from Costa Rica; a large ear spool from Pomona, British Honduras, incised with four god heads; and a miniature stela owned by John Hauberg. Probably many others will be discovered in the future, so that some sort of catalogue of early glyphs might be prepared.

At any rate, the Classic Maya system continued to evolve. Lunar glyphs are found earliest on Stela 18 from Uaxactun, dated 8.16.0.0.0 (A.D. 357), suggesting that perhaps the Maya interest in the moon is much later than has been claimed. Balakbal Stela 5 (8.18.10.0.0 or A.D. 406) records a Period Ending date, and a coefficient finally appears with the month sign. By the close of the fifth century, the comb elements, identified by Thompson (1944) as phonetic indicators, are placed on either side of the Introducing Glyph. Distance Numbers reaching other dates are definitely inscribed by 9.3.0.0.0 or A.D. 501. By the end of the Early Classic, around A.D. 600, the Maya system of monumental stone inscriptions was fully evolved.

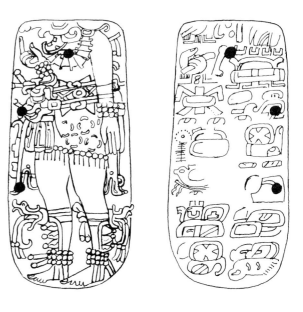

Fig. 17. Dumbarton Oaks, jade plaque, drawn from the original by Valetta Malinowska.

## CONCLUSIONS

The development of the Maya system of writing goes back, we have seen, to the close of the first century B.C., in which significant events took place in central Chiapas and southern Veracruz among peoples who while outside the Maya area as it appears today were most likely Mayan speakers. Probably from the outset, this script was recording some form of the Mayan language. It is usually claimed that the Calendar Round was invented long before the Long Count, but there is absolutely no evidence for this, nor is there any firm evidence that the Olmec were the originators of Mayan writing. There are, however, definite relationships with non-Maya scripts, particularly those of Monte Albán and the central Mexican highlands.

These early steps did not come about in a vacuum; the piecemeal nature of the process of development indicates that no one Maya priest or man of genius thought the whole business up, although the Long Count itself might have been the invention of one person. During the Late Formative in southeastern Mesoamerica, early states must have been evolving, ruled by an elite class that considered itself of divine origin. We know that among the later Maya, monumental inscriptions served the primary purpose of the glorification of the rulers and their lineages and the other lineages with which they were allied by marriage. The remarkable elaboration of the Maya script must thus have taken place in a social, political, and religious milieu centering on lineage continuity and the worship of ancestors.

## References

Berlin, Heinrich
1958   El glifo "emblema" en las inscripciones mayas. *Journal de la Société des Americanistes* 47:111-119.
Coe, Michael D.
1957   Cycle 7 monuments in Middle America: a reconsideration. *American Anthropologist* 59:597-611.
1966   An early stone pectoral from southeastern Mexico. *Studies in Pre-Columbian Art and Archaeology* 1. Dumbarton Oaks, Washington.
Covarrubias, Miguel
1947   *Mexico south: the isthmus of Tehuantepec.* Cassell and Co., Ltd., London.
Girard, Rafael
1962   *Los Mayas Eternos.* Antigua Librería Robredo, Mexico.
Hatch, Marion
1971   An hypothesis on Olmec astronomy, with special reference to the La Venta site. *Contributions of the University of California Archaeological Research Facility* 13:1-64.
Jakeman, M. Wells
1947   The ancient Middle-American calendar system: its origin and development. *Brigham Young University, Publications in Archaeology and Early History* 1. Provo, Utah.
Joralemon, Peter David
1971   A study of Olmec iconography. *Studies in Pre-Columbian Art and Archaeology* 7. Dumbarton Oaks, Washington.
Knorosov, Yuri V.
n.d.   Ancient writing of Central America. Translated from *Sovetskaya Etnografiya* 3:100-118 (1952).

1971   Notes on the Maya calendar. A general survey. *Sovetskaya Etnografiya* 1971(2): 77-86.
Lounsbury, Floyd G.
n.d.   Concluding remarks, Dumbarton Conference on Mesoamerican Writing Systems, 1971.
Lowe, Gareth W.
1962   Algunos resultados de la temporada 1961 en Chiapa de Corzo, Chiapas. *Estudios de Cultura Maya* 2:185-196. Mexico.
Morley, Frances R., and Sylvanus G. Morley
1938   The age and provenance of the Leyden plate. *Carnegie Institution of Washington, Publication* 509. Contributions to American Anthropology and History 5 (24).
Morley, Sylvanus G.
1946   *The ancient Maya.* Stanford University Press, Stanford.
Navarrete, Carlos
1971   Algunas piezas Olmecas de Chiapas y Guatemala. *Anales de Antropología* 8:69-82. Instituto de Investigaciones Históricas, Universidad Nacional Autónoma de México, Mexico.
Proskouriakoff, Tatiana
1950   A study of Classic Maya sculpture. *Carnegie Institution of Washington, Publication* 593.
1960   Historical implications of a pattern of dates at Piedras Negras. *American Antiquity* 25(4): 454-475.
Satterthwaite, Linton
1961   Maya long count. *El México antiguo* 9:125-133.
Shook, Edwin M.
1960   Tikal Stela 29, *Expedition* 2 (2):28-35. University Museum, University of Pennsylvania, Philadelphia.

Spinden, Herbert J.
1924 The reduction of Maya dates. *Papers of the Peabody Museum of Archaeology and Ethnology,* Harvard University 6(4).

Stirling, M. W.
1940 An Initial Series from Tres Zapotes, Veracruz, Mexico. *Contributed Technical Papers Mexican Archaeology Series* 1(1). National Geographic Society, Washington.

Thompson, J. Eric S.
1931 Archaeological investigations in the southern Cayo District, British Honduras. *Field Museum of Natural History, Anthropological Series* 17(3). Chicago.
1944 The fish as a Maya symbol for counting and further discussion of directional glyphs. *Carnegie Institution of Washington, Theoretical Approaches to Problems* 2. Cambridge.
1950 Maya hieroglyphic writing. Introduction. *Carnegie Institution of Washington, Publication 589.*
1962 *A catalog of Maya hieroglyphs.* University of Oklahoma Press, Norman.

# The Iconography of Militarism at Monte Albán and Neighboring Sites in the Valley of Oaxaca

JOYCE MARCUS

Museum of Anthropology and
Department of Anthropology
University of Michigan

M uch ink has been expended on the Aztecs, the Maya, and more recently, the Olmecs. To date no one—with the exception of Alfonso Caso—has been half as much in love with the Zapotecs. With respect to the theme of this conference, the Zapotec contributions in Formative times can no longer be pushed into the background.

## I. THE "NON-PRESENCE" OF THE OLMEC IN THE VALLEY OF OAXACA

Based primarily on ceramic cross-ties, the San José phase (1200-900 B.C.) represents the closest parallel to the Gulf Coast Olmec tradition, specifically in the selection of Olmec motifs (Flannery 1968:82, 101). The type site of San José Mogote has produced vessels with the Saint Andrew's cross, the "paw-wing" design, the U motif, and other motifs in the Olmec design repertoire. Michael Coe (1968:48-57) has shown that Olmec sculptures from San Lorenzo Tenochtitlan and La Venta date from the San Lorenzo phase (1200-900 B.C.), with corroboration supplied by at least 10 C-14 dates.

Although some head fragments from large, white-slipped "baby dolls" have been associated with the Guadalupe phase (900-700 B.C.), the Olmec "influence" was already waning in this phase (Flannery 1968:89-91). By the Rosario and Monte Albán I-A phases (700-300 B.C.) the Valley of Oaxaca (Fig. 1) is characterized by the appearance of a distinctive ware—the waxy-surfaced gray ware—and the indigenous development of a Zapotec art style in the form of *danzantes* and stelae. This floresence in the Zapotec region coincides with or shortly follows the demise of La Venta, San Lorenzo Tenochtitlan, and other Gulf Coast Olmec sites, resulting in a political vacuum in the Olmec climax area. Thus the only Olmec "influence" in the Valley of Oaxaca occurs during the San Lorenzo phase when the San José ceramics display some Olmec motifs. The early horizon 1200-900 B.C. exemplifies a time of contact in the form of trade between Oaxaca and the Gulf Coast, but the presence of actual Olmec people is presently not indicated.

Although several sites in the Etla arm of the Valley of Oaxaca have produced ceramic material from Early and Middle Formative times, the earliest material from the hilltop site of Monte Albán seems to date from Monte Albán I-A (late Middle Formative). A shift in population distribution and density is evident during Monte Albán I-A; at this time the settling and construction of sections of Monte Albán's ceremonial plaza took place (Caso 1938; 1947b). Although there are other Monte Albán I sites on the valley floor, no other known site has produced sculpture securely dating to Monte Albán I. The appearance of monumental art at Monte Albán accompanies the "ceremonial" construction and the growth in population of the urban settlements. An important threshold was apparently reached. A growing upper class with increasing wealth and power is suggested, and a reorganization is evident.

## II. THE *DANZANTES*

Dupaix, on his 1806 expedition, was the first to record *danzantes* at Monte Albán, still the only site where such sculptures are known. Castañeda, Dupaix's artist, in his album illustrated five large slabs with representations of *danzantes* set into the east side of the southern section of the massive platform of the original building of the *Danzantes* or Mound L (1-2, 4-6 in the Batres-Villagra numeration; Kingsborough 1831-1848, Vol. IV: Part 2, L. 20 [65-69]; Dupaix 1834, Atlas: Deuxième Expedition, Pls. XXIII [67-68], XXIV [69-71]; Dupaix 1969, Vol. II: Lám. 20 [41], Fig. 66 [A-E]; Villagra 1947:Figs. 2-3). Sologuren and Belmar, apparently about 1900, uncovered seven additional *danzante* carvings (7-8, 10-11, 13-15), north of and immediately adjacent to those seen by Dupaix and Castañeda, while Batres in his explorations of 1902 exposed nine more (9, 12, 16-22), the last four set into the south side of the projecting platform of the stairway (Batres 1902: 30-31, Láms. V-VI). Other early explorers, such as García (1859), Seler (1904a [1890]), and Holmes (1897), also briefly described and illustrated some

of these same visible *danzantes*. The great majority of *danzante* carvings, which reportedly now number about 310, however, were discovered during the 18 seasons (1931-1958) of the landmark Monte Albán project of Caso and his collaborators, both in and around Mound L itself and as pieces used as construction material in other structures at the site (Villagra 1947; Caso 1947a). Most were systematically drawn by Villagra, but only a portion of these have been published.

Numerous interpretations have been advanced to explain the *danzante* reliefs. Villagra (1947:155) was tempted to interpret those on the risers of the stairway of Mound L as "swimmers" (with Burgoa's report of an ancient lake in the Valley of Oaxaca as supportive evidence) but felt compelled to modify his view on the basis of related representations on the lintel and left jamb of Tomb 120 (Period III). Dávalos Hurtado (1951) proposed that the *danzantes* represented individuals destined for sacrifice or for the priesthood. Dávalos attributed the corpulent bodies and enlarged extremities to the effects of castration. In his interpretation, groin scrolls represented ritual scarification. Only a small percentage of the circa 310 *danzantes* display groin scrolls, however. Furst (1968:166) felt that Dávalos may have been close to the truth in suggesting the *danzantes* as priests engaged in an ecstatic ritual dance; he suggests that the flowerlike designs in the genital area should "be considered as metaphorical rather than literal, symbolizing ritual celibacy rather than recording sexual atrophy or castration." Here Paddock's (1966:118) comments on the interrelationship between the flowerlike motifs and the sexual organs are germane:

> . . . pero hoy el idioma conecta claramente los conceptos de flor y de órgano sexual (masculino o femenino). La flor en Mitla se llama *gui*, a menudo con un sufijo que identifica la especie. La misma palabra con el prefijo posesivo x o sh quiere decir órgano sexual. (Claro que por sus formas muchas flores se prestan para simbolizar los genitales, además de que sean en realidad las partes reproductivas de las plantas.)

Although any of the proposed interpretations may prove to be correct, it is difficult to account for all of the various *danzante* forms employing any single explanation. In such a situation I would opt for an explanation that seems to be consistent with other themes or motifs depicted at the site of Monte Albán and also with other Mesoamerican sites of more recent date.

Captive figures in the Maya region are frequently portrayed in awkward "crumpled" positions, nude or lightly clothed, grimacing, and showing the submissive gesture of placing the right hand on the left shoulder. Some *danzantes* seem to show a variant submissive gesture (see Caso 1947a). Maya captives, however, are often depicted bound with cords, which no known *danzante* shows. During Monte Albán III-A, however, figures, probably captives, are frequently represented bound with cords, with their arms behind their backs. Coe (1962:95-96) also suggests an explanation along similar lines:

> The distorted pose of the limbs, the open mouth and closed eyes indicate that these *(danzantes)* are corpses, undoubtedly chiefs or kings slain by the earliest rulers of Monte Albán. In many individuals the genitals are clearly delineated, usually the stigma laid on captives in Mesoamerica where nudity was considered scandalous. Furthermore, there are cases of sexual mutilation depicted on some *Danzantes*, blood streaming in flowery patterns from the severed part. To corroborate such violence, one *Danzante* is nothing more than a severed head.

Some of the *danzantes* are attired in richer regalia (e.g., Fig. 2), and these may well represent chiefs, but certainly not all of the *danzantes* are slain kings or chiefs! The majority of the *danzantes* probably portray lesser villagemen taken in

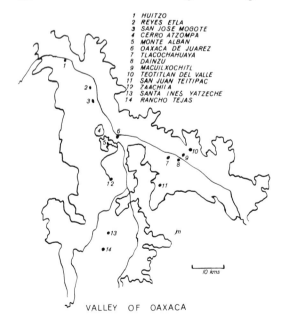

1  HUITZO
2  REYES ETLA
3  SAN JOSE MOGOTE
4  CERRO ATZOMPA
5  MONTE ALBAN
6  OAXACA DE JUAREZ
7  TLACOCHAHUAYA
8  DAINZU
9  MACUILXOCHITL
10  TEOTITLAN DEL VALLE
11  SAN JUAN TEITIPAC
12  ZAACHILA
13  SANTA INES YATZECHE
14  RANCHO TEJAS

10 kms

VALLEY OF OAXACA

Fig. 1. Valley of Oaxaca, based on "Mapa de las Localidades del Valle de Oaxaca," by Cecil R. Welte, 1965.

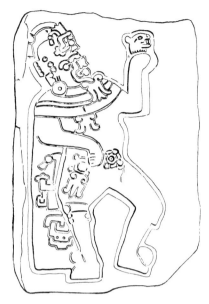

Fig. 2. Danzante 41, Mound J, Monte Albán, from Caso 1947a:Fig. 23.

raids and skirmishes. In most respects this hypothesis is not as romantic or as dramatic as castrated, ecstatic priests, but in being more in line with depictions of subjugated peoples by other Mesoamerican civilizations it is hopefully closer to the truth. The *danzantes* need not be taken literally as portraits of slain captives; they may only be symbols of "potential" or "attained" power and exemplify subjugated peoples dominated by the growing dynastic and ruling groups of Monte Albán.

As an expression of political and ritual power, the 310 *danzantes* must have elicited the expected response of respect and awe. This corpus of 310 Formative (Monte Albán I and II) monuments has no rival, in terms of total number, anywhere in Mesoamerica. Additionally, there are Late Formative "stelae" (e.g., 12, 13, 14, 15, 17, 18) and "conquest slabs" (Caso 1928; 1947a). Various *danzantes* display the same or very similar hieroglyph alongside their heads (Fig. 3; Caso 1947a: Fig. 21k-p). This sign, which Caso (1947a:14) identified as the *atlatl*, spearthrower, may be a family or personal name or it may designate a battle in which these men were captured or slain. A possibly comparable sign for warfare, the shield and banner (e.g., Dibble 1966:276), was a feature of the Aztec writing system. Approximately 46 of the 310 *danzantes* have short hieroglyphic texts probably serving as name captions to the figures portrayed.

Sixteenth-century data recorded by Fray Juan de Córdova (Vocabulario en Lengua Zapoteca, 1578) indicate that the Zapotecs offered human victims for sacrifice. Prisoners taken in raids or war were sacrificed, and their flesh was eaten. Men were sacrificed to the harvest deity, and both adults and children were offered to Cocijo, the thunder-rain god. In his dictionary Córdova indicates the special occasions in connection with which human sacrifices were performed, and he provides the Zapotec terminology connected with this aspect of the native ritual system (summarized in Seler 1904:278).

## III. THE MOUND J PLACE SIGNS

The theme of slain captives evident in Monte Albán I ties in well with the "conquest slabs" set into Mound J, which appear to date from Period II. Evidence of militarism is also conveyed by the construction of a double defensive wall during late Period I or early Period II (Blanton 1973). Several slabs bearing *danzante* representations are also incorporated into Mound J; some were used as construction material (Caso 1947a:8). One of the Mound J *danzantes*, 41 (Fig. 2), which Caso (1947a:19) suggested might possibly date as late as Period II, is particularly significant because the earliest "hill" sign appears to the left of the richly

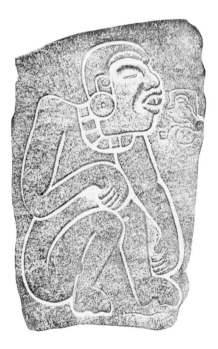

Fig. 3. Danzante 8, *"Los Danzantes"* (Mound L), Monte Albán, from Caso 1947a:Fig. 4.

attired figure, with which other glyphs are also associated.

Caso (1947a:21) defines the "conquest slabs" as typically including the following elements:

1. A human head, upside down, beneath the "hill" sign (Fig. 11).

2. The "hill" or *cerro* glyph that signifies "place."

3. A combination of glyphs that probably represents the name of the place, usually above the "hill" glyph.

4. A hieroglyphic text that in its most complete form includes the year, month, and day—plus other glyphs of unknown meaning.

Caso noted that some of the inverted heads display tattoos or facial painting; many of their eyes are closed, lack pupils, or have a vertical line running through them. On the basis of these characteristics, Caso concluded that these heads represented dead "kings" of towns conquered by Monte Albán.

The hill element (functionally similar to the Aztec *tepetl*, mountain sign) and the inverted head beneath it are the constants in the place sign formula. The inverted head with closed eye in conjunction with the sign for "place" signifies conquered community. The Aztecs sometimes (e.g., Codex Mendoza) conveyed a comparable message by depicting a burning temple structure. The inverted heads wear different headdresses, probably indicative of particular communities or ethnic groups. The variable element, atop the hill sign, is potentially the most informative because it appears to convey the specific site name. An analogy would be the Maya "emblem glyphs"; Berlin (1958) has defined two constants: the "Ben-Ich" superfix and the "water group" prefix that are affixed to a main sign that conveys the particular site name.

If, as Caso maintained, the inscriptions on the slabs set into Mound J during Period II include place signs, (1) we might be able to identify them and (2), since the constant of the "hill" element is so similar to the Aztec *tepetl* or "hill" sign, the Aztec tribute lists providing names in the Valley of Oaxaca would be worth comparing to them. Therefore, in attempting to assign names to these unknown subjugated towns, my starting point was the Matrícula de Tributos, more familiar in the cognate version that constitutes the second section of the Codex Mendoza (fols. 17v-55r; Kingsborough 1964:Láms. XVII-LVII), the traditional source for the names of communities that

paid tribute to Mexico-Tenochtitlan. "Each pair (of pages) relates to a single taxation district, comprising all the towns in it, and the tribute enumerated was paid by the district as a whole." (Long 1942:41). Payments were yearly, half-yearly, "quarterly," or six times a year; various festivals apparently served as a framework for the rendering of tribute, increasing or decreasing as the distance demanded (Barlow 1943:153-154).

Barlow (1949:118-119) assigns 35 towns to the tributary province of Coyolapan, the heart of Oaxaca. The place signs of 11 (Camotlan, Coyolapan, Etlan, Guaxacac, Macuilxochic, Octlan, Quauhxilotitlan, Teticpac, Tlalcuechahuayan, Quatzontepec, and Teocuitlatlan) are depicted on the Codex Mendoza page (fol. 44r; Kingsborough 1964:Lám. XLVI) devoted to that jurisdiction. The remainder he reconstructs from other sources, mostly the 1579-1585 series of *relaciones geográficas:* Atepec, Coatlan, Cuixtlan, Chichicapan, Eztetlan (?), Huixtepec, Itzquintepec, Iztepexi,

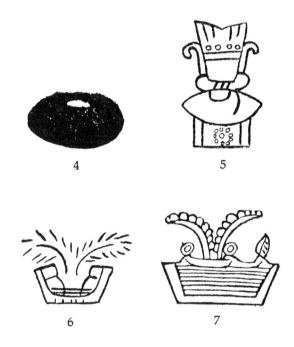

4                                          5

6                                          7

Fig. 4. Place sign, Etlan, Codex Mendoza fol. 44r, from Peñafiel 1895:113.

Fig. 5. Probable place sign, Lápida 15, Mound J, Monte Albán, from Caso 1947a:Fig. 64.

Fig. 6. Probable place sign, Lápida 43, Mound J, Monte Albán, from Caso 1947a:Fig. 64.

Fig. 7. Place sign, Miahuaapan, Codex Mendoza fol. 52r, from Peñafiel 1885:139.

Miahuatlan, Mictlan, Ocelotepec, Quauxtilotic-pac, Tecuicuilco, Teotitlan del Valle, Teotzacual-co, Teozapotlan, Tlacolula, Tlaliztacan, Totoma-chapa, Xaltianguisco, Xilotepec, Yoloxonecuilan, Zenzontepec, and Çoquiapan. By comparing Bar-low's map to a site map of the Valley of Oaxaca and by comparing the Aztec signs for Oaxaca place names to the "place signs" on Mound J carvings, one might be able to identify some sites in Oaxaca circa A.D. 1. This would presuppose more than 1500 years of continuity in place names, however.

An example of continuity in Valley of Oaxaca place names appears to be indicated in the Etla arm. The Aztec place sign for Etlan, "Place of the Bean(s)," is one large bean, *etl*, with the phonetic value *"e"* (*tlan*, "place," is understood; Fig. 4). The Zapotec name, Loohuanna, "Place of Provisions" (Seler 1904:260), is etymologically very close in meaning. The word "Etla" is presently attached to several place names in the Etla arm, for example, San Lázaro Etla, Guadalupe Etla, and Nazareno Etla. During Aztec times Etlan may have referred to a *region* in the Etla arm of the Valley. Earlier, during Monte Albán III-B times, "Etlan" may have referred to the site of Reyes Etla, which is known to have had a very large occupation during Period III-B. Even earlier, Etlan may have formed part of the ancient name for San José Mogote, which was occupied during Monte Albán I-IIIA. One slab (15) set into Mound J depicts a composite place name: a field of maize?, a bean, and the maize flower (Fig. 5). Although Caso (1947a:27) identified it as a stone knife, the central element is quite probably a bean; the hilum seems to be clearly delineated. This slab, therefore, may refer to sites in the Etla arm of the Valley and conceivably either to San José Mogote or the growing center, Reyes Etla.

Lápida 43 set into Mound J features a probable place sign (Fig. 6) quite reminiscent of the Aztec sign for Miahuapan (Fig. 7), "On the Water of the Maize Tassels," which is essentially a variant of Miahuatlan, "Place of the Maize Tassels." The town of that name is located approximately 85 kilometers south of Monte Albán. One of its Zapotec names, Quechetao, apparently had the same meaning (Espíndola 1905:125; Caso and Bernal 1952:364), although it can also mean "Large Town." This second meaning is that assigned by Gutiérrez (1905:289), although he spells it "Guichixo"; he also provides two additional versions, "Guecheto," which he translates

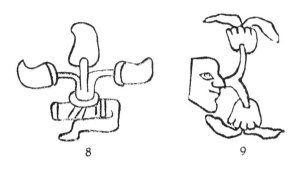

Fig. 8. Probable place sign, Lápida 3, Mound J, Monte Albán, from Caso 1947a:Fig. 64.

Fig. 9. Place sign, Huaxyacac, Codex Mendoza fol. 44r, from Peñafiel 1885:199.

"Pueblo de Mahuci (*sic.* for Mahuei = Maguey)," and "Pelopenisa," "entre las flores del Mais." Rojas (1958-1964, 1:17), however, rejects the latter interpretation, preferring "Our Water Source" or "Where Our Water Source Begins." The possible commemoration of Miahuatlan in Mound J suggests that it might have been an early dependency of Monte Albán during Period II. Since the inverted head is lacking beneath the *cerro* sign, a possible inference is that Miahuatlan may not have been "conquered" but nevertheless functioned as a tributary.

The Nahuatl name for the community of Oax-aca, Huaxyacac, means "At the Tip or Nose of the Guaje(s)," a tree (huaxin; *Leucaena esculenta* Moc. and Sessé) bearing edible pods with wavy edges. The Zapotec name is Luhulaa, with the same basic meaning, "Place of the Guajes" (Mar-tínez Gracida 1883:81). The Aztecs probably simply translated the Zapotec place name into Nahuatl. Mound J's Lápida 3 is the only "conquest slab" depicting a place sign with an upper element that resembles a guaje (Fig. 8). As Caso (1947a:27) recognized, however, the pods on this plant representation resemble chile far more than the wavy-edged guaje pods. Additionally, no human face or "nose" is attached to the guaje, as with some Aztec versions of this place sign (Fig. 9). The lower element of this place sign resembles the Aztec sign for *tzin*(*tli*) or *nantzin*(*tli*) (Barlow and MacAfee 1949:27, 43), the lower portion of the human body (cf. different interpretation of Caso [1947a:27]), but a place with a name such as Chiltzinco or Chilnantzinco does not exist in the

Valley of Oaxaca. There are, however, two places that do incorporate the word "chile" in their names, Chilapa and Chilazoa, although the second does not etymologize well in Nahuatl and may be, as Bradomín (1955:43) suggested, a Zapotec name.

On the same Codex Mendoza page devoted to the Coyolapan tributary province the place sign for Teticpac appears (Fig. 10). San Sebastián, San Juan, and Magdalena Teitipac are currently located in the southern portion of the Tlacolula arm of the Valley of Oaxaca. Just as with Etlan, the Aztec place sign, Teticpac, may have referred to this region. According to Burgoa (1934:2:64, 70), in Zapotec Teticpac was called Zeetoba ("que quiere decir otro sepulcro, o lugar de entierros a distinción del entierro general que tenían los reyes zapotecos en el pueblo de Mitla") and Quehuiquijezaa ("que quiere decir palacio de piedra, de enseñanza, y doctrina, porque se edificó sobre una grandísima losa"). The place sign on Lápida 4 in Mound J (Fig. 11) shows a structure (house or temple?) with a Saint Andrew's cross inset. Teticpac in Nahuatl literally means "On Top of the Stone(s)," but the Codex Mendoza place sign depicts a *house* above a stone. The Lápida 4 place sign, therefore, can perhaps be very tentatively identified with Teitipac, a region encompassing three modern towns and several large archaeological sites some 20 to 30 kilometers from Monte Albán.

Stone 57 from Mound J may refer to a place or hill of some species of bird (Fig. 12). Although the

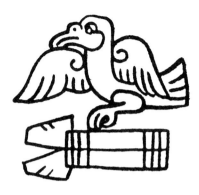

Fig. 12. Probable place sign, Lápida 57, Mound J, Monte Albán, from Caso 1947a:Fig. 63.

upper element of this place sign, the bird, resembles an eagle, the caruncle atop the beak is characteristic of either the king vulture or the turkey (Grossman and Hamlet 1964:47). The lower element has been identified by Caso (1947a: 27) as two bound arrows. Tututepec (Tototepec), "Hill of the Bird(s)," remains a possibility for the connotation of the place sign on this Mound J slab.

Cuicatlan may also be one of the communities signified by a place sign on one of the Mound J slabs, 47 (Fig. 13). A human face fronted by a feathered (?; Caso [1947a:26] characterizes this element as "dos pequeños adornos en forma de cintas con doble punta") speech scroll is evident. In the Codex Mendoza the place sign for Cuicatlan, "Place of Song" (Fig. 14), also displays a head in profile fronted by an ornate speech (= song) scroll. Cuicatlan is about the same distance from

10                              11

13                              14

Fig. 10. Place sign. Teticpac, Codex Mendoza fol. 44r, from Peñafiel 1885:199.

Fig. 11. Lápida 4, Mound J, Monte Albán, from Caso 1947a:Fig. 41.

Fig. 13. Probable place sign, Lápida 47, Mound J, Monte Albán, from Caso 1947a:Fig. 62.

Fig. 14. Place sign, Cuicatlan, Codex Mendoza fol. 43r, from Peñafiel 1885:101.

Monte Albán as Miahuatlan. If Miahuatlan and Cuicatlan as well as intervening towns were dependencies or tributaries of Monte Albán, the extent of Monte Albán's tributary area was far greater than is usually suspected.

Current specific names for the site of Monte Albán in indigenous languages are not employed, although Cruz (1946:157-164) indicated that it was sometimes referred to in Valley Zapotec as Dani-baan, "monte o cerro sagrado," (and from which he, dubiously, tried to derive the "Albán" in Monte Albán). Cruz also stated that according to documents in the nearby community of Xoxocotlan the Mixtec name of the eminence of Monte Albán was Yucuocoñaña, "Hill of Twenty Jaguars." In the same documents its Spanish equivalent was "Cerro del Tigre" (Nahuatl equivalent: Ocelotepec), which he suggested would probably be Danibeeje or Danigalbeeje in Valley Zapotec. A place sign on Lápida 23 from Mound J (Caso 1947a:Figs. 61, 23) resembles a jaguar, but it is only conjecture that "Hill of the (20) Jaguar(s)" constituted the ancient name of Monte Albán.

Various elements are discernible in other place signs on Mound J slabs, but at present it is difficult to connect them with known place names in the Valley of Oaxaca and adjacent territory. For example, the *pan(tli)* component or banner (Caso 1947a:Fig. 63, 18), the *poc(tli)* element or smoke (Caso 1947a:Fig. 63, 7, 13; Fig. 64, 44), and the sign for cotton or *ichca(tl)* (Caso 1947a:Fig. 64, 15; Fig. 45) all seem to be constituents of unidentified site or town names.

It might be useful to summarize, as possible leads for further research, the ancient and modern names—and their meanings, if known—for certain places in the Valley of Oaxaca and neighboring territory (sites, towns, regions), as shown in the table on the next page.

## IV. STELAE IN MONTE ALBÁN III-A

The themes of captives and conquered towns continue into Period III. These themes are conveyed on free-standing (?) stelae for the first time. Of nine stelae probably dating to Monte Albán III-A, six (2, 3, 5, 6, 7, 8) portray bound captives standing on various place signs, evidently their "hometowns" (Caso 1928:89, Figs. 27-32, 35-47). Two of the bound captives, on Stelae 2 and 3, respectively, are wearing jaguar and opossum (?)

outfits. Other figures outfitted in jaguar (or other animal) costumes and standing on place (?) signs include the Lápida de Bazan and the stone from Mound II (Caso 1965:Figs 13, 17). The basic elements of these stones can be tabulated as follows (X = present, O = absent, — = uncertain:

| Stela | Arms bound behind back | Speech scroll | Place sign | Dressed as Animal | Year sign |
|---|---|---|---|---|---|
| 2 | X | O | X | X | X |
| 3 | X | X | X | X | X |
| 5 | X | — | X | O | X |
| 6 | X | X | X | O | X |
| 7 | X | — | X | O | — |
| 8 | X | X | X | O | X |

Other stelae, 1 (Caso and Bernal 1952:Fig. 350) and 4 (Caso 1928:Figs. 33-34), portray local (?) rulers wielding lances. The lord on Stela 1 is seated upon a jaguar cushion resting on a throne-place sign. Beneath the throne two long-nosed "cipactli" heads can be made out. Another "cipactli" is evident in the ruler's headdress. The hieroglyphic text fronting this lord is arranged in two columns, presumably read from left to right and from top to bottom (Caso 1928:127). The text continues on the top side of the monument where it is divided into three separate compartments, a pattern also present on Stela 8. On Stela 4 no year sign accompanies the glyph 8 Deer; therefore, it seems possible that the name of the ruler was 8 Deer, his day of birth.

The place signs on Monte Albán III-A stelae are difficult to identify, but they are definitely different from those on the "conquest slabs" of Mound J in Period II. The amount of information conveyed on Monte Albán III-A stelae represents a substantial increase over that presented on the "conquest slabs" of Period II. *Danzantes* of Period I-II convey the least amount of information. Monte Albán I texts (with the exception of Stelae 12, 13) are very brief, rarely exceeding five glyphs or signs. Monte Albán II texts include year signs and supposed day and month signs as well as other signs that are sometimes arranged in double columns. Monte Albán III-A texts are the longest and often include many new signs not employed in earlier inscriptions. In conjunction with increasingly greater attention to details in iconography, the amount of information conveyed in lengthier written texts increases through time.

|                     *Nahuatl*                      |     *Zapotec (Z), Mixtec (M), Cuicatec (C)*     |
| --- | --- |
| 1. Miahuatlan, "Place of the Maize Tassels" | Quechetao (Z), "Town of the Maize Tassels"; "Large Town"<br>Pelopeniza (Z), "Where Our Water Source Begins?" |
| 2. Ocotlan, "Place of the Pine(s)" | Lacheroo, Lachetao (Z), "Large Valley"<br>Quelache (Z), "Marketplace of the Valley"<br>Ñundedzi (M), "Place of the Elotes" |
| 3. Teitipac (Teticpac), "On Top of the Stone(s)" | Ze(e)tobaa (Z), "Other Sepulcher"<br>"Quehuiquijezaa" (Z), "Stone Palace"<br>Miniyuu (M), "Lake or Hollow-Stone" |
| 4. Mitla (Mictlan), Miquitlan, "Place of the Dead," "Underworld" | Liobaa (Z), "Center of (Entrance to?) the Sepulchers (Rest)"<br>Yoobaa (Z), "House of the Sepulcher(s)" |
| 5. Tlacolula (Tlacolollan: "Place of Crooked Things"[?], "Place of Dry Farming"[?]; Tlacuilollan: "Place of Paintings"[?]) | Paca, Bahk (Z), ?<br>Guichibaa ( = Quechebaa) (Z), "Town of the Sepulcher(s)"(?) |
| 6. (Teo)zapotlan, "(Sacred) Place of the Zapote" | Zaachila (Z), uncertain; "Cloud-Crocodile"(?); "Place of Authority or Dominion"(?);<br>Tocuisi (M), "Level (White?) Domain"(?) |
| 7. Macuilxochitl (Macuilxochic), "Place of 5. Flower (Deity)" | Quiabelagayo ( = Quiepeloocayo?) (Z), "Sierra of 5. Flower (Deity)" |
| 8. Teotitlan, "Next to the Deity (Sun God)" | Xaquie (Z), "At the Foot of the Sierra" |
| 9. Cuilapa (Coyolapan), "On the Water of the Guacoyoles (*Coyol* palm: *Acrocomia mexicana*, Karw.)" | Sahayucu (M), "At the Foot of the Hill"<br>Yu(ti)caha, Ynch(ti)caha (M), "River of the Guacoyoles" |
| 10. Tlacochahuaya (Tlalcuechahuayan), "Place Where the Earth is Moistened" | Zuun (Z), ? |
| 11. Monte Albán: Ocelotepec(??), "Hill of the Jaguar" | Danibaan (Z), "Sacred Hill"<br>Yucuocoñaña (M), "Hill of 20 Jaguars"?<br>Danibeeje, Danigalbeeje (Z), "Hill of the Jaguar"(??) |
| 12. Oaxaca (Huaxyacac), "At the Nose or Promontory of the Guajes (*Leucaena esculenta* Moc. and Sessé)" | Luhulaa (Z), "Place of the Guajes"<br>Nuunduvua (M), "Place of the Guajes" |
| 13. Etla (Etlan), "Place of the Bean(s)" | Loo(a)huanna (Z), "Place of Provisions"<br>Ñuunduchi (M), "Place of the Bean(s)" |
| 14. Cuauhxilotitlan, "Next to the Cuajilote" (*Parmenteria edulis* Benth.) | Huitzo (Huiyazoo) (Z), "Military Lookout"<br>Ñuundodzo (M), "Place of the Quetzal Bird"(?) |
| 15. Cuicatlan, "Place of Song" | Yabahku, Ibahku (C), "Place of Houses", or "Guetrabanco" ( = Kaatabahku, "House of Song"[?]) |

## V. REGIONAL STYLES AT VALLEY FLOOR SITES

The fundamental theme of Monte Albán I through III-A sculpture can be characterized as pertaining to militarism: the slain captives of Periods I and II, the place signs of conquered towns of Period II, and the names and/or dates, plus place signs, of bound captives of Period III-A. At other Zapotec sites on the valley floor the themes are quite different. Jaguars and various ritual themes are particularly conspicuous. A sample of the extensive corpus of carvings from other Valley of Oaxaca sites can be summarized as follows:

A. *Dainzú:* 80 + carved stones (Bernal 1967, 1968a, 1968b)
1. Seated and standing human figures with large headdresses.
2. Seated "humanized" jaguars or men outfitted as jaguars.
3. Ball players.
Date: End of Period I or beginning of Period II.

B. *Teotitlan del Valle:* 12 + carved stones
1. The standing jaguar (Seler 1904b:Fig. 70a; Rickards 1910:121).
2. Collared jaguar (Fig. 15).

3. Human figures carrying various staffs or weapons; all characterized by large spiral scroll at the corners of the mouths of the feathered (bird?, animal?) headdresses and by long, pendulous feathers (Seler 1904b: Figs. 69, 70b-c; Rickards 1910:121; Figs. 16-19).
Date: Period II or Period III-A?

C. *Macuilxochitl:* 25 + carved monuments
1. The "Marriage Scene" (to the left of church doorway).
2. Standing lord with right hand outstretched (similar to "scattering" gesture) and the left holding the bag (to the right of church doorway; Fig. 20).

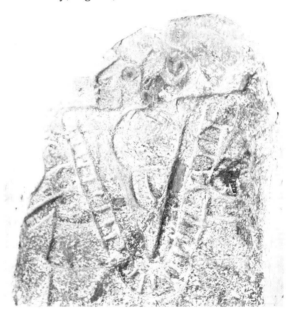

Fig. 16. Fragment of relief carving, Teotitlan del Valle, Valley of Oaxaca

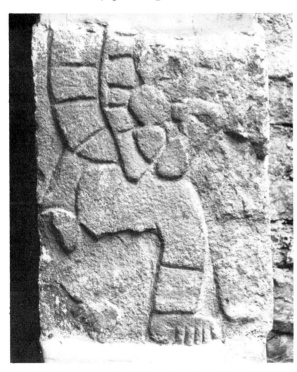

Fig. 15. Fragment of relief carving, Teotitlan del Valle, Valley of Oaxaca

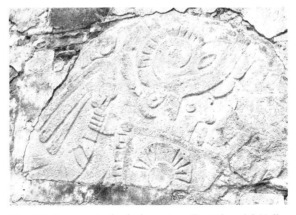

Fig. 17. Fragment of relief carving, Teotitlan del Valle, Valley of Oaxaca

3. Fragment of a jaguar. Possibly used as a
place name; if so, this would constitute the
only known example outside of Monte
Albán (located within church cloisters).

Date of No. 1: Period III-B, or, more probably,
IV.

Date of No. 2: Period III-A or III-B.

Date of No. 3: Period III-A?

Date of other monuments: post-III-B.

D. *Santa Inés Yatzeche:* at least 2 carved stones

1. Seated jaguar with shield (Fig. 21). Prom-
inent cross-hatching on eye and nose orna-
ment, on the device adjoining the shield,
and on a portion of the headdress (?). Two
"cipactli" heads face each other at the top of
this slab, and above them are depicted a
possible variant of Caso's Glyph E (D?) and
a monkey (?) head. We may be dealing here
with a human figure outfitted as a jaguar,
judging from the human hand "playing" the
shield.

2. Human skull with date 10 E (D?)? (Fig. 22).

Date of No. 1: Period III-A?

Date of No. 2: Period III-B or later.

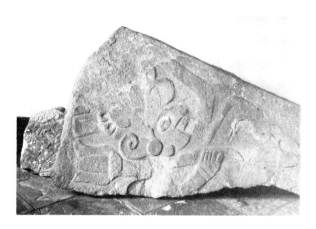

Fig. 19. Fragment of relief carving, Teotitlan del Valle,
Valley of Oaxaca

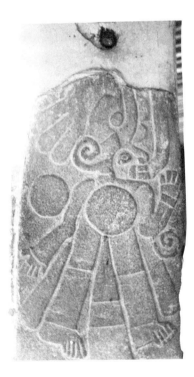

Fig. 18. Fragment of relief carving, Teotitlan del Valle,
Valley of Oaxaca

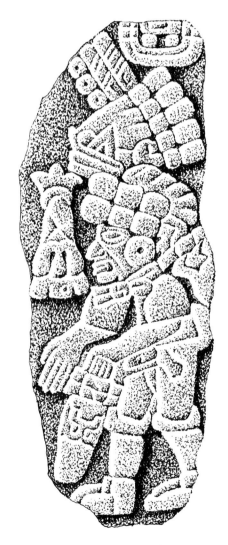

Fig. 20. Relief carving, Macuilxochitl, Valley of Oax-
aca, redrawn from Bernal and Seuffert 1973.

E. *Tlacochahuaya:* 11+ carved stones
   1. Long-nosed head lacking lower jaw (Fig. 23).
   2. Ruler holding staff similar to those shown at Dainzú and Teotitlan del Valle.
   Date of No. 1: Period II?

F. *Rancho Tejas:* 4+ carved stones (others unturned)
   1. Giant bat with huge pouch or bag; inset head in latter may be a monkey (Fig. 24).
   2. Kneeling human figure (Fig. 25). Glyph(s) (calendric?) to left of head. What appears to be a vessel is depicted to the left of the figure's outstretched hands.
   Date of No. 1: Period II or III-A?
   Date of No. 2: Period IV?
   Date of other monuments: Very late in style.

G. *Zaachila:* 9+ carved monuments
   1. In-the-round sculpture of a "long-nosed god" (Caso 1965:Fig. 18).
   2. Various carvings of figures and calendric signs in texts (Caso 1928:Figs. 75-77, 81; Rickards 1910:118).
   Date of No. 1: Period III-A?
   Date of No. 2: Period III-B or IV?

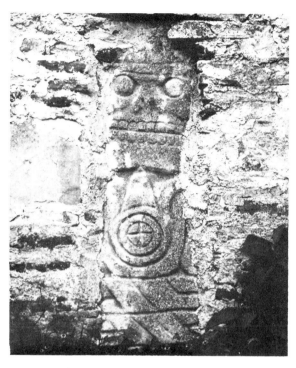

Fig. 22. Relief carving, Santa Inés Yatzeche, Valley of Oaxaca

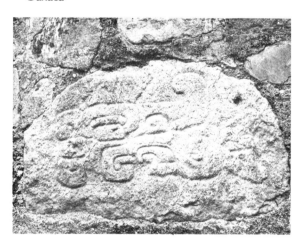

Fig. 23. Relief carving, Tlacochahuaya, Valley of Oaxaca

These monuments from seven sites on the valley floor constitute a representative sample of the regional styles; some are contemporaneous with those of Monte Albán. Approximately 100 carved monuments are known from sites other than Monte Albán; at Monte Albán more than 300 monuments have been located.

Few parallels can be drawn between style conventions and themes portrayed at Monte Albán and lesser towns in the valley. The Santa

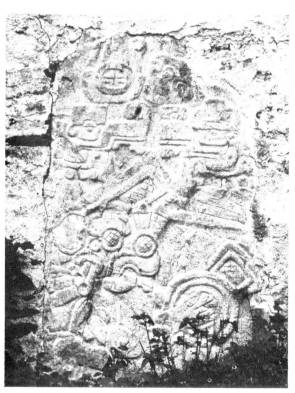

Fig. 21. Relief carving, Santa Inés Yatzeche, Valley of Oaxaca

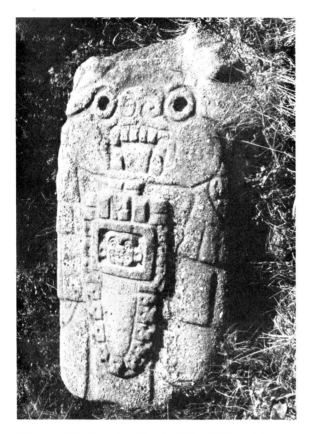

Fig. 24. Relief carving, Rancho Tejas, Valley of Oaxaca

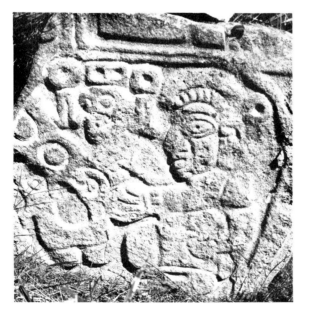

Fig. 25. Fragment of relief carving, Rancho Tejas, Valley of Oaxaca

Fig. 26. Monument 1, San José Mogote, Valley of Oaxaca

Fig. 27. Monument 2, San José Mogote, Valley of Oaxaca

Inés Yatzeche monument (Fig. 21), however, includes two long-nosed "cipactli" heads that are shown facing each other. Stela 1 at Monte Albán shows two similar "cipactli" heads below the throne which face away from each other. These two sculptures probably date to Monte Albán III-A times. The "long-nosed god" of Tlacocha-huaya (Fig. 23) relates stylistically to similar depictions in the Izapan style and to the full round sculpture from Zaachila (Caso 1965:Fig. 18), but very little is known about the specific relationships of the Zapotec region to the Izapan. What is clear is that all regional styles were abandoned by Monte Albán III-A times and those sites that continued to carve monuments did so in the Monte Albán style.

## VI. SUMMARY AND CONCLUSIONS

1. The period of so-called Olmec "influence" in the Valley of Oaxaca is 1200-900 B.C. , during the San José phase (late in the Early Formative). The similarities are limited to shared ceramic motifs.

2. The Guadalupe and Rosario phases (900-500 B.C.) witness the waning of these Olmec motifs in ceramics.

3. During Monte Albán I (500-100 B.C. ?) the site of Monte Albán is characterized by representations of slain captives, that is, *danzantes*; at least 300 *danzantes* date to 400 B.C. or more recent times. Neither the ball players of Dainzú or the *danzantes* of Monte Albán appear to be contemporaneous with Olmec sculpture of the Gulf Coast; rather, these Zapotec carvings seem to postdate Olmec monuments by at least 400 years. Thus, it is not surprising that these Oaxacan carvings show no Olmec traits.

4. Monte Albán in late Period I or early Period II constructed a double defensive wall (Blanton 1973), which coincided with or preceded the completion of the subjugation of towns memorialized on slabs set into Mound J.

5. By Monte Albán III-A times the subjugation of politically autonomous valley floor towns was relatively complete, and various regional sculptural styles disappeared and became more consistent with the dominant style of the capital, Monte Albán.

6. During Monte Albán IV times the power seat shifted to Zaachila and other sites like Lambityeco (Paddock, personal communication) on the valley floor.

## VII. SUMMARY OF THE POLITICAL HISTORY

Between 500 and 100 B.C. substantial population growth was manifested in the Valley of Oaxaca by an increase in the number of sites and the appearance of local political units, each with its own administrative center displaying monuments carved in a regional style. From 100 B.C. to A.D. 100 the largest of these Zapotec towns, Monte Albán, began to absorb and consolidate these previously autonomous centers into its political sphere, presumably by conquest and thereafter by exacting tribute. After a period of fortification evidenced by the construction of defensive walls and an intensive irrigation terrace system (Blanton 1973), Monte Albán may have pacified an area of about 30,000 square kilometers from Tehuacan and Cuicatlan to Tehuantepec and Tututepec, nearly eliminating regional styles in sculpture and replacing them with the dominant style developed at Monte Albán. In this process Monte Albán showed the first Mesoamerican use of the "emblem glyph" or place sign, the bar-and-dot system of numeration, the 260-day ritual calendar (Caso 1928), the first political conquest records, and the system of naming rulers by their birth dates. Many of these developments anticipated the "indigenous" developments in the Maya region by at least 500 years. The impact and antecedent role of this early urban and militaristic civilization on other Mesoamerican civilizations have been greatly underestimated (Flannery and Marcus 1972).

## ADDENDUM

Since this paper was written two carved stones (Figs. 26, 27) have been found at San José Mogote which securely date to the San José phase (1200-900 B.C.). Neither is at all Olmec in style, confirming that Olmec "influence" in the Valley of Oaxaca does not go beyond shared ceramic designs.

## Acknowledgments

The fieldwork for this project was carried out with financial support provided by the Ford Foundation grant through the University of Michigan's Museum of Anthropology. Other aid was supplied by the American Association for University Women and Dumbarton Oaks, Washington, D.C. My thanks go to Elizabeth P. Benson and Kent V. Flannery for reading earlier drafts of this paper and to Richard Amt for developing my photographs at Dumbarton Oaks. Lois Martin drew Figures 20, 26, and 27.

# References

Barlow, Robert H.
1943    The periods of tribute collection in Mocte-
        zuma's empire. *Carnegie Institution of Wash-
        ington, Notes on Middle American Archae-
        ology and Ethnology* 23:152-154.
1949    The extent of the empire of the Culhua
        Mexica. *Ibero-Americana* 28.
Barlow, Robert H., and Byron MacAfee
1949    Diccionario de elementos fonéticos en escri-
        tura jeroglífica (Códice Mendocino). *Univer-
        sidad Nacional Autónoma de México, Publi-
        caciones del Instituto de Historia, Primera
        Serie* 9.
Batres, Leopoldo
1902    *Exploraciones de Monte Albán por ... Año de
        1902.* Casa Editorial Gante, Mexico.
Berlin, Heinrich
1958    El glifo "emblema" en las inscripciones mayas.
        *Journal de la Société des Américanistes* 47:
        111-119.
Bernal, Ignacio
1967    La presencia Olmeca en Oaxaca. *Culturas de
        Oaxaca, Publicación* 1. Museo Nacional de
        Antropología, Mexico.
1968a   The Olmec presence in Oaxaca (introductory
        note by John Paddock). *Mexico Quarterly
        Review* 3:5-22.
1968b   The ball players of Dainzú. *Archaeology* 21:
        246-251.
Bernal, Ignacio, and Andy Seuffert
1973    Esculturas asociadas del Valle de Oaxaca.
        *Corpus Antiquitatum Americanensium*, Mex-
        ico VI. Union Academique Internationale,
        Instituto Nacional de Antropología e Historia,
        Mexico.
Blanton, Richard E.
1973    *The Valley of Oaxaca Settlement Pattern
        Project.* Progress report to the National
        Science Foundation. MS.
Bradomín, Jose María
1955    *Toponimia de Oaxaca (crítica etimológica).*
        Mexico.
Burgoa, Fr. Francisco de
1934    Geográfica descripción. *Publicaciones del Ar-
        chivo General de la Nación* (Mexico) 25, 26.
Caso, Alfonso
1928    *Las estelas Zapotecas.* Publicaciones de la
        Secretaría de Educación Pública. Monografías
        del Museo Nacional Arqueología, Historia y
        Etnografía. Talleres Gráficas de la Nación,
        Mexico.
1938    Exploraciones en Oaxaca, quinta y sexta
        temporadas 1936-1937. *Instituto Panameri-
        cano de Geografía e Historia, Publicación* 34.
1947a   Calendario y escritura de las antiguas culturas

de Monte Albán. In *Obras completas de
        Miguel Othón de Mendizábal* 1:115-143.
        Mexico.
1947b   Resumen del informe de las exploraciones en
        Oaxaca, durante la 7ª y la 8ª temporadas
        1937-1938 y 1938-1939. In *Vigesimoséptimo
        Congreso Internacional de Americanistas,
        Actas de la Primera Sesión Celebrada en la
        Ciudad de México en 1939*, 2:159-187.
1965    Sculpture and mural painting of Oaxaca. In
        *Handbook of Middle American Indians*, ed-
        ited by Robert Wauchope and Gordon R.
        Willey, 3:849-870. University of Texas,
        Austin.
Caso, Alfonso, and Ignacio Bernal
1952    Urnas de Oaxaca. *Memorias del Intituto
        Nacional de Antropología e Historia* 2.
        Mexico.
Coe, Michael D.
1962    *Mexico.* Frederick A. Praeger, New York.
1968    San Lorenzo and the Olmec civilization. In
        *Dumbarton Oaks Conference on the Olmec,*
        edited by Elizabeth P. Benson, pp. 41-78.
        Dumbarton Oaks Research Library and Col-
        lection, Washington.
Cruz, Wilfrido C.
1946    *Oaxaca recóndita: razas, idiomas, costum-
        bres, leyendas y tradiciones del Estado de
        Oaxaca.* Mexico.
Dávalos Hurtado, Eusebio
1951    Una interpretación de los danzantes de Monte
        Albán. In *Homenaje al Doctor Alfonso Caso*,
        pp. 133-141. Imprenta Nuevo Mundo, Mex-
        ico.
Dibble, Charles E.
1966    The Aztec writing system. In *Readings in
        Anthropology*, edited by E. Adamson Hoe-
        bel, Jesse D. Jennings, and Elmer R. Smith,
        pp. 270-277. McGraw-Hill Book Co., New
        York.
Dupaix, Guillermo
1834    *Antiquités Mexicaines. Relation des trois
        expéditions du Capitaine Dupaix, ordonnées
        en 1805, 1806, et 1807, pour la recherche des
        antiquités du pays, notamment celles de
        Mitla et de Palenque; accompagnée des des-
        sins de Castañeda ...* 2 vols. (text and atlas
        of plates). Bureau des Antiquités Mexicaines,
        Paris.
1969    *Expediciones acerca de los antiguos monu-
        mentos de la Nueva España, 1805-1808.*
        Edición, introducción y notas por José Alcina
        Franch. 2 vols. (text and atlas of plates).
        Colección Chimalistac de Libros y Documen-
        tos acerca de la Nueva España, Ediciones

José Porrúa Turanzas, Madrid.

Espíndola, Nicolás
1905 Relación de Chichicapa y su partido. In *Papeles de Nueva España, Segunda Serie, Geografía y Estadística*, edited by Francisco del Paso y Troncoso, 4:115-143. Madrid.

Flannery, Kent V.
1968 The Olmec and the Valley of Oaxaca: a model for inter-regional interaction in Formative times. In *Dumbarton Oaks Conference on the Olmec*, edited by Elizabeth P. Benson, pp. 79-117. Dumbarton Oaks Research Library and Collection, Washington.

Flannery, Kent V., and Joyce Marcus
1972 *The rise of Zapotec civilization; archaeology and epigraphy of the Valley of Oaxaca, Mexico.* Lecture presented at Dumbarton Oaks, Center for Pre-Columbian Studies, Washington.

Furst, Peter T.
1968 The Olmec were-jaguar motif in the light of ethnographic reality. In *Dumbarton Oaks Conference on the Olmec*, edited by Elizabeth P. Benson, pp. 143-178. Dumbarton Oaks Research Library and Collection, Washington.

García, José María
1859 Descripción de algunos sitios del Departamento de Oaxaca. *Boletín de la Sociedad Mexicana de Geografía y Estadística*, época 1, 7:268-275.

Grossman, Mary Louise, and John Hamlet
1964 *Birds of prey of the world.* Bonanza Books, New York.

Gutiérrez, Esteban
1905 Descripción del partido de Miahuatlan. In *Papeles de Nueva España, Segunda Serie, Geografía y Estadística*, edited by Francisco del Paso y Troncoso, 4:289-300. Madrid.

Holmes, William H.
1897 Archaeological studies among the ancient cities of Mexico. Part II, monuments of Chiapas, Oaxaca and the Valley of Mexico. *Chicago, Field Columbian Museum, Publication 16, Anthropological Series* 1(1).

Kingsborough, Lord (Edward King)
1831- *Antiquities of Mexico.* 9 Vols. Robert Havell
1848 and Henry G. Bohn, London.
1964 *Antigüedades de México, basadas en la recop-ilación de Lord Kingsborough.* Estudio e interpretación, José Corona Nuñez. Volumen I. Secretaría de Hacienda y Crédito Público, Mexico.

Long, Richard C. E.
1942 The payment of tribute in the Codex Mendoza. *Carnegie Institution of Washington, Notes on Middle American Archaeology and Ethnology* 10:41-44.

Martínez Gracida, Manuel
1883 *Catálogo etimológico de los nombres de los pueblos, haciendas y ranchos del Estado de Oaxaca.* Oaxaca.

Paddock, John.
1966 Monte Albán: ¿sede de imperio? *Revista Mexicana de Estudios Antropológicos* 20:117-146.

Peñafiel, Antonio
1885 *Nombres geográficos de México . . .* Secretaría de Fomento, Mexico.

Rojas, Basilio
1958- *Miahuatlan: un pueblo de México.* 3 vols.
1964 Mexico.

Seler, Eduard
1904a- Die archäologischen Ergebnisse meiner ersten
(1890) mexikanischen Reise. In his *Gesammelte Abhandlungen zur Amerikanischen Sprachen- und Alterthumskunde*, 5 vols., Verlag A. Asher and Verlag Behrend, Berlin, 2:289-367 (augmented version, with many added illustrations, of article first published in the proceedings of the Seventh International Congress of Americanists, Berlin, 1888 [Berlin, 1890], pp. 111-145).
1904b The wall paintings of Mitla. In Mexican and Central American antiquities, calendar systems, and history; twenty-four papers by Eduard Seler, E. Förstemann, Paul Schellhas, Carl Sapper, and E. P. Dieseldorff, translated from the German under the supervision of Charles P. Bowditch. *Bureau of American Ethnology, Bulletin* 28:247-324.

Villagra, Agustín
1947 "Los danzantes": piedras grabadas del Montículo "L," Monte Albán, Oax. In *Vigesimoséptimo Congreso Internacional de Americanistas, Actas de la Primera Sesión Celebrada en la Ciudad de México en 1939*, 2:143-158.

# Late and Terminal Preclassic:
# The Emergence of Teotihuacán

## Hasso von Winning

Southwest Museum, Los Angeles

This is plain that there at Teotihuacán, as they say, in times past, when yet there was darkness, there all the gods gathered themselves together, and they debated who would bear the burden, who would carry on his back, would become, the sun. And when the sun came to arise, then all the gods died that the sun might come into being. None remained who had not perished. And thus the ancient ones thought it to be.

<div align="right">Sahagún, Florentine Codex</div>

In central highland Mexico the transition from the Preclassic to the Classic period is determined by the coming of age of the largest city of Pre-Columbian America, Teotihuacán. It was the dominant political and religious center in the Basin of Mexico for more than five centuries, during which time it exerted far-reaching influences that radiated in various directions over ancient trade routes, as far as the Maya area. These are evident in the peculiar art style of Teotihuacán ceramics, in sculpture, and architecture.

Even today, almost thirteen centuries after its decline and fall, Teotihuacán presents a formidable aspect with its two enormous pyramids, its religious and residential compounds intersected by streets, its architectural sculptures and mural paintings. Impressive, too, is the layout of the city with its rectangular Ceremonial Precinct, arranged according to an early conceived plan along the north-south axis—the Street of the Dead—and the sheer vastness and monumentality of the buildings.

We are here concerned only with the beginnings of Teotihuacán. What factors contributed to the cultural development during the incipient stages of the Teotihuacán culture? Particularly, what are the early manifestations in religious art and where did these originate?

## RESEARCH

Teotihuacán and the Teotihuacán Valley are among the most thoroughly explored archaeological sites in Mexico. It is not necessary here to recapitulate the early history of explorations that began with Batres in 1889 and were continued by numerous researchers through the early 1960s. Since then three major research projects have yielded a vast body of information and, in particular, have shed light on the early beginnings of Teotihuacán.

The Teotihuacán Valley Project was carried out 1960-1965 by the Pennsylvania State University under the direction of William T. Sanders. Research focused on rural settlement patterns and covered a survey area of 600 square kilometers. Its

approach was directed from the rural hinterland toward the periphery of the Classic urban center. Specifically, the project traced the history of the development of agriculture and of rural and outlying urban communities. In the reports published so far, data on agricultural practices, land use, settlement patterns, and demography are discussed in chronological sequence from the Early Preclassic through modern times (Sanders 1960-1963, 1964, 1965, 1970).

In 1962 the Teotihuacán Mapping Project was initiated by René Millon and James A. Bennyhoff, as research associate, both of the University of Rochester. The purpose was to map, through the use of photogrammetry and ground survey, the ancient city and to determine its maximum extension and configuration. According to preliminary reports, Teotihuacán already in Late Preclassic times was a settlement of large size. The project was recently completed and a series of small maps showing the progressive development and extension of the early city were published (R. Millon, 1966, 1967, 1970). A final report with large maps is forthcoming.

Simultaneously, the Mexican government, under the auspices of the Instituto Nacional de Antropología e Historia (INAH), accomplished a large scale program of exploration and reconstruction in the ceremonial compound of Teotihuacán, 1962-1964. It was concentrated on the buildings flanking the Street of the Dead and the plaza in front of the Pyramid of the Moon. Some spectacular discoveries have been made, relating mainly to the Classic period, and were partially published by Acosta (1964) and Bernal (1963, 1965). Analysis of vast amounts of potsherds apparently has not been completed. A sequential summary of select pottery types was published but without illustrations (Kolb 1965; Müller 1966) and a large wall chart in the Museo Nacional de Antropología in Mexico City gives a fairly good overview of the development through time of diagnostic items such as *braseros, floreros, candeleros,* Tlaloc effigies, and the like. It accompanies a display of Teotihuacán pottery and figurines, but the sequential order of this impressive collection is impaired

by lack of labeling and subsequent rearrangements. The Regional Museum at Teotihuacán, located in a new building since 1964, contains a display on a much smaller scale.

To gain an overview of the accomplishments of the three projects, the XI Mesa Redonda Conference, organized by the Sociedad Mexicana de Antropología, was held in Mexico City in August 1966. The papers presented were published in two volumes, the first of which appeared in 1968 (dated 1966), and the second in 1972 (Teotihuacán Onceava Mesa Redonda 1966, 1972).

## CHRONOLOGY

Traditionally, Teotihuacán was considered to date back to nebulous antiquity. It was believed that the enormous pyramids could only have been built by giants, according to legend recorded in the sixteenth century. As the Place of the Gods it was still revered by the Aztecs and therefore thought to

have preceded the works of ordinary humans.

The great age of the Sun Pyramid was first confirmed by Noguera's discovery, in the fill of the Pyramid, of a very early type of figurine that at the time was not recognized elsewhere in Teotihuacán (Noguera 1935; Pérez 1935).

A greatly refined ceramic sequence resulted from the recent explorations. There are some differences between the INAH nomenclature and dates and those used by the American projects. Among the various chronologies published so far— and there are more different versions than for any other site—there is general agreement on the succession of phases if not on duration. For present purposes we shall be concerned mainly with the Late Preclassic (600-200 B.C.) and the Terminal Preclassic phases (200 B.C.-A.D. 250) (see chronological chart).

The phase names are taken from the type sites in the Teotihuacán Valley. A brief summary of the phase characteristics in terms of settlement and population seems indicated.

Map of the Teotihuacán Valley. From Sanders, 1965. 1, Sun Pyramid; 2, Moon Pyramid; 3, Ciudadela.

Chronological chart.

**Date scale (top):** 800 700 600 500 400 300 200 100 0 100 200 300 400 500 600 700 800 900 1000

**TEOTIHUACAN CONSOLIDATED SEQUENCE (CHW 1973)**

EARLY CLASSIC / PRECLASSIC (TERMINAL, LATE, MIDDLE)

Métepec · L.Xolalpan · E.Xolalpan · L.Tlamimilolpa · E.Tlamimilolpa · Miccaotli · L.Tzacualli · E.Tzacualli · Patlachique · Tezoyuca · Cuanalán · Chiconautla · Altica

**VALLEY of MEXICO (Heizer and Bennyhoff 1972)**

CLASSIC / PRECLASSIC (TERMINAL, LATE, MIDDLE)

Teo II–IIIA · Teo IIA · Miccaotli · Cuicuilco VB Tzacualli, Teo.I,I.A · Cuicuilco VA (Chimalhuacán) Patlachique · Cuicuilco IV/Ticomán IV Tlapacoya/Tezoyuca · Cuicuilco III/Ticomán III · Cuicuilco II/Ticomán II · Cuicuilco IB/Ticomán IB · Cuicuilco IA/Ticomán IA

**TEOTIHUACAN — AMERICAN NOMENCLATURE (Leonard 1971 Millon 1966)**

CLASSIC / PRECLASSIC

Metepec = Teo IV · E/L.Xolalpan= Teo IIIA · Teo III · L.Tlamimilolpa · E/L.Tlamimil.= Teo III · Miccaotli = Teo IIA–III · E/L.Tzacualli = Teo II A · Patlachique = Teo II · Tezoyuca = Teo I A · L.Cuanalán = Teo I · M.Cuanalán · E.Cuanalán · Tlatilco · M.Prec.

**Leonard, Piña Chan 1967**

TEOTIHUACAN / LATE PRECLASSIC

Teo D · Teo C · Cuanalán

**INAH NOMENCLATURE (Müller 1966)** / Leonard 1971 (Armillas)

Proto-Coyotlatelco · Teotihuacán IV (Metepec) · Teo IIIA (L.Xolalpan) · Teo III (E.Xolalpan) · Teo IIA–III (L.Tlamimilolpa) · Teo IIA (E.Tlamimilolpa) · Teo Transition · Teo II (Miccaotli) · Teo IA (L.Tzacualli) · Teo I A (E.Tzacualli) · Proto-Teotihuacán (Patlachique) · Proto-Teotihuacán (Tezoyuca)

Leonard 1971 (Armillas): Teo IV · Teo IIIA · Teo III · Teo IIA-III · Teo IIA · Teo II · Teo IA · Teo I · Proto-Teo I

**TEOTIHUACAN VALLEY (Sanders 1965)**

PRECLASSIC (TERMINAL, LATE, MIDDLE, EARLY) / CLASSIC

Metepec · Maquixco (L.Xolalpan) · Xolalpan · Late Tlamimilolpa · Early Tlamimilolpa · Miccaotli · Apetlac (E.Miccaotli) · Teopan · Oxtotla · Tezoyuca–Patlachique · Cuanalán · Chiconauhtla · Altica

**Date scale (Sanders column):** 800 700 600 500 400 300 200 100 0 100 200 300 400 500 600 700 800 900 1000

*Altica phase* (ca. 1000-900 B.C. ). The type site is located in the southeast corner of the valley, to the east of the Patlachique Range (see map). Communities tended to be very small and were located mostly to the southeast of the Classic Ceremonial Precinct. Beginning in the Middle Preclassic *Chiconautla phase* (800-700 B.C.) a very light but consistent occupation of the alluvial plain and nearby piedmont is noted. The type site is at the southwestern entrance to the valley. No structures have been preserved on any Altica and Chiconautla phase sites (Sanders 1965:153-154).

During the *Cuanalan phase* (beginning of the Late Preclassic, ca. 600-200 B.C.; type site in the Lower Valley, between Cerro Chiconautla and the Patlachique Range) more nucleated, densely settled communities emerge with a more evenly distributed population over the entire valley (Sanders 1965:93). Pottery, burials, house floors, and walls indicate the emergence of small villages of about 250-300 people.

The *Tezoyuca phase* (200-100 B.C.; Proto-Teotihuacán I in the Mexican nomenclature; type site in the Lower Valley between Patlachique Range and Lake Texcoco to the west) bears the first indication of civic architecture at Tezoyuca, consisting of a large platform mound with a single sloping *talud* and a facing of irregular blocks of *tepetate*. Other Tezoyuca phase sites have one or two ceremonial buildings and a small, densely settled occupation zone. A very close relationship of Tezoyuca ceramics to those of Cuanalan suggests that the Tezoyuca potters descended from Cuanalan.

Until the *Patlachique phase* (100-1 B.C. ) a fairly uniform ceramic complex prevailed over the entire central Mexican region.

The Terminal Preclassic, which includes the *Tzacualli* and *Miccaotli* phases (Teotihuacán Ia, renamed Tzacualli by Armillas, and Teotihuacán II, respectively), indicates striking changes in population, settlement, and agricultural patterns in the Teotihuacán Valley which heralded the florescence of the Classic civilization. Sanders felt that the Tzacualli phase is actually the initial Classic and he therefore included the Miccaotli phase in the full Classic (Sanders 1965:16). H. B. Nicholson tends to favor this point of view (personal information). Other investigators (INAH, Millon, Heizer, and Bennyhoff) draw the line between Terminal Preclassic and full Classic at the beginning of the Early Tlamimilolpa phase

at A.D. 250 when the spectacular growth of the gigantic metropolis was well under way.

In general, there is strong evidence for a cultural and population continuity in the Teotihuacán Valley from the first Middle Preclassic occupation throughout the prehistory of Teotihuacán to the end of the Early Classic period.

## ENVIRONMENT AND CLIMATE

The Teotihuacán Valley is the drainage basin of the Río San Juan, which empties into Lake Texcoco to the southwest, and it forms part of a larger unit, the Basin of Mexico. The valley is approximately 35 kilometers long and slopes gently from northeast to southwest. This slope is perceptible along the Street of the Dead, which is in part terraced. The altitude of the valley floor is 2240 to 2300 meters.

In the north the valley is limited by the Cerro Gordo, a 3050 meter high mountain that seems to have been a pivotal feature in the planning of the city. The south and southeast edges of the valley consist of small plateaus and a series of hills with tributary valleys, called the Patlachique Range. To the northeast the valley is open to the Tepeapulco-Apan plain with a long ridge that serves as a watershed. To the west the valley is open with access toward the southwest to Lake Texcoco (Sanders 1965:22-23).

Rainfall is fairly typical of that in the Basin of Mexico but there is a greater tendency for a later beginning of the rainy season and for generally lower rainfall than elsewhere in the basin. Furthermore, internal droughts are more severe in the valley than anywhere else in the Basin of Mexico. The pattern of precipitation retards planting and delays plant growth, which is also affected by early frosts. There are about 80 springs in a small area within and just outside of the village of San Juan that provide a regular supply of water. Understandably, water is the most important single factor that affected settlement in the area.

The climate during the Early and Middle Preclassic was favorable for extensive agriculture, according to fossil pollen analysis (Kovar's pollen graphs in Sanders 1965:Fig. 16a). The Late Preclassic and particularly the Terminal Preclassic were periods of lower rainfall, which reduced the lake level. In Sanders' opinion, it was a challenging period for the farmers who had to find ways to adapt themselves to the new ecological situation.

During the Classic periods the climate was generally favorable (Sanders 1965:24).

## AGRICULTURE

Agriculture and land use were dominant factors in the growth of Teotihuacán with its large populations estimated tentatively by Millon between 70,000 and 125,000, perhaps even exceeding 200,000 at the peak of Xolalpan phase (Millon 1970:1080). In pre-Tzacualli times a modified form of slash-and-burn cultivation called *tlacolol* was favored because of high yields. Tlacolol cultivation, which is still practiced in parts of Highland Mexico, involves clearing of vegetation that is burned when sufficiently dry. The system requires that after two or three years of successive cultivation the field must lie fallow for an equal or longer period.

Significant changes in the pattern of land use occurred between the Patlachique and Tzacualli phases. A much more productive agricultural economy supported the first large urban or semi-urban community and the first really monumental architecture of that period.

In Miccaotli times and during the incipient florescence of Teotihuacán the practicing of intensive agriculture can be deduced from indirect evidence. The distribution of occupation sites suggests that the lands directly under control by the urban population seem to have been limited to the alluvial plain and adjacent piedmonts of the Teotihuacán Valley. The location of the city appears to be a strategic one in relation to agricultural land and water. For the Classic period it is assumed that intensive cultivation involved floodwater and permanent irrigation in the plain and terracing in the piedmont. In addition, food was probably imported by trade or as a result of taxation from outlying areas, so that the population could have been supported by an area only slightly larger than the Teotihuacán Valley (Sanders 1965:157-158).

The history of water control in the valley appears to be of considerable antiquity. Water conservation was a necessity. Sanders found abundant indications of abandoned canals, drainage ditches, and dams, but these provide no secure base for dating owing to erosion and deposition. He described the canals excavated in Teotihuacán as nothing more than excavated ditches. The only direct evidence of Early Classic irrigation is the

Tepantitla mural depicting the Tlalocan. In the Tlalocan green rectangular areas are intersected by blue bands that indicate canals in fairly regular patterns (Armillas in Sanders 1965:159).

Verification of terracing is equally difficult. No definite terracing remains are in evidence for the pre-Tzacualli population, since nearly all Teotihuacán sites have components of a later Aztec occupation (Sanders 1965:152).

## CUICUILCO, THE PRECURSOR OF TEOTIHUACAN, AND CHIMALHUACAN

At this point it is pertinent to consider the cultural development in the rest of the Basin of Mexico as far as it relates to Late and Terminal Preclassic Teotihuacán.

Excavations at Cuicuilco in 1957 by Heizer and Bennyhoff, which were not published in final form until 1972, constitute a major contribution to the prehistory of the Valley of Mexico which ranges back in time to the Early Preclassic Tlalpan phase (ca. 2000 B.C.). Specifically, the explorations established three subphases for the Terminal Preclassic of Cuicuilco. Cuicuilco is now regarded on the basis of a new ceramic tradition as the main center that dominated the Valley of Mexico during the entire Late Preclassic. As such it contributed to the emerging Teotihuacán tradition. It is now suggested that the newly established phases be named after their major center, Cuicuilco, rather than Ticoman, which was only a small village.

At the beginning of the Terminal Preclassic Cuicuilco IV phase (ca. 200-100 B.C.) a disruption occurred in the Cuicuilco tradition of the previous Phase III. Localized cultures emerged in various parts of the Valley of Mexico and at the same time a strong intrusion from the north, derived from the Chupícuaro tradition, manifested itself by the H-4 figurine horizon, as well as adaptation to new pottery traits. Social upheaval resulted in the destruction of temple platforms at the Cuicuilco A Pyramid and in other mounds.

Phase IV Cuicuilco in the new scheme is equivalent to Ticoman IV/Temesco/Tlapacoya/ Cerro del Tepalcate and, at Teotihuacán, with Tezoyuca.

A resurgence of the Cuicuilco tradition, in Phase V-A (ca. 100 B.C.-A.D. 1) is noted by the modified incorporation of southern ceramic complexes that already were introduced from Puebla in Phase IV, while Chupícuaro traits were being

largely rejected. Cuicuilco Phase V-A is equated with Chimalhuacan and with Patlachique at Teotihuacán where we have seen the beginning of small ceremonial structures. Obviously, the rapid growth of Teotihuacán spelled a potential threat to Cuicuilco supremacy.

Phase V-B Cuicuilco is regarded as the final occupation phase during which, or immediately after, the site was completely overshadowed by Teotihuacán (Tzacualli phase). A few Tzacualli trade sherds found in the hearting of a Cuicuilco structure indicate distinct ceramic innovations developed in Teotihuacán. Midden deposits for this and later phases were not found. It is therefore suggested that the rivalry between Teotihuacán and Cuicuilco led to the cessation of its ceremonial function by A.D. 150. Volcanic eruptions may have occurred during this phase. The major eruption of Xitle, with its subsequent lava flow that covered the pyramid, is believed to have taken place in A.D. 400 (=Late Tlamimilolpa or Teotihuacán II-IIIA).

A cache containing two stone figurines comparable to Miccaotli types was recently found on top of a temple platform covered by the lava flow. It is assumed that this offering was left by devotees who returned to the abandoned ceremonial center, a practice that was widespread in Mesoamerica. (Heizer and Bennyhoff 1972:93-104).

Now that the Terminal Preclassic sequence is clarified by a subdivision into four phases, Vaillant's point of view that Ticoman, which he had compacted into one phase, is contemporaneous with Teotihuacán I (Tzacualli) is no longer tenable. Cuicuilco is considerably earlier and marked the beginnings of urbanism and the origin of the city state in the Valley of Mexico.

Chimalhuacan, a small village site on the eastern shore of Lake Tezcoco that had been excavated by Noguera (1943), produced a distinctive pottery complex that was similar to that found in the Pyramid of the Sun but also showed resemblances with Late Ticoman. The Teotihuacán Valley Project discovered many sites with Chimalhuacan pottery. These ceramics are now recognized to be a local variant developed at Teotihuacán and were given the name Patlachique phase, to distinguish the variant from the Chimalhuacan phase outside the Teotihuacán Valley. The Patlachique phase represents, according to West (1965:194-201), one of the many local movements that occurred in the Valley of Mexico and which

contributed to the development of urban traits at Teotihuacán.

## ARCHITECTURE

Data on the nonceremonial architecture in the Teotihuacán Valley during the early part of the Middle Preclassic are meager. The use of building materials was related to the distribution of raw materials. Adobe houses were built in the plainside communities, stone houses in the piedmont and hilly terrain. A Cuanalan phase house consisted only of a single room with a lean-to kitchen.

The first, although minor, civic architecture dates from the Tezoyuca phase. It is a large platform mound with single sloping *talud* and with a facing of irregular blocks of *tepetate* covering a nucleus of earth and rock. Apparently the platform was constructed in three successive stages. No traces remain of a construction on top (Sanders 1965:94-95). At Cuicuilco cobble-faced structures predate the Tezoyuca platform by approximately three centuries (Heizer and Bennyhoff 1972:99).

Remains of a Patlachique ceremonial site outside the Early Classic city are inadequate evidence because of reconstruction and modification in Aztec times.

Construction in what is now the Ceremonial Precinct was initiated by 100 B.C. and continued on a grandiose scale thereafter. Foremost among these buildings is the Pyramid of the Sun. Its enormous size impressed even Sahagún, who recorded the belief of the sixteenth-century inhabitants that this pyramid and its companion, the Pyramid of the Moon, had been built by giants. Later investigators, who were equally impressed because such a building was raised to its present full height of 63 meters, thought that it must have been erected in one single operation during the earliest phase of Teotihuacán occupation when no comparable structures were built elsewhere in Mesoamerica. Therefore the question was raised whether Teotihuacán civilization had been imported in toto, perhaps from the Gulf Coast, or whether the pyramid could have been built by the local population that early in Teotihuacán history. Reconstruction to its present appearance—the accuracy of which is criticized by some scholars—was carried out by the Mexican archaeologist Leopoldo Batres between 1905 and 1910. His excavations had suggested that there were no major

masonry structures inside the pyramid, an assumption that was confirmed by Gamio (Marquina in Gamio 1922:I:132-134), who in 1917 excavated a tunnel from the rear of the pyramid to its center. This tunnel, however, revealed pottery and figurines of a type so far unknown at Teotihuacán, thereby raising new problems.

A second tunnel, excavated by Noguera in 1933, once again confirmed that the pyramid had been built in one single operation, containing no earlier substructure, and that the ceramic material was found nowhere else in Teotihuacán except in the adobes in the interior of the Pyramid of the Moon and in the fill of two other structures. Since no occupation areas or in situ midden deposits were known or recognized to contain Tzacualli phase ceramics, it was doubted that the pyramid could have been built by a people who had never occupied Teotihuacán in appreciable numbers. Yet it seemed certain that the pyramid was built at an early date since no ceramic or other remains later than Teotihuacán I were found in the tunnels.

The problem was clarified later with the discovery at Oztoyahualco (located within the Teotihuacán archaeological zone) of a major Tzacualli phase urban community, with ceremonial architecture, which covered several square kilometers. The argument for doubting an early date of the pyramid was thereby removed. That no interior structures had been recognized, however, and that therefore a pyramid of such enormous dimensions must have been built in one single undertaking did not agree with Mesoamerican building concepts, where platforms and structures were periodically enlarged. The possibility that an earlier interior structure of earth and clay had been overlooked led to further investigations of the tunnels in 1959 by a team of the University of Rochester (Millon, Drewitt, and Bennyhoff 1965).

Reexamination of the tunnel system yielded significant information. The pyramid still appears to have been built, perhaps over a period of 50 years, in the Late Tzacualli phase and was completed before the emergence of the developed Miccaotli phase. It can be dated between A.D. 100 and 200. It was found to contain a smaller stone-faced structure of yet undetermined dimensions. The so-called Plataforma Adosada was formerly faced with adobes and was not directly attached to the pyramid. The present Plataforma Adosada was presumably built in the Miccaotli phase. Furthermore, no materials characteristic of the Miccaotli phase were found inside the pyramid, except in the later Plataforma Adosada.

The populous and stratified Tzacualli society residing in Teotihuacán and in the hinterland is deemed capable of erecting the pyramid, which is considered to be perhaps the greatest single construction project in Mesoamerican history. The incentives, however, are not clear. Millon and his associates believe that the motivation stemmed from the conviction that the people, in building the pyramid, were doing something fundamentally good and desirable. Religious motivation must have been a strong factor, but this point cannot yet be verified (Millon, Drewitt, and Bennyhoff 1965:35).

In Tzacualli times also the Pyramid of the Moon was built, as well as other buildings that must have existed at lower levels. Traces of some of these constructions were found at Oztoyahualco.

During the INAH explorations the Plaza de la Luna and its adjacent buildings, in particular the Palacio de Quetzalpapalotl (now called Quetzal Mariposa), an area of about three hectares, was cleared of debris and reconstructed. Most of these buildings, including the substructure of the Palacio de Quetzalpapalotl, display the typical Classic Teotihuacán closed *tablero* above a small *talud*. Three carbon 14 dates, based on wooden pillars of the Antesala 1 and from the Patio de los Pilares, range between A.D. 50 and 250. These are unacceptable, according to Acosta, who, on architectural and stylistic grounds, attributes the entire building complex to the Late Xolalpan phase (A.D. 550-650) (Acosta 1964:63).

Bernal reviewed the problem of the surprisingly early radiocarbon dates. He cited seven dates for Quetzalpapalotl, which range between A.D. 50 and 290, and therefore tentatively shifted Teotihuacán III (Late Tlamimilolpa, and Early and Late Xolalpan) back by 250 years. To bridge the gap between the chronology based on architecture and that based on ceramics Bernal postulates two collapses, the first one indicated by the cessation of all building activity and a virtual end to the functions of the Ceremonial Precinct at approximately A.D. 300, and a second, final, collapse of the peripheral city in A.D. 650 (Bernal 1965:27-35; incidentally, Millon, 1967:48, dates the collapse at A.D. 750). It seems unlikely, however, that Teotihuacán ceased to exist as a spiritual and political center as early as A.D. 300, since there is abundant evidence of continued and widespread

Teotihuacán influence in other areas. This is not the place to pursue the subject further; it was brought up here only because the early dates fall within the Terminal Preclassic. The architectural features, however, including the numerous sophisticated mural paintings, are linked iconographically with decorated ceramics for which a convincing developmental sequence has been established which reaches well beyond the supposed early collapse of the ceremonial center.

Returning to one final point concerning the early architecture of Teotihuacán, it now appears that the plan for the city was established as early as Tzacualli, with the Street of the Dead as the main north-to-south axis. Marquina concluded that the position of the Sun Pyramid determined the orientation of the city. The orientation of the pyramid and of all other major ceremonial structures is usually given as 17 degrees west of north (Marquina 1951:71, "derivación aproximada 17° del oeste al norte") but was actually 15° 25' east of north (Drewitt 1966:82-84). The reason for this orientation was that buildings facing west would have the sun on the day it passes zenith directly in front of the monument. Another hypothesis for the alignment of the Street of the Dead has been advanced by Tobriner (1972:103-113), who noted that this main axis points directly to the Cerro Gordo with the Pyramid of the Moon at its foot. The reason for building the street pointing to the Cerro Gordo, which is an impressive 3050 meter high mountain, is that it had been a major source for the water supply and was therefore in some way associated with the worship of the rain god. This brings us to the subject of religion.

## RELIGION

Water was the most important factor that determined settlement in the Teotihuacán Valley. Understandably, the cult of the rain god was supreme and its representation in sculpture, mural paintings, and ceramics is most common. In the Early Classic the rain god complex is variously depicted combining reptile, jaguar, starfish, flower, and warrior aspects (Kubler 1967:9). Known as Tlaloc in Highland Mexico—from *tlatoa*, to make sprout, or "earthy" (the latter translation by Thelma Sullivan, personal information from H. B. Nicholson)—the rain god complex was associated with the various aspects of water (rain, moisture, lakes, rivers, frost) and therefore

agricultural fertility. Its connection with the jaguar is expressed in several mural paintings at Yayahuala and elsewhere, showing Tlaloc emerging from the jaws of a feline (Caso 1966:252, Fig. 8; von Winning 1968). Esther Pasztory, in a paper, "The Iconography of the Teotihuacán Tlaloc," to be published in *Studies in Pre-Columbian Art and Archaeology*, Dumbarton Oaks, distinguishes two types of Tlaloc in Classic Teotihuacán, with occasionally intermixed diagnostic traits and presumably different but related cults.

Covarrubias traced the stylistic evolution of the Olmec jaguar mask into Classic period representations of rain gods in Highland Mexico, at El Tajín, Monte Albán, and the Maya area (Covarrubias 1957:62, [Fig. 22]). In Teotihuacán the first evidence of a rain god cult are effigy vases with modeled Tlaloc features, whose characteristics continued through Aztec times; these also suggest Olmec derivation according to Covarrubias' chart. The outstanding attributes of the typical Teotihuacán Tlaloc vase are protruding eyeballs or rings around the eyes, eyebrows, and a long curved upper lip or jaw with prominent teeth or long canines protruding from the corners of the mouth.

The earliest Tlaloc effigy vase, which is recognizable as such by its bulbous eyeballs and curved upper lip but without teeth, was found at the juncture of the Sun Pyramid and the Plataforma Adosada and is believed to have been made during the Tzacualli phase on account of the paste composition (Millon, Drewitt and Bennyhoff 1965:Fig. 95) (Fig. 1). Classic period Tlaloc vases are but little more elaborate: the rim sometimes shows the addition of three leaf-shaped elements and to the sides of the head is attached a serpent, the emblem of lightning. In the Postclassic the nose of Tlaloc is often represented by a twisted serpent body that extends above the eyes, forming the brows in place of the usual goggles. The large curved upper lip and the teeth complement the isolated protruding canines of earlier times. It can be concluded that the evolution of the Teotihuacán Tlaloc vase, from Tzacualli on, shows little elaboration. Covarrubias, who could not have known of the Tzacualli vase, showed in his chart (1957:Fig. 22) the very sophisticated (Xolalpan phase) jade vase (1957:Fig. 22r) which was given to Bishop Plancarte in the village of Nachititla in the state of Mexico, as a direct descendant of an unspecified Olmecoid vase (Fig. 22q) followed, in

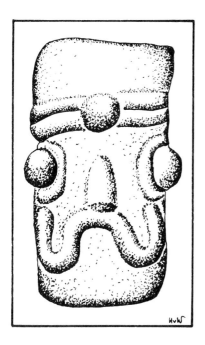

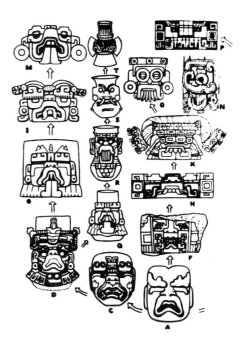

Fig. 1. Earliest known Tlaloc effigy; Tzacualli phase, after Millon, Drewitt, and Bennyhoff 1965:Fig. 95.

Fig. 2. Chart showing "Olmec influence on evolution of the jaguar mask into rain gods," from *Indian Art of Mexico and Central America*, by Miguel Covarrubias, Fig. 22. (Copyright © 1957 by Alfred A. Knopf, Inc. Reprinted by permission of the publisher.)

turn, by a very simple Tlaloc effigy (Fig. 22s). I think that in the light of the Tzacualli find Covarrubias' evolution of the rain god vases (Fig. 22c, d, q, r, s) is no longer acceptable (see Fig. 2).

The oldest god recognizable in archaeological remains in Highland Mexico is Huehueteotl, the Old Fire God. He is distinguished by a wrinkled toothless face, sits in a forward bent position, and has a basin on his head or back. The earliest clay effigies are known from Cuicuilco (Fig. 3), and a stone fire god figure has been reported from

Ticomán (Nicholson 1971:96). Beatríz Barba de Piña Chán mentioned in her Tlapacoya report (1956:37) that a figure with wrinkled face and a basin on the head was found at Tlatilco, but her reference is incomplete and cannot be checked. The basin obviously served for the burning of incense because the receptacles of Classic Teotihuacán fire god stone sculptures show smoke stains.

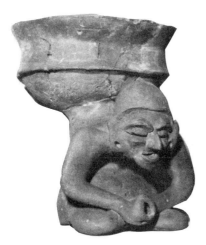

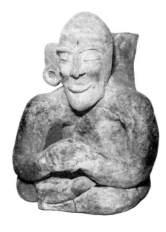

Fig. 3. Earliest fire god effigies from Cuicuilco. Museo Nacional de Antropología, Mexico. Photograph HvW.

152    HASSO VON WINNING

It has been suggested that the conception of the fire god, a deity that controls the mostly devastating effects of fire, originated in a region and at a time of great volcanic activity in the Valley of Mexico (Covarrubias 1957:39-40). A minor volcano, Xitle, erupted repeatedly and eventually covered Cuicuilco with ash and lava. Since Cuicuilco was the dominant power in the Valley of Mexico during the early part of the Late Classic, it is conceivable that its cult was imported in Teotihuacán in Tezoyuca or Patlachique times.

Related to the cult of the fire god are flat-based *braseros* that occur in the Tezoyuca phase. These assume hourglass shape with pedestal base in Patlachique and continue with conical or hemispherical shape during Tzacualli. Censers remain fairly simple and coarse during Miccaotli but acquire the basic shape—yet without smoke tube—from which evolved the elaborate Early Classic censer (Kolb 1965).

A third deity, probably introduced in Tzacualli times, was the God with the Mask or Xipe. Certain figurines are characterized by no more than three holes for eyes and mouth, others have an additional band around the head and one around the chin (Fig. 4). These bands and the eyes suggest that the face is completely covered by a mask, one of the principal attributes of Xipe (Caso 1966:269-270). Xipe does not seem to have acquired major following in Teotihuacán. The face of the masked god is occasionally depicted on pottery, but only two very crude flat stone carvings of the Xipe face of uncertain date are known (Beyer 1922:169, pl. 81c; Linné 1942:Fig. 181).

It now seems certain that the primeval Olmec deities, as well as the calendar, were ancestral to pan-Mesoamerican religion. Joralemon's study of Olmec iconography (1971) indicates that the Olmec pantheon was much more diversified than was formerly thought. It includes three gods that occur also in Preclassic Teotihuacán. God I, a most important deity identified as a jaguar-dragon with flame eyebrows, is considered the god of fire and heat and perhaps the prototype of Huehueteotl, according to Joralemon. God IV was once believed to have been the chief divinity of Olmec culture. Since he is always portrayed as an infant, or dwarf, he may be related to the *chaneques* and therefore to Tlaloc. God VI is believed to be the god of spring and renewal and is perhaps a prototype of Xipe. Joralemon (1971:90) speculated that many of these Olmec gods appear to be resurrected in Aztec times, and Michael Coe made a strong case for this continuance by linking Tezcatlipoca with the Olmec jaguar cult (1972:5). If this uninterrupted succession of deities is acceptable one must expect iconographic evidence also in intermediate cultures, such as Teotihuacán. The ties, however, between the three earliest Teotihuacán gods and their Olmec prototypes are very tenuous.

Other gods—and their number is relatively small—appeared on the scene in the Early Classic (Caso 1966:249ff.).

Many animals had a sacred character in Teotihuacán and some of these were replicated in clay. A chronological sequence of animal figurines has not yet been worked out satisfactorily so that it is hazardous to attribute ritualistic significance to the animal figures of the Preclassic.

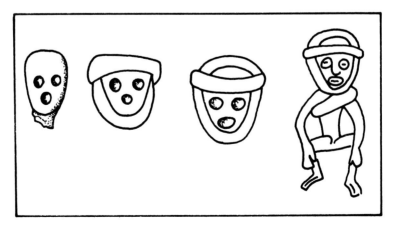

Fig. 4. Evolution of figurines portraying Xipe; redrawn after Séjourné 1959:Fig. 75.

Religious ceremonialism cannot be documented for the Preclassic and can only be implied to have existed—certainly on a much less sophisticated scale than during the florescence of Teotihuacán—in Tezoyuca and Patlachique with the emergence of ceremonial architecture and simple incense burners. The substructure of the Pyramid of the Sun contained a Tzacualli phase ritual offering of anthropomorphic obsidian figurines that had been placed carefully (Millon and Drewitt 1961:378). During Miccaotli times obsidian figures continued to be part of the religious ritual; they were found in a major offering in the platform added to the Sun Pyramid and in the main temple of the Ciudadela.

There is no evidence of an established calendar during the Preclassic. The orientation of the Sun Pyramid, however, and the north-south alignment of the Street of the Dead in Tzacualli times imply knowledge of the astronomical significance of the four cardinal directions and of a calendar. A fully established calendar functioned in Oaxaca about 600 B.C. The appearance of Thin Orange pottery in Late Tzacualli, a ware imported from southern Puebla, indicates connections with the south, although direct links with Monte Albán are confined to the Classic.

## ART

Early Teotihuacán art was in its infancy compared with the rich repertory of Classic pictorial expression. The earliest mural paintings are unobtrusive simple designs on the sides of the Temple of Quetzalcoatl with its monumental sculptures (Clara Millon 1972). Although the paintings are considered to be earlier than any others, the Quetzalcoatl Temple itself is generally ascribed to Teotihuacán II (end of Miccaotli) and already displays the great vigor and monumentality of the full Classic. "Very early" paintings were reported from Palacio B at La Ventilla; these also are of modest design, apparently without attempt at composition. As Clara Millon pointed out, much has been lost of this fragile art. At any rate, these early beginnings developed into a unique style with, in Kubler's words, "a preponderance of compound forms which have no counterpart in visible reality" (Kubler 1967:3).

Inside a vaulted construction on the circular pyramid at Cuicuilco appear red designs vaguely recognizable as animal heads, painted directly on

stone. Perhaps this kind of ritualistic decoration, and the well developed polychrome resist decoration on pottery, also a legacy of Cuicuilco, inspired the early inhabitants to try their hand at mural painting on stuccoed surfaces.

Still unsolved is the provenience of the life-sized stone masks. Covarrubias felt that they have Olmec antecedents because both Olmec and Teotihuacán masks are related by shape, manner of carving, and the way they are finished in the back (Covarrubias 1957:134). He saw a clear evolution of the style until it reached its ultimate Classic configuration with a radical change in the physical type represented. In Guerrero a transitional style prevailed which Covarrubias placed at about 500 B.C. Actually, some of the features on some Teotihuacán masks convey a vague Olmecoid feeling (cf. Nicholson 1971:Fig. 13).

There is only one conspicuous trait that occurs in both Olmec and early Teotihuacán art: the cleft forehead (Fig. 5). It occurs frequently in Olmec frontal and profile representations, but Joralemon (1971:7) does not consider it a single determinative for any one deity image. The cleft appears on God II, who is characterized by maize symbols that grow from the cleft head (1971:59). God VI and God VIII are generally portrayed with the cleft (1971:79, 85).

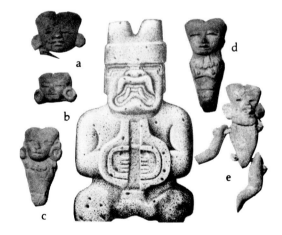

Fig. 5. Cleft in forehead on Olmec sculpture and Teotihuacán figurines. Center: Monument 10, San Lorenzo, from *Indian Art of Mexico and Central America*, by Miguel Covarrubias, Fig. 32. (Copyright ©1957 by Alfred A. Knopf, Inc. Reprinted by permission of the publisher.) *a, e:* Late Tzacualli; *b.* Miccaotli; *c, d:* Tlamimilolpa phase. Figurines *a-e* from Teotihuacán; *c-e* are articulated; coll. HvW.

In Teotihuacán the cleft forehead occurs in Late Tzacualli and continues through Period II (Miccaotli) and Period III (Tlamimilolpa-Xolalpan) in figurines of the "retrato type," but these are not images of deities. Michael Coe (1972:3) suggested that the Olmec cleft represents the furrow running front to back along the top of the jaguar head and that the motif is probably related to fertility. What the cleft signifies in Teotihuacán I do not know. The life-sized Teotihuacán stone masks, which are related in style to Olmec stone masks, do not show the cleft.

In both the Teotihuacán and Olmec traditions the cleft appears to be symbolic rather than merely decorative and it may well be a case of Panofsky's principle of disjunction of form and meaning, as outlined by Kubler (1967:11). In other words, the Olmec style cleft may have acquired an entirely different meaning some six centuries later in Teotihuacán.

To summarize, the only iconographic parallels between Olmec and Preclassic Teotihuacán deities are Huehueteotl, Tlaloc, and perhaps Xipe. In spite of the continuity of fundamental aspects of Mesoamerican religion from the Middle Preclassic on, it is difficult to demonstrate the equivalence of early Xipe-like representations with the later ideological connotation of the Xipe cult (Nicholson 1972).

Huehueteotl was introduced in Teotihuacán via Cuicuilco. The immediate source of the other two deities cannot be identified. No sites comparable to the Tlatilco cemetery are known in the Teotihuacán Valley. The Chiconautla phase includes only the ceramic types that are characteristic of the refuse from the village site at Tlatilco.

The cleft forehead and the stone masks are the only other links with the Olmec past.

The large repertory of symbolic art motifs that occur on Classic ceremonial pottery and murals has no Preclassic antecedents and is therefore an autochthonous development of the Tlamimilolpa-Xolalpan phases. Only one sign, "eye in profile," is conspicuous among the early, generally curvilinear pottery decorations (Fig. 6). It appears on a cylindrical vase in the Patlachique phase from Oztoyahualco (Millon, Drewitt, and Bennyhoff 1965:70, Fig. 96). On Classic plano-relief pottery

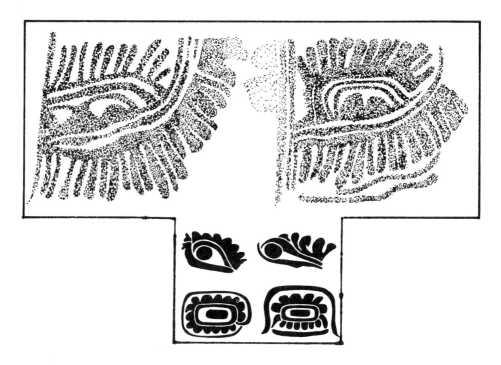

Fig. 6. "Eye in profile" on Tzacualli phase cylindrical vessel, drawn after photograph in Millon, Drewitt, and Bennyhoff 1965:Fig. 96, and (below) "Serpent's eye glyph" on Xolalpan phase planorelief pottery from Teotihuacán, from von Winning 1961:Fig. 1.

this sign is known as the bird's eye, or serpent's eye, motif. It had calendrical significance since it appears thrice with dot numerals on a conch shell (Caso 1936-1939:141, Fig. 11). The meaning or its position in the tonalpohualli are not known.

## SUMMARY AND CONCLUSIONS

The Teotihuacán Valley, during the Early and Middle Preclassic, presents no evidence of social, religious, and political organization that extended beyond the small community level. No remains of specialized religious structures were discovered.

In the Late Preclassic Cuicuilco, a large ceremonial center south of Lake Texcoco dominated the entire Basin of Mexico and contributed to the rise of Teotihuacán. Cuicuilco eventually was eclipsed by Teotihuacán and the Basin of Mexico became fragmented into multiple cultural units.

In the Teotihuacán Valley generally favorable climatic conditions, an adequate water supply, an efficient agriculture, and a steadily growing population provided the basis for the cultural development in the Terminal Preclassic. The planning and building of the city at an early stage in the prehistory of Teotihuacán indicate an exceptional interest in architectural endeavors on the part of the ruling elite. The management of a huge labor force, engaged in construction projects that continued over five centuries, presupposes a powerful and intelligent leadership, probably a hereditary succession of priest-rulers at the head of a hierarchical priesthood and an efficient bureaucracy. The early deities of Teotihuacán can be traced back to the Olmec pantheon and to Cuicuilco. Religious art during the Preclassic is confined to certain clay effigies and massive ceremonial architecture.

## References

Acosta, Jorge R.
1964    El palacio de Quetzalpapálotl. *Memorias del Instituto Nacional de Antropología e Historia* 10, Mexico.

Bernal, Ignacio
1963    *Teotihuacán, descubrimientos y reconstrucciones.* Instituto Nacional de Antropología e Historia, Mexico.
1965    Teotihuacán: nuevas fechas de radiocarbono y su posible significado. *Anales de Antropología* 2:27-35. Instituto de Investigaciones Históricas, Universidad Nacional Autónoma de México, Mexico.

Beyer, Hermann
1922    Estudio interpretativo de algunas grandes esculturas. In Gamio 1922, 1 (see below):168-174.

Caso, Alfonso
1936-   Tenían los teotihuacanos conocimiento del
1939    tonalpohualli? *El Mexico Antiguo* 4:131-143.
1938    *Thirteen masterpieces of Mexican archaeology.* Editoriales Cultura y Polis, Mexico.
1966    Dioses y signos teotihuacanos. In *Teotihuacán, Onceava Mesa Redonda*, Sociedad Mexicana de Antropología 1, pp. 249-279.

Coe, Michael D.
1972    Olmec jaguars and Olmec kings. In *The cult of the feline: a conference in Pre-Columbian iconography*, edited by Elizabeth P. Benson, pp. 1-18. Dumbarton Oaks Research Library and Collections, Washington.

Covarrubias, Miguel
1957    *Indian art of Mexico and Central America.* Alfred A. Knopf, New York.

Drewitt, Bruce
1966    Planeación en la antigua ciudad de Teotihuacán. In *Teotihuacán, Onceava Mesa Redonda*, Sociedad Mexicana de Antropología 1, pp. 79-94.

Gamio, Manuel
1922    *La población del Valle de Teotihuacán.* 3 vols. Secretaría de Agricultura y Fomento, Dirección de Antropología, Mexico.

Heizer, Robert F., and James A. Bennyhoff
1972    Archaeological excavations at Cuicuilco, 1957. *Research Reports*, pp. 93-104. National Geographic Society, Washington.

Joralemon, Peter D.
1971    A study of Olmec iconography. *Studies in Pre-Columbian Art and Archaeology* 7. Dumbarton Oaks, Washington.

Kolb, Charles C.
1965    A tentative ceramics classification for the Teotihuacán Valley. Department of Sociology and Anthropology, The Pennsylvania State University. Mimeographed.

Kubler, George
1967    The iconography of the art of Teotihuacán. *Studies in Pre-Columbian Art and Archaeology* 4. Dumbarton Oaks, Washington.

Leonard, Carmen Cook de
1971    Ceramics of the Classic period in Central Mexico. *Handbook of Middle American Indians*, edited by Robert Wauchope, Gordon Ekholm, and Ignacio Bernal. 10:179-205. University of Texas Press, Austin.

Linné, Sigvald
1942    Mexican Highland cultures. *The Ethnographic*

*Museum of Sweden, n.s., Publication 7.* Stockholm.

Marquina, Ignacio
1951 Arquitectura prehispánica. *Memorias del Instituto Nacional de Antropología e Historia 1.* Mexico.

Millon, Clara
1972 The history of mural art at Teotihuacán. In *Teotihuacán, Onceava Mesa Redonda,* Sociedad Mexicana de Antropología 2, pp. 1-16.

Millon, René
1966 Extensión y población de la ciudad de Teotihuacán en sus diferentes períodos; un cálculo provisional. In *Teotihuacán, Onceava Mesa Redonda,* Sociedad Mexicana de Antropología 1, pp. 57-78.
1967 Teotihuacán. *Scientific American* 216 (6 June):38-48.
1970 Teotihuacán: Completion of map of giant ancient city in the Valley of Mexico. *Science* 170(3962, 4 Dec.):1077-1082.

Millon, René, and Bruce Drewitt
1961 Earlier structures within the Pyramid of the Sun at Teotihuacán. *American Antiquity* 26(3):371-380.

Millon, René, Bruce Drewitt, and James A. Bennyhoff
1965 The Pyramid of the Sun at Teotihuacán: 1959 investigations. *Transactions of the American Philosophical Society* 55(6).

Müller, Florencia
1966 Secuencia cerámica de Teotihuacán. In *Teotihuacán, Onceava Mesa Redonda,* Sociedad Mexicana de Antropología 1, pp. 31-51.

Nicholson, H. B.
1971 Major sculpture in Prehispanic Central Mexico. *Handbook of Middle American Indians,* edited by Robert Wauchope, Gordon Ekholm, and Ignacio Bernal, 10:92-134. University of Texas Press, Austin.
1972 The cult of Xipe Totec in Mesoamerica. In *Religión en Mesoamérica, XII Mesa Redonda,* edited by Jaime Litvak King and Noemi Castillo Tejero, Sociedad Mexicana de Antropología, pp. 213-218A-3.

Noguera, Eduardo
1935 Antecedentes y relaciones de la cultura teotihuacana. *El México Antiguo* 3(5-8):3-90.

1943 Excavaciones en El Tepalcate, Chimalhuacán, Mexico. *American Antiquity* 9(1):33-43.
1962 Nueva clasificación de figurillas del horizonte clásico. *Cuadernos Americanos* 124(5):127-136.

Pérez, José, R.
1935 Exploración del túnel de la pirámide del sol. *El México Antiguo* 3(5-8):91-95.

Piña Chán, Beatríz Barba de
1956 Tlapacoya, un sitio preclásico de transición. *Acta Antropológica,* Mexico, época 2, 1(1). Escuela Nacional de Antropología e Historia, Sociedad de Alumnos, Mexico.

Piña Chán, Román
1967 *Una visión del México prehispánico.* Universidad Nacional Autónoma de México, Mexico.

Sanders, William T.
1960- Teotihuacán Valley Project: Preliminary report, 1960-63 field sessions. The Pennsylvania
1963 State University. Mimeographed.
1970 The natural environment, contemporary occupation and sixteenth-century population of the valley. The Teotihuacán Valley Project; Final report, vol. 1. *Occasional Papers in Anthropology,* The Pennsylvania State University.

Séjourné, Laurette
1959 *Un palacio en la ciudad de los dioses (Teotihuacán).* Instituto Nacional de Antropología e Historia, Mexico.

Teotihuacán, Onceava Mesa Redonda. Sociedad Mexicana de Antropología, Mexico. Vol. 1, 1968; Vol. 2, 1972.

Tobriner, Stephen
1972 The fertile mountain: an investigation of Cerro Gordo's importance to the town plan and iconography of Teotihuacán. In *Teotihuacán, Onceava Mesa Redonda,* Sociedad Mexicana de Antropología 2, pp. 103-115.

von Winning, Hasso
1961 Teotihuacán symbols: the Reptile's Eye glyph. *Ethnos* 26(3):121-166.
1968 Der Netzjaguar in Teotihuacán, Mexico; eine ikonographische Untersuchung. *Baessler-Archiv, Neue Folge,* 16:31-46.

West, Michael
1965 Transition from Preclassic to Classic at Teotihuacán. *American Antiquity* 31(2):193-202.

# Preclassic Mesoamerican Iconography from the Perspective of the Postclassic: Problems in Interpretational Analysis

H. B. Nicholson

Department of Anthropology
University of California, Los Angeles

Among the most vigorous recent trends in Mesoamerican studies is a determined attempt to extract specific meanings from pre-Postclassic pictorial and sculptural representations, over and above purely formal esthetic-stylistic analyses. This is the essence of *iconography* as defined, for example, by the prominent European art historian, Erwin Panofsky (e.g., 1955:26). In cultures with fully developed phonetic writing systems, iconographic interpretations of this type are often greatly aided by directly associated or otherwise relevant texts. In Mesoamerica this situation only pertains to the period of the Conquest, for which a relatively abundant ethnohistorical documentation is available in certain areas. For earlier periods, above all the Lowland Maya region during the Classic, many representations display associated hieroglyphic texts. Although this system of writing is only partly deciphered, considerable progress, sparked especially by Proskouriakoff's "dynastic hypothesis," has recently been made in relating these texts to their juxtaposed scenes. As we move back into the Preclassic, however, text-associated representations become more and more rare, and, at the same time, our understanding of the scripts involved is much less satisfactory.

How, then, can accurate meanings be assigned to very ancient Mesoamerican scenes and symbols? Various methods have been employed. The commonest is a version of what in New World archaeology and ethnohistory has been called "upstreaming" (Fenton 1949:236, 1952:334-335) and/or the "direct historical approach," which "involves the elementary logic of working from the known to the unknown" (Steward 1942:337)—or, to put it another way, from the living to the dead: utilizing knowledge of the culture flourishing in the area at the time of European Contact to interpret archaeological finds in that same area. Thus defined, the direct historical approach can be viewed as one type of interpretation of ancient remains by "ethnological" or "ethnographic analogy." This strategy has been much discussed in the recent literature on archaeological methodology. A concise statement by Willey (1973:155) probably comes close to presenting a consensus view:

archaeologists operate with two kinds of analogical material: general comparative and specific historical. . . . The first allows inferences that are drawn from general life situations about people, without restrictions as to space and time; the second permits inferences only within a geographically circumscribed and historically defined context. This specific historic kind of analogy is usually referred to as "ethnographic analogy" and has particular pertinence for the New World, where archaeological cultures are frequently interpreted with the aid of ethnographic or ethnohistoric accounts that relate to Indian cultures believed to be in direct line of descent from these archaeological cultures.

Another method can be designated "intrinsic configurational iconographic analysis," which relies on detailed internal contextual examination of entire symbol systems (e.g., Kubler 1967, 1972a, 1973:165)—and, when relevant, comparisons with other iconographic systems in the same area co-tradition. This paper is devoted to a concise discussion of the problems connected with the direct historical approach, focusing on the Preclassic.

The validity and success of the direct historical approach in interpreting Late Postclassic Mesoamerican iconography has been repeatedly confirmed. Eduard Seler was the first modern master of this method. Although various of his specific interpretations can today be challenged, he achieved landmark results, above all when directing his attention to native tradition pictorials and archaeological remains from the Basin of Mexico and adjacent territory which clearly date from the Late Postclassic. When he attempted the same kinds of iconographic analyses of similar data further removed in time and space from Late Postclassic central Mexico he achieved significantly less success, principally because much more pertinent ethnographic information is available for Contact central Mexico than for any other area of Mesoamerica.

But the key issue in relation to the theme of this symposium is: granted its success when concerned

with archaeological materials dating from the Late Postclassic, can the direct historical approach also be successfully utilized to interpret *pre*-Late Postclassic iconography? Here we enter a somewhat controversial area. Intersecting with and underlying this issue is the more fundamental problem: to what degree was there basic continuity and overall cultural unity in pre-Hispanic Mesoamerica? How the student approaches this question naturally conditions his willingness to employ the direct historical approach to interpret the earlier iconographic systems. Today some leading Mesoamericanists (e.g., Bernal 1960, 1969:7, 187-188, 1971: 30; Willey 1973) adhere quite explicitly to a fundamentally "unitary" view of Mesoamerican civilization, from putative Olmec genesis to Cortés. Predisposed by this orientation, for example, Michael Coe (1968:111-115, 1972, 1973)—and latterly his pupil, David Joralemon (1971, article this volume)—has boldly attempted to interpret Olmec iconography freely utilizing Contact central Mexican ethnographic data. Many years ago, Hermann Beyer (1922) urged considerable caution in employing this method (specifically, in relation with the interpretation of Teotihuacán materials), and recently a major art historian, George Kubler (1967:11-12, 1970:140-144, 1972a, 1973), has strongly argued against the validity of the application of the direct historical approach in pre-Late Postclassic iconographic analysis.

Kubler (1967:11) warns that "we must beware of disjunctive situations where form and meaning separate and rejoin in different combinations." He invokes Panofsky's (1960:84-106) "principle" or "law of disjunction," which the latter derived from the separation of form and significance in late medieval European art, that is, the reinterpretation of borrowed forms of classical antiquity with Christian meaning and the presentation of classical themes in contemporary, Christian forms. Kubler (1970:143-144) generalizes this principle thus:

Disjunction, which is a mode of renovation, may be said to happen whenever the members of a successor civilization refashion their inheritance by gearing the predecessor's forms to new meanings, and by clothing in new forms those old meanings which remain acceptable. Continuous form does not predicate continuous meaning, nor does continuity of form or of meaning necessarily imply continuity of culture. On the contrary, prolonged continuities of form or meaning, on the order

of a thousand years, may mask . . . a cultural discontinuity deeper than that between classical antiquity and the middle ages. . . . We may not use Aztec ritual descriptions as compiled by Sahagún about 1550 to explain murals painted at Teotihuacan a thousand years earlier, for the same reason that we would not easily get agreement in interpreting the Hellenistic images of Palmyra by using Arabic texts on Islamic ritual. The idea of disjunction . . . makes every ethnological analogy questionable by insisting on discontinuity rather than its opposite whenever long durations are under discussion.

Kubler (1973:166-167) further contends that "analogizing also leads to misleading fragmentations, by pinning or imposing whole clusters of late ethnohistorical detail upon isolated fragments of very ancient symbolic behavior, as when the mythological and ritual meanings of the cult of Quetzalcoatl are identified as present in Olmec culture because a feathered form appears there." This he would regard "as like arguing that the Good Sheperd of modern Sunday School imagery, shown caring for a lost animal in his flock, explains as Jesus a similar figuration of the youth bearing an animal on his shoulders in Greek archaic sculpture before 500 B.C." Kubler (1970: 141-142) objects that "Seler's method of historico-ethnological analogy still governs Mexican and Maya studies in all departments of archaeological and ethnographical research," and he complains that "few people resist its invitation to explain the remote past by the tribal present," going on to affirm roundly that "to use Sahagún to explain the oldest Mexican urban societies is as unprofitable as to try to explain ancient Egypt by the Muslim historians." As a corollary of his application to Mesoamerican culture history of Panofsky's disjunction principle, Kubler (1972a, 1973:163-164) also seriously challenges the unitary interpretation of Mesoamerican civilization, the notion of a "single huge cultural system" for this area co-tradition, contending that "the supporting evidence for such a unitary view is . . . so thin that both the thesis and the antithesis are still beyond proof."

Kubler's vigorous negative position on this issue highlights its importance. How much continuity in religious concepts and ritual was there in Mesoamerica from Preclassic to Conquest times? If there was very little, then Contact period ethnographic data will obviously be of little aid in interpreting Preclassic iconography. If Mesoamerican civilization, however, was essentially a single

overall unified co-tradition beginning with the Olmec efflorescence, then many fundamental religious-ritual continuities must have characterized it. Actually, in my opinion both views can be supported with various arguments and data, depending on what aspects of Mesoamerican culture history one selects and emphasizes in support of one's position. There were undoubtedly many partial or complete iconographic-conceptual disjunctions between Olmec and Aztec, but, at the same time, evidence can be adduced that there were probably many continuities as well. In short, I suspect that we are dealing with a very mixed bag. If so, detailed analyses of specific instances are obviously going to prove to be more effective in attacking this problem than sweeping pronouncements pro or con.

Before citing some concrete cases, however, the point should be made that the legitimacy of applying Panofsky's "disjunction principle" to areas whose culture histories have been quite different from that of Western Europe is perhaps debatable. The culture histories of certain other Old World regions would appear to provide some rather striking examples of long term iconographic-conceptual *continuities*, notably Egypt, India, and China. Certainly, for instance, identical meanings were not attached to New Kingdom and Greco-Roman representations of Osiris, Isis, and Horus, but the basic connotations do seem to have been quite similar, in spite of a temporal span of well over 1500 years. This is because one fundamental religious ideology persisted, from Early Dynastic times on, with remarkable tenacity in the Valley of the Nile. After Christianization and subsequent Islamization, of course, the situation changed radically, for the imposition and acceptance of these quite different foreign ideological systems resulted in profound iconographic disjunctions—as occurred, owing to similar causes, elsewhere in the Near and Far East and Europe.

Certainly Panofsky (1944, 1960:84-113) himself applied his principle only to Western Europe and went to some pains to analyze the particular series of culture-historical events that eventuated in that divorce between form and meaning in Classical images utilized during the "proto-Renaissance" and "proto-Humanistic" renascences of the High Middle Ages. Although he later stressed what he considered to have been the medieval tendency to "compartmentalize" and the inability to make

"historical distinctions," in his original article Panofsky (1944:226) succinctly expressed his basic explanation for this phenomenon thus:

The high-mediaeval attitude toward classical Antiquity . . . is characterized by an ambivalence which we, having gone through the Italian "rinascimento" find very hard to reexperience. . . . there was, on the one hand, a sense of unbroken connection or even continuity with classical Antiquity, linking the mediaeval German Empire to Julius Caesar, mediaeval music to Pythagoras, mediaeval philosophy to Plato and Aristotle, mediaeval grammar to Donatus—and, on the other, the consciousness of an insurmountable gap that separated the Christian present from the pagan past. . . . To the mature mediaeval mind Jason and Medea were acceptable as long as they were represented as a knight and damsel playing chess in a Gothic chamber, and a classical goddess was acceptable as long as she did service as a Virgin Mary. But a classical Thisbe waiting by a classical mausoleum would have been an archaeological reconstruction incompatible with the sense of continuity; and a Venus classical in form as well as content would have been a diabolical idol anathematized by the aversion to paganism.

In short, in his view the Classical-Late Medieval form-meaning disjunction was caused, above all, by the comparatively sharp break between two successive religious ideological systems, Classical paganism and Christianity. When Classical images were employed during the Late Middle Ages they perforce had to be divested of their pagan connotations and reinvested with a "correct" *interpretatio Christiana*. Obviously, only a very special set of historical circumstances could have led to such a result.

In Mesoamerica there is certainly no evidence for any comparable historical development. No Mexica viewing a Teotihuacán cultic image could have exhibited the same attitude of ambivalence and trepidation that a twelfth-century European might well have felt on beholding the statue of a pagan deity. Archaeological data evidence some significant changes in religious-ritual systems over time but hardly any replacement as drastic as that of Classical paganism by Christianity. Violent political shifts must not have been infrequent— and were probably accompanied by some ideological changes such as the rise of deity cults and associated rituals favored by and in certain cases actually imposed by politically successful groups —but there do not seem to have been any

sweeping supersedures of whole religious ideolog-
ical systems comparable to those that followed the
rise of Judaeo-Christianity and Islam. All that is
known about indigenous Mesoamerican religious-
ritual-systems would point precisely to the con-
trary. Far from being militantly exclusivist they
seem to have been characteristically rather eclec-
tic, generally tolerant of other systems, and
receptive to the incorporation of compatible for-
eign religious concepts and rituals. Under these
conditions changes in the religious sphere of the
culture normally tend to be more gradual and,
especially, accretive, frequently exhibiting a tena-
cious conservatism in the retention of fundamental
concepts.

No one would seriously argue that the succes-
sive religious-ritual systems of Teotihuacán, Xo-
chicalco, Tollan, Colhuacan, Azcapotzalco, and
Mexico Tenochtitlan, for example, were identical.
Undeniably there seems to have been a rather
sharp break in the continuity of historical record-
keeping during the Classic-Postclassic transition
(Nicholson 1974), as well as some very significant
cultural changes—although it is also becoming
increasingly evident that archaeologically the
break between the Classic and Postclassic in
Central Mexico was less drastic than some had
previously supposed (e.g., Hicks and Nicholson
1964; Dumond and Müller 1973). But all this
archaeological evidence for substantial Classic-
Postclassic Central Mexican culture change not-
withstanding, in the religious-ritual sphere, with
its recognized tendency to conservatism, the de-
gree of basic continuity was probably quite high,
even in some specific deity concepts.

In support of his application to Mesoamerica of
Panofsky's disjunction principle, Kubler lays par-
ticular stress on the length of time involved
between the "fall" of Teotihuacán and the rise of
Tenochtitlan, admittedly a substantial block of
time (ca. 7 centuries?). It seems unlikely, however,
that degree of form-meaning disjunction is very
closely tied to mere temporal duration. It probab-
ly depends much more on other, specifically
historical factors of the kind so incisively analyzed
for Western Europe by Panofsky. Aside from
emphasizing the temporal aspect, Kubler (1973:
166), in his most explicit attempt to explain
disjunction at least in central Mexico—after ex-
pressing his view that spatially and temporally the
Mediterranean basin and Mesoamerican urban
civilizations were about equivalent—suggests that

"Islam is a divergent successor state to the Roman
Empire in much the same way as the Aztec
confederacy was a divergent successor to the
civilization of Teotihuacán some 800 years earlier.
Both the Moslems and the Chichimec ancestors of
the Aztecs were frontier peoples of nomadic origin
who broke in upon the decayed cities of a prior
state, bringing different beliefs and rituals that
replaced or paralleled those of the older peoples."
Earlier, Kubler (1972b:38) had presented a basic-
ally similar reconstruction: "the Toltec and Aztec
peoples . . . brought about a new era of political
expansion, using old symbolic forms for the
worship of new gods brought into the Valley of
Mexico by wandering tribes from the north who
came as hunters and nomads after the collapse of
the polity and faith represented by Teotihuacán."

I would agree with Willey (1973:160) that
"Kubler's parallel of Hellenistic Palmyra and
Arabic texts, on the one hand, and Teotihuacán
and Aztec ritual, on the other, is not an apt one."
The "Chichimec" ancestors of the Mexica cannot
be fitly compared to the galloping desert warriors
of the Prophet who in the seventh and eighth
centuries overran and spread throughout much of
the Near East, North Africa, and Iberia a new
religious ideology quite distinct from those that
had previously flourished in these regions. The
intricate fabric of the complex religious-ritual
system centered on the Basin of Mexico at Contact
(Nicholson 1971b) almost certainly was woven
from earlier, indigenous Mesoamerican systems of
which that of Teotihuacán must have been a major
strand—although its most immediate major source
appears to have been Toltec. The post-Toltec
"Chichimec" contribution was probably not too
substantial. As noted, a considerable cultural shift
seems to have occurred between the eclipse of
Teotihuacán and the rise of Tollan, but hardly one
comparable to the Hellenistic-Roman to Islamic
transition in the Near East—and it is interesting
that Kubler (1972b) himself has particularly
stressed the Teotihuacán-to-Tollan continuity of
one important icon, the "jaguar-serpent-bird,"
although, characteristically, he argues that the
significance changed.

Whether all major Mesoamerican groups parti-
cipated in an essentially similar religious-ritual
system or not—an issue that has been the subject
of much recent discussion (e.g., Caso 1971;
Jiménez Moreno 1971)—it seems clear that at least
a core of interrelated basic concepts was widely

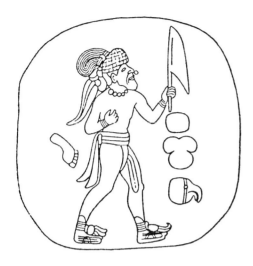

Fig. 1. La Venta Monument 19, from Joralemon 1971: Fig. 4.

shared. Granted many political disruptions and power shifts such as must have accompanied the abandonments of the important centers represented by the archaeological sites of San Lorenzo, La Venta, Cuicuilco, Teotihuacán, Monte Albán, Xochicalco, Tajín, and Tula; granted various influxes of more barbaric frontier peoples introducing somewhat differently oriented ideologies; granted a certain amount of constant change and flux in all Mesoamerican religions—it can still be argued that once the fundamental structure of the overall Mesoamerican religious system had crystallized, probably no later than the end of the Preclassic, it steadily evolved without major breaks or broad scale "disjunctions" until Cortés. In any case, the whole question of Mesoamerican Preclassic-Classic-Postclassic continuities in reli-

gious iconography requires a much more thorough, comprehensive analysis than it has yet received. Until this is accomplished, an attitude of some reserve toward sweeping generalizations such as Kubler's invocation of Panofsky's "law of disjunction" would appear to represent the most prudent position.

Assuming for the moment that there was some degree of Pre- to Postclassic continuity in Mesoamerican religious iconography, how is this continuity to be determined? Here we undeniably face challenging problems of archaeological inference. I assume that it would be generally agreed that iconographic continuity can be best established by careful determination of similarity of images through time. And a single motif, it would probably be further agreed, would normally have less value than a consistently associated cluster of iconographic elements, the more complex the better. Since few absolute Olmec-to-Aztec iconographic similarities could be expected, the working out of developmental series through what has been called "similiary seriation" (Rowe 1961)—that is, arranging representations in a sequential series on the basis of their degrees of similarity, wherein "like fits on to like"—is crucial. There is obviously great danger of artificiality and procrustean bed forcing here, but, to establish valid iconographic continuities, I see no escape from the necessity of at least attempting to establish these developmental-sequential chains.

To concretize the discussion, some specific examples should be cited. The first to be considered is a single element, the footprint(s). Seemingly its earliest appearance is on La Venta Monument 13 (Fig. 1), of Middle Preclassic date. It

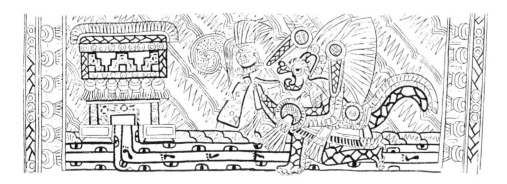

Fig. 2. Teotihuacán, Tetitla, Room 12, Mural 8, from von Winning 1968:Abb. 2.

is positioned behind a stalking, "turbaned" male figure who holds what appears to be a banner. Fronting this personage is a vertical row of three probable hieroglyphs. It has been plausibly suggested (e.g., Coe 1968:115) that, as it certainly did later, the footprint constitutes here an ideogram connoting movement or travel and that the figure represents "one who has traveled," perhaps a foreign emissary or representative who is identified by the three hieroglyphs with his name(s) and/or title(s). In the Late Postclassic Mixteca-Puebla/Aztec system, a series of footprints was usually employed to indicate this concept—but occasionally a single one only. The possible continuity in the use of this simple ideogram between Olmec and Aztec (Fig. 4) is provided by Teotihuacán (Fig. 2) and Xochicalco (Fig. 3) instances (Toltec so far seems unrepresented, but I suspect this may be owing to accidents of preservation rather than a genuine gap in its use in Early

Postclassic central Mexico). Although we are admittedly dealing here with a relatively minor element, the likelihood of long-range iconographic-conceptual continuity in this case suggests that other Preclassic-to-Postclassic iconographic continuities might well also be expected.

Another single element case is instructive because it effectively illustrates some of the difficulties faced by the investigator attempting analyses of this kind. The element involved is the vertical line or band running through or very close to the eye(s) on representations that are certainly or putatively supernatural personages. The presence of this feature is precisely the basis for the identification as Xipe Totec, the macabre "Flayed God" well known both iconographically and conceptually from ethnohistorical sources (Nicholson 1972), of a group of Olmec representations which Joralemon (1971:79-81, 90)—following up suggestions by Michael Coe—labeled "God VI."

Fig. 3. Xochicalco, "Piedra del Palacio," from Caso 1962:Fig. 1.

Many depictions of certain or possible deities from different areas within Mesoamerica, dating to different periods, display this feature—and a reasonably spaced out sequential series can be established, from Middle Preclassic to the Conquest. Selected examples from this series are illustrated: Olmec (Figs. 5-6), Monte Albán (Figs. 7-9), Teotihuacán (Figs. 10-11), Postclassic Lowland Maya (Fig. 12), Toltec style of Early Postclassic El Salvador (Fig. 13), Codex Borgia group pictorials (Late Postclassic South Puebla-Central Veracruz-Northwest Oaxaca?; Figs. 14-15), and Late Postclassic central Mexico or "Aztec" (Fig. 16). When other iconographic indicia of Xipe Totec are present, connecting early images with his cult may well be justified, for its widespread distribution at Contact evidences for it a considerable antiquity (Nicholson 1972). When the only feature that provides a link with this deity is the line through the eye(s), however, the identification is hazardous since various other Mixteca-Puebla tradition Late Postclassic deities—for example,

Fig. 5. "Profile A" incised on right shoulder of Las Limas, Veracruz, seated Olmec stone figure, from Joralemon 1971:Fig. 232—identified by Coe (1968: 111-114) and Joralemon ("God VI") as Xipe Totec.

Ehecatl-Quetzalcoatl (Fig. 17), the Mixteca solar deity "1. Death" (Fig. 18), and the young male maize deity, Centeotl (Figs. 19, 25; cf. Fig. 23 for similar feature on Codex Dresden "God E")—prominently display this element in one form or another. The Coe-Joralemon hypothesis identifying "God VI" as a proto-Xipe Totec, therefore, as I (Nicholson 1971a:17) have previously pointed out, hardly seems compelling. It should be viewed, rather, as an interesting hypothesis that future discoveries may or may not tend to support. It would be greatly strengthened, of course, if other known identificatory insignia of the Postclassic deity were to be eventually discerned on indubitable Olmec pieces.

Another interesting and pertinent case is that of Olmec "God II," which Joralemon (1971:59-66, 90) suggests was a maize deity because a plant motif, which he identifies as maize, usually issues from the cleft in the top of the head. Although Joralemon did not cite or illustrate any cases in his comprehensive catalog, this feature is also encountered with his "God IV" (Fig. 20), whom he (Joralemon 1971:90) identifies with the rain god,

Fig. 4. Codex Mendoza, fol. 66r: Mexica ambassadors whose movement as travelers is indicated by footprints; cf. Fig. 1.

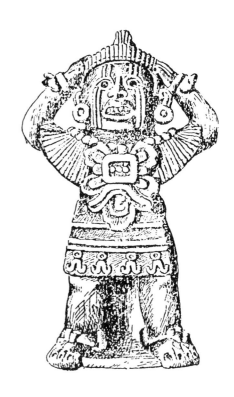

Fig. 6. Profile head incised on greenstone plaque (Museo Nacional de Antropología), of unknown provenience, decorated with subsidiary profiles belonging to Joralemon's "God VI" category (cf. Fig. 5), from Joralemon 1971:Fig. 233.

Fig. 8. Funerary urn, Tomb 51, Monte Albán, from Séjourné 1957:Fig. 60.

Fig. 7. "Glyph P" (Caso system), Mound J, Monte Albán, Lápida 13, from Caso 1947:Fig. 67.

Fig. 9. Ceramic vessel, Monte Albán, West Platform, surface, from Caso and Bernal 1952:Fig. 410c.

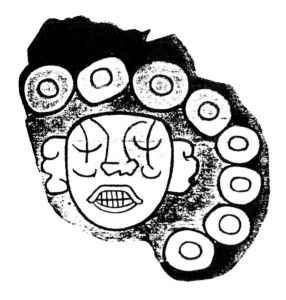

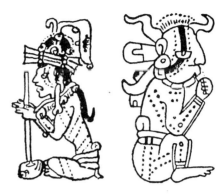

Fig. 12. "God Q" (left: Codex Dresden 6b; right: Codex Madrid 27d; from Anders 1963:Abb. 137.) Postclassic Lowland Maya region.

Fig. 10. Teotihuacán, Zacuala, "conjunto noreste (Q)," fragment of wall painting, from Séjourné 1959: Fig. 6.

Fig. 13. Head of Toltec style ceramic figure representing Xipe Totec, Chalchuapa, El Salvador, from Boggs 1944:Fig. 2e.

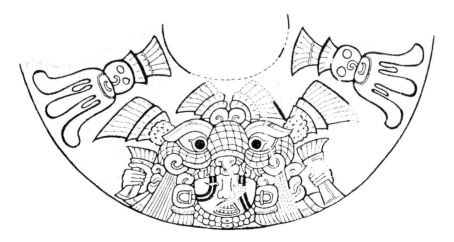

Fig. 11. Head of probable Teotihuacán deity, flanked by trilobal signs, on painted and stuccoed ceramic vessel, Tikal, Burial 10 (ca. A.D. 450), from W. Coe 1967:102.

"always depicted as an infant or dwarf." His interpretation would appear to receive some support from the frequency of maize cobs and/or parts of the maize plant as elements decorating the upper heads and headdresses of deities almost certainly connected with maize, rain, and fertility in later Mesoamerican cultures, up to Contact: Teotihuacán (Fig. 21), Monte Albán (Fig. 22), Postclassic Lowland Maya (Fig. 23), Borgia group pictorials (Figs. 24-26), and Aztec (Fig. 27). The establishment of this long-term sequence of icons displaying this common feature would appear to buttress significantly the hypothesis that the Olmec images of "Gods II and IV" which display vegetal motifs emerging from occipital clefts are indeed probably directly ancestral to the later Mesoamerican maize-rain-fertility deities.

Another example, too familiar to merit detailed illustration, involves a small iconographic cluster. At Contact the most fundamental rain-fertility deity, Tlaloc, was characterized by a striking array of iconographic features; standing out most prominently were rings surrounding the eyes and a thick, voluted upper labial band from which depended large fangs. He was also frequently depicted holding the lightning, often zoomorphized as an undulating serpent. This cluster unquestionably went back through Toltec and Xochicalco at least to Teotihuacán (Fig. 21) and possibly earlier in central Mexico. It clearly constitutes one of the most generally accepted cases of long term iconographic continuity in pre-Hispanic Mesoamerica. Nearly every student appears to regard the earlier images as directly ancestral to the historic Tlaloc, although the Teotihuacán "Tlaloc complex" is turning out to be somewhat more complicated than was formerly believed (cf. Armillas 1945 and Caso 1966 with Pasztory 1972 and C. Millon 1973). It is also pertinent to mention that Tlaloc is only the best-known member of an extensive family of intimately interrelated Mesoamerican rain-fertility deities and "dragons" that were especially characterized by prominently projecting "upper lips" and/or snouts, the prototypes of which can be traced back to Izapan and Olmec. This intricate complex, which deserves more thorough analysis than it has yet received, appears to constitute one of the best cases for overall Mesoamerican iconographic and probably conceptual continuity. Covarrubias (1946:Lám. 4), in a famous chart, was the first to publish a "family tree" for the major Mesoamerican rain-fertility deities, although he stressed the *en face* mouth configuration, commencing with the Olmec "baby/were-jaguar face," more than the projecting upper lip-snout feature as the key element linking together various earlier and later forms.

Many more examples of obvious iconographic continuities, involving both individual motifs as well as clusters, between Olmec or at least Early Classic Teotihuacan and the early sixteenth century could be illustrated and analyzed, but spatial limitations preclude much more

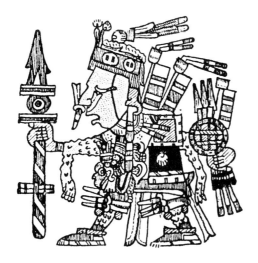

Fig. 14. Xipe Totec, Codex Borgia 25, from Seler 1904-1909, I, Reproduction:25.

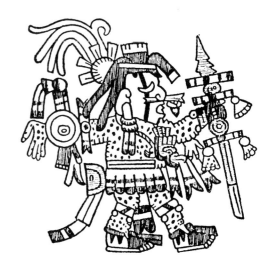

Fig. 15. Xipe Totec, Codex Vaticanus B 19, from Seler 1904-1909, II:Abb. 112.

Fig. 16. Place sign (head of Xipe Totec) of Chipetlan, Guerrero, Matrícula de Tributos 10r, from Beyer 1919:Fig. 5.

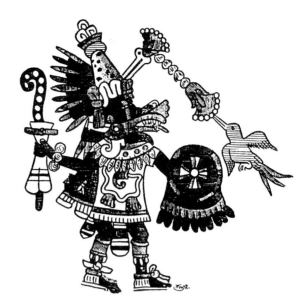

Fig. 17. Ehecatl-Quetzalcoatl, Codex Magliabechiano 61r, from Seler 1902-1923, IV:Abb. 78b.

discussion. Joralemon, in his article in this volume, has demonstrated considerable iconographic continuity in Mesoamerican "dragon" representations. Another interesting case has recently been described and discussed by Stocker and Spence (1973): the trilobal dripping liquid (water-blood) symbol, closely similar forms of which can readily be traced from Olmec via Teotihuacán, Monte Albán, and Xochicalco up through Toltec, following which it fades out. A somewhat similar case is that of the so-called "Fat God," a frequent and important representation in various regions of Preclassic and Classic Mesoamerica but which had apparently disappeared by at least Late Postclassic times. I (Nicholson 1971a:16) have

suggested—in agreement with José Luis Franco, who has made the most thorough and comprehensive study of the occurrences of this deity image —that many of his conceptual connotations appear to have survived in the Centeotl-Xochipilli deity complex (Nicholson 1971b:416-419), but the iconographic "disjunction" here, as with the trilobal liquid sign, appears to be undeniable. A few ostensible Classic to Preclassic iconographic continuities between Classic Veracruz and Postclassic central Mexico, in contrast, have been discussed in an earlier article (Nicholson 1971a).

Granted, then, that various Mesoamerican iconographic continuities spanning relatively long time periods can be established, the much more difficult

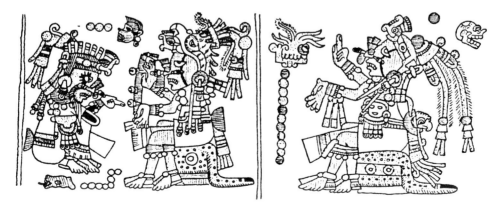

Fig. 18. Two versions of the solar deity "1. Death," Codex Zouche-Nuttall 79, from Caso 1959:Fig. 7.

question remains: to what extent did their conceptual connotations hold constant during these long evolutionary sequences? This returns us, of course, to the principal issue raised by Kubler. As we have seen, he vigorously attacks the notion of any significant amount of Classic-to-Postclassic iconographic-conceptual continuity, which implies the likelihood of even less continuity when dealing with material dating from the Preclassic. Kubler (1970:143-144, 1972a:19-20) argues that even when the icons themselves are retained over long temporal spans, owing to a "principle of least effort," this by no means guarantees their conceptual equivalency. Quite the contrary, he suggests that it is rather the norm for these connotations to shift whenever a substantial period of time is involved.

Without the aid of coeval or otherwise relevant texts it is undeniably very difficult to determine whether representations and symbols formally similar but temporally widely separated actually did convey basically similar meanings. Methodologically, perhaps the most promising technique is to analyze carefully all relevant iconographic

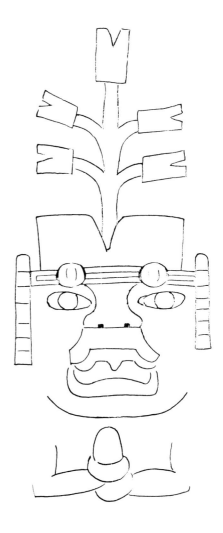

Fig. 20. Engraving on Olmec celt: Joralemon's "God IV" with plant motif emerging from cleft on top of head. Reportedly from "Arroyo Pesquero," Veracruz, drawing by José Luis Franco.

Fig. 21. Side border decoration on dado, Teotihuacán, Zone 11, Portico 5, Mural 5: "Tlaloc" head with maize cobs in headdress (oriented 90° differently on original); from Miller 1973:Fig. 152.

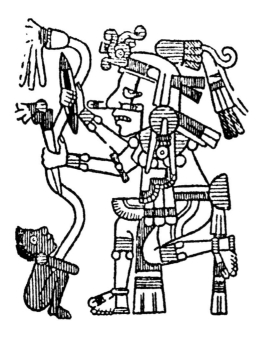

Fig. 19. Male deity, probably version of young solar-maize god, Codex Fejérváry-Mayer 24, from Seler 1904-1909, I:Abb. 427.

*contexts*, searching out any consistently associated clusters of individual elements. The essential fertility connotation of the Rain God or Tlaloc cluster, for example, is rather clearly expressed by various associated elements (vegetal and aquatic motifs, brandishing of the "lightning serpent," etc.), which, whenever encountered and whatever the degree of temporal separation, must forcibly suggest a basically similar significance. Likewise, when rows of footprints are directly associated with moving figures and/or are delineated on strips that, from their contexts, are obviously roads or paths, the interpretation of a similar "travel or movement" connotation is virtually demanded—whatever the temporal gap between their occurrences. In contrast, with the "line(s) through the eye(s) argument" in an attempt to establish conceptual connections between deity representations much separated in time considerable caution must be exercised since, as we have seen, various Mesoamerican deities displayed this characteristic. Focusing on Xipe Totec to the exclusion of the others may be justified, but, unless other elements of his recognized insignia are

present, these identifications do not appear too convincing.

It is largely through discerning significant *associations*, then, that reasonable explanatory hypotheses concerning the significance of iconographic elements can be achieved on whatever time level. The application of the direct historical approach often provides solid points of departure from which to work back, again, as Steward originally expressed it, merely applying the elementary logic of proceeding from the known to the unknown. And, as I (Nicholson 1973:72) have recently argued, while recognizing the basic cogency of some of Kubler's warnings, particularly the exaggerated or overly naive utilization of Conquest period ethnohistorical data to interpret archaeological remains dating from much earlier epochs, "the 'direct historical approach,' the thrust of which is simply working back from the living to the dead in order to more fully reconstruct and understand the past . . . if pursued with critical restraint and disciplined imagination, can yield positive results of great value." If the elements themselves are similar and occur in similar clusters then the likelihood of retention of similar meanings over time seems greatly increased. Even when the iconographic elements are isolated, the application of this approach at least makes possible the advancing of cogent hypothesis to elucidate their meanings, to be tested against further data as they become available.

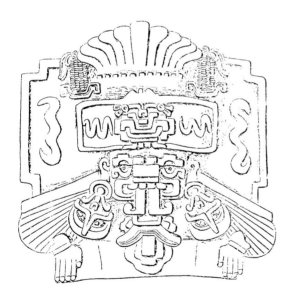

Fig. 22. Monte Albán tradition funerary urn, from Hacienda de Noriega, near Zaachila, representing the fundamental rain-fertility deity ("Cocijo"), with maize cobs in headdress, from Seler 1890:Fig. 11. Maize cobs decorating the headdress are more commonly a feature of the "God of Glyph L."

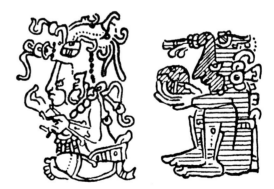

Fig. 23. "God E," left: Codex Dresden 9a; right: Codex Madrid 28d; from Seler 1902-1923, IV:Figs. 364, 365. Note lines through eyes, comparable to Mixteca-Puebla representations of the maize deity (Figs. 19, 25).

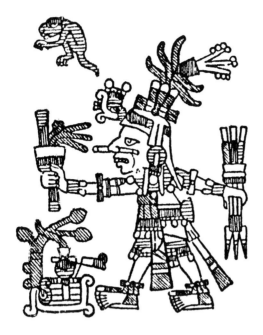

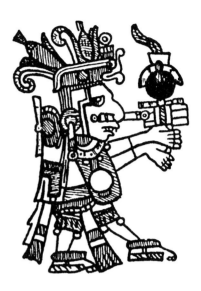

Fig. 24. Maize deity, Codex Fejérváry-Mayer 3, from Seler 1904-1909, I:Abb. 397.

Fig. 25. Maize deity, Codex Borgia 14, from Beyer 1910:Abb. 6.

Religious iconographic devices in all cultures undoubtedly undergo some shift in meaning over long time spans, but when the ideological systems whose concepts they graphically express do not undergo radical modification it seems likely that most of them tend to retain their essential original meanings more or less indefinitely. Certainly the core array of Christian symbols persisted without sharp semantic shifts for many centuries, not to speak of the iconographic systems of ancient Egypt, India, and the Far East. Kubler's own logic of the "principle of least effort" was probably operative here. If a symbol is traditional and has connoted the same fundamental meaning for centuries, apparently only under very strong pressures would its significance sharply alter—as in those cases in Mesoamerican culture history where some religious ideological changes occurred owing to such events as local political power shifts, foreign conquests, and long-range migrations. It would be expected that the replacement of one religious system by another over a relatively brief period of time, as in the cases of the Christianization of the Roman Empire and the later spread of Islam, would naturally result in rather profound disjunctions. As I have argued above, however, there seems to be no evidence that any ideological shifts on the order of this magnitude ever occurred in pre-Hispanic Mesoamerica between the Late Preclassic-Early Classic and the Conquest. Once relatively continuous series of similar iconographic images that endured for long time periods have been discerned, therefore, the presumption of persistence of concomitant conceptual significances is not unreasonable. In fact, I would suggest that the burden is on those who would argue for disjunction in these cases, rather than the reverse.

This paper has concerned itself with only one approach in the interpretation of early Mesoamerican iconographic systems. I would also favor the utilization of possible other approaches, however, whenever cogent results seem likely to emerge: specific ethnographic analogy, general comparative analogy, intrinsic configurational analysis, and the like—always with the caveat that these methods should be applied with a certain degree of caution and prudence, if for no other reason than to provide a necessary counterweight to the extravagant fantasies of romantics, mystics, and downright crackpots which have infested this field from the beginning. In other words, a comprehensive, synthetic approach to the problems of the interpretation of early Mesoamerican iconographic systems will probably eventually yield the most successful results (cf. Pasztory 1973:150).

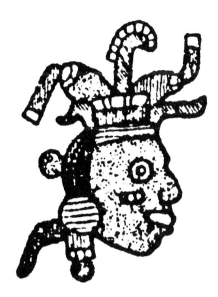

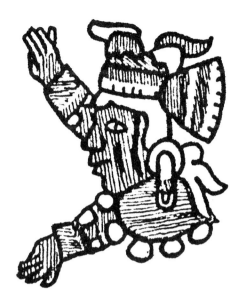

Fig. 26. Head of maize deity (4th of 9 Lords), Codex Cospi 4, from Beyer 1920:Fig. 13.

Fig. 27. Maize deity (4th of 9 Lords), Codex Borbonicus 6, from Beyer 1910:Abb. 5.

To summarize and conclude, I suggest that the direct historical approach can be profitably employed in Mesoamerican research to interpret even the iconographic systems of cultural traditions as early as those of the Preclassic. The soundest method would seem to be the attempt to plot iconographic continuities, working back from well-documented elements or, better, clusters of elements. Although it would obviously be a serious mistake to assume that all of the concepts connoted by a particular image at Contact were also conveyed by the same ancestral Preclassic and/or Classic representation, it would appear likely that the most fundamental meanings were similar. Crucial in determining possible Preclassic to Postclassic conceptual equivalences are the associations, the iconographic contexts of individual motifs. If these clusters can be ascertained to have been essentially similar to those current at the time of the Conquest, then the case for ideological continuity would be considerably strengthened—and one apparent example (Tlaloc cluster) was discussed above.

Although general comparative analogy would seem to be a much less promising approach, I feel that even it can be legitimately employed to a certain extent. When available, it is certainly preferable to utilize ethnographic and/or ethnohistorical data concerning groups residing in the same general area as that in which the archaeological remains were found. Cautiously roving further afield may in some cases be justified, however, especially when the local indigenous population has either physically disappeared or culturally profoundly altered through transculturative processes.

Panofsky's "principle of disjunction" has probably been frequently operative in Mesoamerican culture history, but I should think somewhat less so than in Western Europe and the Near East. We are probably treading on firmer ground, therefore, in attempting to interpret Preclassic Mesoamerican iconography employing ethnographic information of relatively recent date than would the European or Near Eastern culture historian interpreting very ancient representations in his area if he had no texts to aid him. The most basic religious-ritual patterns were probably widely shared throughout Mesoamerica from Late Preclassic or at the latest Early Classic times on. This probability, in my view, provides us with exceptional opportunities to interpret the more ancient Mesoamerican iconographic systems through a sensible, critical application of the direct historical approach—whereby we move, cautiously but systematically, back from the living of the sixteenth century to the remote dead of the end of the second millenium before Christ.

# References

Anders, Ferdinand
1963   *Das Pantheon der Maya.* Akademische Druck- u. Verlagsanstalt, Graz, Austria.

Armillas, Pedro
1945   Los dioses de Teotihuacán. *Anales del Instituto de Etnología Americana* 6:161-178.

Bernal, Ignacio
1960   Toynbee y Mesoamérica. *Estudios de Cultura Náhuatl* 2:43-58.
1969   *The Olmec world.* University of California Press, Berkeley and Los Angeles.
1971   The Olmec Region—Oaxaca. In *Observations on the Emergence of Civilization in Mesoamerica,* edited by Robert F. Heizer, John A. Graham, and C. W. Clewlow, pp. 29-50. *Contributions of the University of California Archaeological Research Facility* 11. Berkeley.

Beyer, Hermann
1910   Das aztekische Götterbild Alexander von Humboldt's. In *Wissenschaftliche Festschrift zur Enthüllung des von Seiten Seiner Majestät Kaiser Wilhelm II, dem Mexikanischen Volke zum Jubiläum, seiner Unabhängigkeit gestifteten Humboldt-Denkmals,* pp. 107-119. Müller Hnos, Mexico.
1919   ¿Guerrero o Dios? Nota arqueológica acerca de una estatua mexicana del Museo de Historia Natural de Nueva York. *El México Antiguo* 1:72-81.
1920   Una pequeña colección de antigüedades mexicanas. *El México Antiguo* 1:159-197.
1922   Relaciones entre la civilización Teotihuacana y la Azteca. In *La Población del Valle de Teotihuacán,* edited by Manuel Gamio, 1:269-293. Secretaría de Agricultura y Fomento, Dirección de Antropología, Mexico.

Boggs, Stanley
1944   A human-effigy pottery figure from Chalchuapa, El Salvador. *Carnegie Institution of Washington, Division of Historical Research, Notes on Middle American Archaeology and Ethnology* 31.

Caso, Alfonso
1947   Calendario y escritura de las antiguas culturas de Monte Albán. In *Obras completas de Miguel Othón de Mendizábal* 1:115-143. Mexico.
1959   El dios 1. Muerte. In *Amerikanistiche Miszellen; Festband Franz Termer,* edited by Wilhelm Bierhenke, Wolfgang Haberland, Ulla Johansen, and Günter Zimmermann, pp. 40-43. *Mitteilungen aus dem Museum für Völkerkunde in Hamburg* XXV.
1962   Calendario y escritura en Xochicalco. *Revista Mexicana de Estudios Antropológicos* 18:49-79.
1966   Dioses y signos Teotihuacanos. In *Teotihuacán, Onceava Mesa Redonda,* 1, Sociedad Mexicana de Antropología, pp. 249-279.

1971   ¿Religión or religiones Mesoamericanas? In *Verhandlungen des XXXVIII. Internationalen Amerikanistenkongresses, Stuttgart-München 12. bis 18. August 1968,* 3:189-200.

Caso, Alfonso and Ignacio Bernal
1952   Urnas de Oaxaca. *Memorias del Instituto Nacional de Antropología,* 2. Mexico.

Coe, Michael
1968   *America's first civilization.* American Heritage Publishing Co., in association with the Smithsonian Institution, New York.
1972   Olmec jaguars and Olmec kings. In *The cult of the feline: a conference on Pre-Columbian iconography, October 31st and November 1st, 1970,* edited by Elizabeth P. Benson, pp. 1-18. Dumbarton Oaks Research Library and Collection, Washington.
1973   The iconology of Olmec art. In *The iconography of Middle American sculpture,* pp. 1-12. The Metropolitan Museum of Art, New York.

Coe, William
1967   *Tikal: a handbook of the ancient Maya ruins.* The University Museum, University of Pennsylvania, Philadelphia.

Covarrubias, Miguel
1946   El arte "Olmeca" o de La Venta. *Cuadernos Americanos* 28(4):153-179.

Dumond, Donald, and Florencia Müller
1973   Classic to postclassic in highland central Mexico. *Science* 175(4027):1208-1215.

Fenton, William
1949   Collecting materials for a political history of the Six Nations. *Proceedings of the American Philosophical Society* 93:233-238.
1952   The training of historical ethnologists in America. *American Anthropologist* 54(3):328-339.

Hicks, Frederic, and H. B. Nicholson
1964   The transition from Classic to Postclassic at Cerro Portezuelo, Valley of Mexico. In *XXXV Congreso Internacional de Americanistas, México, 1962, Actas y Memorias,* 1:493-506.

Jiménez Moreno, Wigberto
1971   ¿Religión o Religiones Mesoamericanas? In *Verhandlungen des XXXVIII. Internationalen Amerikanistenkongresses, Stuttgart-München 12. bis 18. August 1968,* 3:201-206.

Joralemon, Peter David
1971   A study of Olmec iconography. *Studies in Pre-Columbian Art and Archaeology* 7. Dumbarton Oaks, Washington.

Kubler, George
1967   The iconography of the art of Teotihuacán. *Studies in Pre-Columbian Art and Archaeology* 4. Dumbarton Oaks, Washington.
1970   Period, style, and meaning in ancient American art. *New Literary History; A Journal of Theory and Interpretation from the University of Virginia* 1-2:127-144.

1972a  La evidencia intrinseca y la analogía etnología en el estudio de las religiones mesoamericanas. In *Religión en Mesoamérica: XII
Mesa Redonda*, edited by Jaime Litvak King
and Noemí Castillo Tejero, Sociedad Mexicana de Antropología, pp. 1-24.

1972b  Jaguars in the Valley of Mexico. In *The cult of
the feline: a conference in Pre-Columbian
iconography, October 31st and November
1st, 1970*, edited by Elizabeth P. Benson, pp.
19-49. Dumbarton Oaks Research Library and
Collection, Washington.

1973  Science and humanism among Americanists.
In *The iconography of Middle American
sculpture*, pp. 163-167. The Metropolitan
Museum of Art, New York.

Miller, Arthur

1973  *The mural painting of Teotihuacán.* Dumbarton Oaks, Washington.

Millon, Clara

1973  Painting, writing, and polity in Teotihuacán,
Mexico. *American Antiquity* 38(3):294-314.

Nicholson, H. B.

1971a  The iconography of Classic Central Veracruz
ceramic sculptures. In *Ancient Art of Veracruz*, edited by Olga Hammer, pp. 13-17. The
Ethnic Arts Council of Los Angeles.

1971b  Religion in pre-Hispanic Central Mexico. In
*Handbook of Middle American Indians*, edited by R. Wauchope, G. Ekholm, and I.
Bernal, 10:395-447. University of Texas Press,
Austin.

1972  The cult of Xipe Totec in Mesoamerica. In
*Religión en Mesoamérica: XII Mesa Redonda*,
edited by Jaime Litvak King and Noemí
Castillo Tejero, Sociedad Mexicana de Antropología, pp. 213-218A-3.

1973  The late pre-Hispanic Central Mexican (Aztec) iconographic system. In *The iconography
of Middle American sculpture*, pp. 72-97. The
Metropolitan Museum of Art, New York.

1974  Western Mesoamerican native historical traditions and the chronology of the Postclassic.
In press, *Chronologies in New World archaeology*, edited by Clement Meighan and R. E.
Taylor. Academic Press, New York.

Panofsky, Erwin

1944  Renaissance and renascences. *Kenyon Review*
6:201-236.

1955  *Meaning in the visual arts: papers in and on
art history.* Doubleday Anchor Books, Doubleday and Company, Inc., Garden City,
New York.

1960  *Renaissance and renascences in Western art.*
Almqvist and Wiksells, Stockholm.

Pasztory, Esther

1972  The iconography of the Teotihuacán Tlaloc.
Paper presented at the pre-Columbian session
of the Annual Meeting of the College Art
Association, San Francisco.

1973  The gods of Teotihuacán: a synthetic approach in Teotihuacán iconography. In *Atti
del XL Congresso Internazionale degli Americanisti, Roma-Genova 3-10 Settembre 1972*,
1:147-159.

Rowe, John

1961  Stratigraphy and seriation. *American Antiquity* 26(3):324-330.

Séjourné, Laurette

1957  *Pensamiento y religión en el México antiguo.*
Fondo de Cultura Económica (Breviarios,
128), Mexico.

1959  *Un palacio en la ciudad de los dioses (Teotihuacán).* Instituto Nacional de Antropología
e Historia, Mexico.

Seler, Eduard

1890  Die sogennannten sacralen Gefässe der Zapoteken. *Königliche Museen zu Berlin, Veröffentlichungen aus dem Königlichen Museum
für Völkerkunde*, I. Band—4. Heft:182-188.

1902-   *Gesammelte Abhandlungen zur amerika*
1923    *nischen Sprach- und Altertumskunde.* 5 vols.
Verlag A. Asher and Verlag Behrend, Berlin.

1904-   *Codex Borgia, Eine altmexikanische Bilder*
1909    *schrift der Bibliothek der Congregatio de
Propaganda Fide, Herausgegeben auf Kosten
Seiner Excellenz des Herzogs von Loubat . . .
Erläutert von . . .* 3 vols. Berlin.

Steward, Julian

1942  The direct historical approach to archaeology.
*American Antiquity* 7(4):337-343.

Stocker, Terrance, and Michael Spence

1973  Trilobal eccentrics at Teotihuacán and Tula.
*American Antiquity* 38(2):195-199.

von Winning, Hasso

1968  Der Netzjaguar in Teotihuacán, Mexico: eine
ikonographische Untersuchung. *Baessler-Archiv*, Neue Folge, 16:31-46.

Willey, Gordon

1973  Mesoamerican art and iconography and the
integrity of the Mesoamerican ideological
system. In *The iconography of Middle American sculpture*, pp. 153-162. The Metropolitan Museum of Art, New York.

# INDEX

Abaj Takalik, 81, 144
Acanceh, 98, 99, 100
Acosta, Jorge R., 143, 149
Akkadian culture, 102
Anderson, Arthur J.O., 61
Andrews, E. Wyllys, 89, 92, 93
Archaeology, excavational, 3
Armillas, Pedro, 147, 168
Arroyo Pesquero, 40, 47, 52
Arroyo Sonso Jaguar, 20
Art Institute of Chicago, 120
Atlihuayan Figure, 47
Aztecs, 125, 128, 129, 130, 144, 147, 148, 150, 152,
    160, 161, 162, 163, 164, 165, 168; beliefs, 40, 65;
    culture, 9; dragons, 59; iconography, 33; Sun Stone,
    40; writing, 110, 112, 114, 127

Baktun, 7, 112
Batres, Leopoldo, 125, 143, 148
Belmar, 125
Bennyhoff, James A., 143, 147
Berlin, Heinrich, 111, 128
Bernal, Ignacio, 91, 93, 143, 149
Beyer, Hermann, 160
Bilbao Monument, 42, 79, 81, 84
Bradomín, José María, 130
Brainerd, George W., 93
British Museum, 112
Buddhism, 4
Burgoa, Fray Francisco de, 130
Bushnell, Geoffrey, 4

Calendar (calendrics), 6, 99, 100, 109-113, 118, 120,
    135, 152-154
Calendar Round, 110, 112, 121
Campeche, 96, 97
Caso, Alfonso, 125, 128, 129, 130, 134
Castañeda (artist), 125
Centeotl-Xochipilli deity complex, 165, 169
Central Highlands, 9, 20, 24, 61, 121
Ceramics, 3, 10, 24, 47, 89, 91-93, 96, 98, 100, 111,
    125, 136, 137, 143, 144, 147-154
Cerro Chiconautla, 146
Cerro de las Mesas, 20, 24, 113
Cerro Gordo, 146, 150
Cervantes, María Antonieta, 5, 7-25
Chalcatzingo, 40
Chenes, 82, 93

Chiapa de Corzo Bone 1, 78, 81, 83, 84
Chiapa de Corzo Bone 3, 83
Chiapa de Corzo, Chiapas, 112
Chiapas-Guatemala Highland region, 5, 20, 24, 77,
    112, 117, 121. See also Izapan
Chicanel period, 100
Chichimec, 162
Chiconautla phase, 154
Childe, V. Gordon, 3
Chimalhuacan, 147, 148
Chinese writing, 108
Christians and Christianity, 4, 160-162, 172, 173
Chupícuaro tradition, 147
Cipactli, 65
Classic Maya, 75; art, 76; culture, 103; system of
    writing, 110, 111, 114, 115
Classic Lowland Maya period, 5, 6, 112, 159
Classic Monte Albán, 6
Classic period, 6, 9, 75, 82, 91, 109, 111, 143, 146,
    147, 150, 162, 163, 169, 172, 173
Cocijo (thunder-rain god), 127
Codex Borgia Group, 110, 112, 114, 165, 168
Codex Dresden, 165
Codex Mendoza, 128, 130
Coe, Michael D., 6, 9, 10, 29, 33, 40, 96, 102, 107-122,
    125, 126, 152, 154, 160, 164, 165
Colima, 20
Colombo, 114
Conquest period, 5, 6, 159, 160, 165, 171-173
Contact, 5, 160, 162, 165, 168, 173
Córdova, Fray Juan de, 127
Cortés, Hernán, 160, 163
Costa Rica, 120
Cotzumalhuapa, 110
Covarrubias, Miguel, 9, 29, 58, 89, 151, 153, 168
Coyolapan, 128, 130
Cruz, Wilfrido C., 131
Cuadros, 96
Cuicatec, 132
Cuicatlan, 130, 136
Cuicuilco, 147, 148, 151-155, 163
Cultural ecology, 3, 4, 6
Culture versus style, 24

Danzantes, 125, 126, 127, 131, 136
Dávalos Hurtado, Eusebio, 126
Dumbarton Oaks, 33, 52, 114, 115, 120, 150
Dupaix, Guillermo, 125

Preclassic period, Late, 141-156, 172, 173
Preclassic period, Middle, 165
Preclassic period, Terminal, 141-156
Preclassic Teotihuacán, emergence of, 141-156
Pre-Columbian America, 143; art, 75; iconography, 27-71
Pre-Conquest period, 61
Pre-European New World civilization, 3
Pre-Hispanic Mesoamerica, 3, 4, 9, 110, 160, 168, 172
Pre-Late Postclassic period, 160
Price, Barbara, 3, 4
Proskouriakoff, Tatiana, 111
Protoclassic period, 6, 113
Pyramids, 143, 144, 147, 148, 149, 150, 153. *See also* Mounds

Quetzalcoatl, 33, 65, 153, 160, 165
Quintana Roo, 114
Quirarte, Jacinto, 5, 73-86

Regional Museum, Teotihuacán, 144
Religion, 4; Teotihuacán, 150-153
Religious ideology of Pre-Hispanic Central Mexico, 3, 4, 5
Reyes Etla, 129
Rich, Barbara, 118
Río Chiquito, 29
Rojas, Basilio, 129
Rosario phase, 125, 136

Sáenz Collection, 120
Sahagún, 148, 160
Saint Andrews Cross, 95, 102, 125, 130
San Andrés Tuxtla, 117
Sanders, William, 3, 4, 143, 147
San Isidro, 24
San José Mogote, 125, 129, 137
San José phase, 125, 136, 137
San Lorenzo, Veracruz, 9, 10, 24, 37, 47, 52, 96, 97, 111, 125, 163
San Lorenzo Tenochtitlan, 125, 128
Santa Inés Yatzeche Monument, 135-136
Santa Rosa Xtampak, 96
Satterthwaite, Linton, 111
Saville, Marshall H., 29
Sayil, 93
Seler, Eduard, 3, 5, 125, 159, 160
Selerian period, 3
Sociedad Mexicana de Antropología, 144
Soconusco region, 93
Sologuren, 125
Spanish conquest, 59; influence on New World, 98
Spence, Michael, 169
Spinden, Herbert J., 111
Stelae, 24, 75-79, 81-84, 110, 112-115, 118, 119, 120, 125, 127, 131, 136

Steward, Julian, 3
Stirling, Matthew, 9, 10, 29, 76, 112
Stocker, Terrance, 169
*Studies in Pre-Columbian Art and Archaeology*, 150
Sullivan, Thelma, 150
Sumerian culture, 102
Supplementary Series, 120
Survivals wing, National Museum of Anthropology, Mexico, 9
Swadesh, Morris, 96

Tabasco, 10, 20, 52, 111. *See also* La Venta
Tajín culture, 9; writing, 110, 163
Tehuacan, 137
Tehuantepec, 137
Telantunich, 93
Tenango head, 9
Tenochtitlan, 162
Teotihuacán, 5, 79, 91, 160, 161-165, 168, 169; architecture, 148-150; art, 153-155; chronology of, 144-146; emergence of 141-156; environment and climate, 146-147
Teotihuacán Mapping Project, 143
Teotihuacán Valley Project, 143, 148
Texcoco, Lake, 146, 148
Tezcatlipoca, 152
Tezoyuca phase, 146
Thompson, J. Eric S., 4, 61, 96, 111, 112, 115, 120
Ticoman, 148, 151
Tikal, 75-77, 83, 84, 98, 99, 100, 118, 119
Tlaloc, 143, 150, 151, 152, 154, 168, 171, 173
Tlapacoya, 20, 37, 151
Tlatilco, 20, 52, 93, 151, 154
Tobriner, Stephen, 150
Tollan, 162
Toltecs, 65, 75, 96, 110, 162, 165, 168, 169
Tonacatecuhtli, Lord of Our Flesh and Sustenance, 65
Tres Zapotes, Veracruz, 24, 78, 79, 84, 112
Tula, 163
Turner, Allen, 118
Tututepec, 137
Tuxtlas, 97
Tuxtla Statuette, 26, 78, 99, 117, 118
Tylor, E. B., 109, 110
Tzacualli phase, 147-154
Tzakol phase, 103

Uaxactun, Stela 18, 120
Uaxactun Structure E-VII, 82, 98, 99
UCLA Conference on Origins of Religious Art and Iconography in Preclassic Mesoamerica, 5
University of Pennsylvania, 75
University of Rochester, 143, 149
Uo (Jaguar god of the Underworld), 113
"Urban Revolution," 3

Vague Year, 110
Valley of Mexico, 110, 147, 148, 152, 162
Valley of Oaxaca, 6; iconography of militarism in, 123-139
Veracruz, 10, 110-113, 117, 121, 165. *See also* San Lorenzo
Veracruz, Classic, 4, 169
Vikings, 98
Villagra, Agustín, 125, 126
von Winning, Hasso, 6, 141-156

Waterman, T. T., 114
Wenner-Gren Conference, 4
Were-Jaguar, 89, 93, 98, 102, 114, 115, 118
Western culture, 9
White, Leslie, 4

Willey, Gordon R., 4, 159, 162
Writing, Maya, 107-121

XI Mesa Redonda Conference, 144
Xipe, 152, 154
Xipe Totec, Fire Serpent, 33; "Flayed God," 164, 165, 171
Xitle Volcano, 148, 152
Xiuhcoatl (Fire Serpent), 40; (Turquoise Serpent) 61
Xiuhtecuhtli (Fire god), 61, 65
Xochicalco, 5, 110, 162-164, 168, 169

Yucatan, 6, 75; Olmec influence in, 87-105
Yucatecs, 96, 98

Zapotecs, 125-139
Zegache vase, 84

Photo composition in Compugraphic Paladium
by Freedmen's Organization
Los Angeles, California

Printed by Publisher's Press
Salt Lake City, Utah